Liquid Stone

Liquid Stone

New Architecture in Concrete

Jean-Louis Cohen and G. Martin Moeller, Jr., editors

Princeton Architectural Press, New York

Contents

Building construction, one the oldest activities of humankind, has a complex and often nonlinear history. Materials and processes used for millennia, for instance, have sometimes suddenly become objects of unexpected and surprising invention. Such is the case with concrete, a major component of Roman buildings and infrastructure, that today is almost certainly the world's most widely used structural material.

Rediscovered in the context of the Industrial Revolution, concrete has been transfigured by scientific theories and laboratory experiments; it has become an object of mass production, not only in its constituent elements such as cement and steel but also in the very types of buildings it has generated, from the "daylight factory" of the early twentieth century to the modernist housing block and office slab. In addition to advancing the technology of building, concrete has also contributed to the formation of modern architectural identities in an age of unprecedented urbanization.

The prominent role of this material in the sphere of modernization has all too often led to a general association of concrete with the brutality of many urban renewal schemes and the monotony of contemporary suburban developments. Despite the considerable amount of ingenuity spent in trying to "animate" its surface, concrete is widely perceived as dull and repetitive—in short, a sort of frightening metonymy of the industrial age. Herein lies one of the paradoxes of concrete: a material initially considered ethically superior—ideally suited to modernism's aspiration to structural "honesty" and to the movement's social optimism—has become a liability.

Widely pronounced dead, concrete has, however, not only been resuscitated, but has also entered a new and astonishingly vital cycle.

The exhibition Liquid Stone: New Architecture in Concrete, presented at the National Building Museum in Washington, D.C., between 2004 and 2006, revealed the many aspects of concrete's new identity and potential scope. A complementary symposium held at Princeton University's School of Architecture further confirmed the wide range of stimulating interpretations made possible by parallel developments in laboratories, architectural offices, and research seminars.

The new potentialities of concrete are related not only to advances in the science of materials; unprecedented developments in mathematics, physics, and optics have enabled manufacturers of building components to escape the limitations that previously characterized the material. Concrete has now evolved into an exceptionally smooth, flexible, colored, or even translucent substance. Perhaps the most significant innovation deals with the very concept of reinforced concrete. Revolutionary changes in concrete's constituent components, ranging from the introduction of microscopic aggregate particles to the elimination of traditional reinforcing rods (as in the high-performance concrete known as Ductal®), have made possible new forms of concrete with the thinness and elasticity of steel.

The forms of expression that have emerged alongside these technical developments reflect shifts in the profession's theoretical underpinnings. Renewed interest in the issue of tectonics has led many Swiss and Austrian architects, for example, to embrace a more complex view of the relationship between structure and envelope in concrete buildings. Eschewing the style liberally defined as "high-tech" and characterized by the superficial application of industrial-looking finishes, some designers have rediscovered the virtues of crafted, often grainy surfaces. The use of photoengraving and of digital etching methods in concrete has led to innovative and often surprising uses of imagery

on building skins: the images cast by Herzog & de Meuron and the etched surfaces of Wiel Arets, for instance, introduced a new relationship between texture and iconicity, allowing for a technologically based *architecture parlante*. At the same time, a more pragmatic attitude toward the exclusive use of concrete has replaced what could be called the "fundamentalism" of concrete, in which "monomaterial" construction was regarded as ideal. Accepting and even exploiting the integration of heterogeneous materials in a single structure is no longer a mark of moral depravity.

These bold innovations by architects and structural engineers have been complemented by historiographical developments addressing the genealogy of concrete. Narratives focused on major engineers or designers have been supplemented by studies of influential but relatively unknown firms such as that of François Hennebique (1842–1921). Historians of science and technology have contributed to our understanding of the cognitive bases upon which concrete construction has developed. In-depth analyses of canonical projects that had been caricatured in previous historical interpretations now contribute to our understanding of the material.

This book takes stock of what seems to be a moment of unprecedented creativity in concrete construction by assembling contributions from engineers, architects, and historians involved in the current renaissance of the material. Each essayist considers specific aspects of concrete's long and varied lineage. Antoine Picon offers a general perspective on the technological history of the material. Jean-Louis Cohen examines the clash of French and German national cultures of architecture. Adrian Forty makes clear that concrete is much more than a material and should be considered a process, using the much overlooked scene of northern Italy in the late 1950s as the focus of his investigation. Finally, Réjean Legault interprets contemporary developments on the North American scene, which reshaped the visible face of concrete.

The current condition of concrete construction is discussed in a second group of essays. In relation to the issue of structure, Guy Nordenson underlines the theatrical dimension that the assembly of concrete systems often takes. Tod Williams and Billie Tsien, who designed the Liquid Stone exhibition, comment on the vast spectrum of innovations encountered on the surface of concrete, whereas G. Martin Moeller, Jr., reflects on the surprisingly tenacious moralistic attitudes that have characterized the debate about concrete's potential as a vehicle for sculptural form. Opening the doors of the research laboratory, Franz-Josef Ulm reveals amazing new directions of scientific investigation that will undoubtedly shape future developments on the drawing board (or the computer screen) and on the building site. Appearing alongside these essays are several dozen recent projects that together reveal the astounding breadth of contemporary concrete architecture around the world.

We hope that these diverse contributions will convey the excitement generated by the convergence of emerging technologies and design innovation that is currently infusing concrete with an unprecedented and imaginative new spirit.

Antoine Picon

Architecture and Technology: Two Centuries of Creative Tension

As various architects, theorists, and historians have pointed out, no material has been more closely associated with the origins and development of modern architecture than concrete. This status is partly linked to the fact that concrete seemed to epitomize the relations between modern architecture and technology, relations that were seen as crucial by the founding fathers of the modern movement. In his *Bauen in Frankreich, bauen in Eisen, bauen in Eisenbeton* (1928), Sigfried Giedion wrote, for instance, that "scientific, industrialized building production stands behind the concrete entrepreneur."[1] Since that time, for better and for worse, concrete has retained an emblematic character. Its use is still associated with issues pertaining to the relations between architecture and technology.

In this essay, we look first at some fundamental features of these relations, beginning with the tensions that have marked them at least since the eighteenth century, at the time when technology began to assert its autonomy. We then envisage the way concrete has helped modern designers answer the challenge of technology through its shaping power, its dynamism, and its capacity to produce fascinating objects and systems. Finally, we turn to the present in order to discuss some recent technological evolutions and how concrete, or rather the new types of concrete that are developing under our eyes, may play an essential role in them. The story of concrete by no means ended with the development of prestressed techniques. It is an ongoing adventure that may still hold many a surprise for us.

The Challenges of Technology

In the history of the relations between architecture and technology, the Enlightenment represents a turning point, an examination of which may provide useful insights into what would later be at stake in their confrontation. Indeed, it is in the eighteenth century that technology became both autonomous and influential on society and culture at large.

Until that period, technology, and engineering in particular, was not considered distinct from architecture. The art of the engineer was often defined as a branch of architecture dealing with problems having to do with water, from the construction of canals, bridges, and ports to the design of waterwheels and mills. Engineering was often called hydraulic architecture. In the *"système figuré de l'architecture"* (figured system of architecture) that was added to the 1755 edition of the *Dictionnaire d'architecture civile et hydraulique* by the French theorist Augustin Charles D'Aviler, hydraulic architecture was still considered an integral part of the architectural discipline.[2] [Figure 1]

In the history of the relation between architecture and technology, the second half of the eighteenth century clearly marks a departure from this situation. In countries such as England and France, civil engineering in particular acquired greater autonomy. In France, for example, the bridge builder Jean Rodolphe Perronet (1708–1794), the founder and first director of the École des Ponts et Chaussées, boasted of having given his bridges structure and form that were no longer subject to architectural precepts.[3] [Figure 2]

For the new engineer emerging at the time, structure and form were inseparable from two dimensions that further distinguished engineering from architecture. The first was a regional dimension. The engineer considered himself in charge of a region or territory as a whole, rather than of a limited project. By the late eighteenth century, French engineers liked to compare themselves to gardeners, in charge of a national territory comparable in scale to a large park. [Figure 3] The second dimension that distinguished

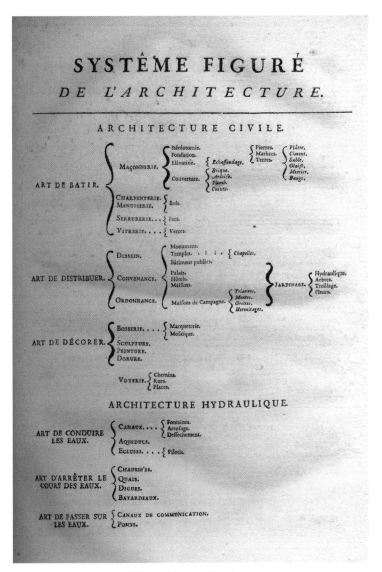

Figure **1** Augustin Charles D'Aviler, "Système figuré de l'architecture," from *Dictionnaire d'architecture civile et hydraulique* (1755)

engineering from architecture was that of process. The engineer appeared to be more a manager of dynamic technological and economic processes than a designer of static objects.

Since this split between architecture and engineering took place, technology has constantly challenged architecture: throughout the nineteenth and twentieth centuries it obliged the discipline to redefine its objectives and methods. The sheer power of technology, its capacity to order regional and urban development through its various processes of production, constitutes the first of these challenges. The industrial world seemed more in step with this kind of power than with the subtleties of architecture. From Eugène Emmanuel Viollet-le-Duc to Manfredo Tafuri, from William Morris to Archigram, the possible reconciliation between the logic and rhythms of the industrial age and the principles of architecture has represented a nagging dilemma for theorists, historians, and practitioners. Was architecture only an artistic superstructure in a world ruled by technology and capitalism, as Tafuri suggested in 1973 in *Architecture and Utopia*,[4] or could it regain its power to affect spatial and social change? This question was surely easier to address for civil engineers, who possessed a true understanding of infrastructural considerations, as amply demonstrated in their various accomplishments, from bridges to aqueducts to dams.

In addition to power, dynamism seemed another fundamental feature of technology. In civil engineering, the fascinating character of so many construction techniques and processes represented a privileged expression of this dynamism: How could one not be struck by the cantilevered assembling techniques employed by Gustave Eiffel on the site of the Garabit Viaduct (1884), or by Eugène Freyssinet's spectacular use of a large floating arch form for the Albert Louppe Bridge at Plougastel (1930)? [Figure **4**] Compared with the dynamic world of the engineer, full of moving objects, forces, and tensions, architecture often seemed hopelessly static.

Throughout the nineteenth and twentieth centuries, technology was not only synonymous with power and dynamism, but it also produced fascinating objects.[5] Some of these objects were mass produced, like the automobile; others were of a more prototypical nature, like civil engineering realizations. What they had in common were qualities of style and emotion, which designers like Le Corbusier aimed at bringing back to the architectural realm.

These objects were engaging not only because of their aesthetic seduction; they seemed also to possess the paradoxical capacity to be meaningful at two extreme and almost contradictory levels. On the one hand, technological artifacts and feats of civil engineering in particular spoke the primitive language of need and of natural phenomena. Bridges, for instance, appeared as direct consequences of the immemorial need to cross rivers as well as expressions of the timeless constraints of gravity. They crystallized simultaneously advanced scientific and technological knowledge, like the most

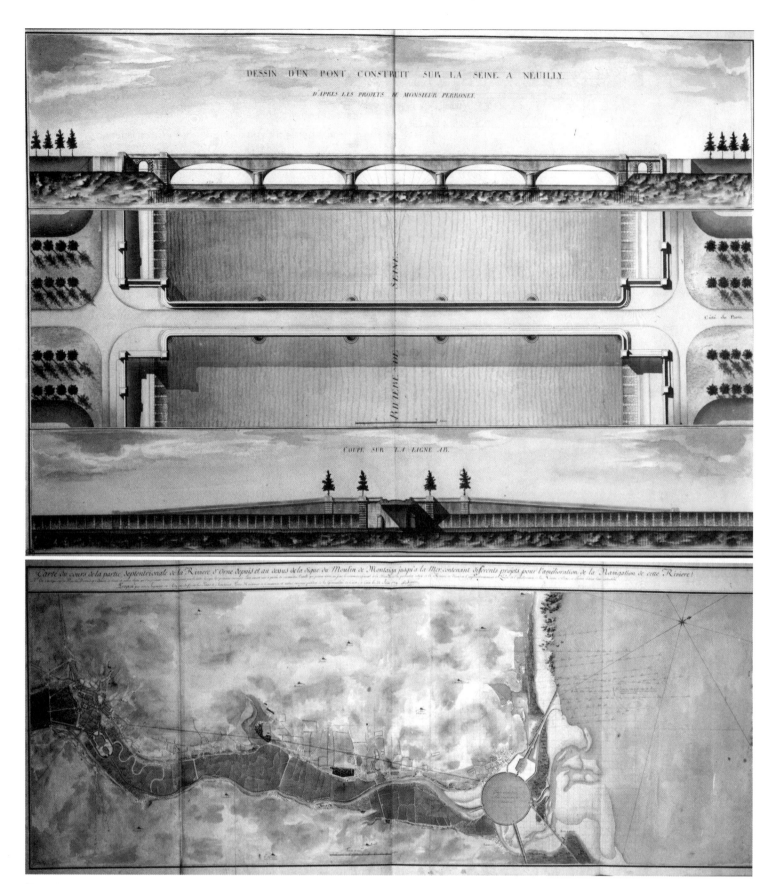

Figure **2** Jean Rodolphe Perronet, Neuilly Bridge, 1774, drawing, École Nationale des Ponts et Chaussées, Paris

Figure **3** A. B. Lefebvre, project for the improvement of navigation on the Orne River between Caen and the sea, 1779, drawing, École Nationale des Ponts et Chaussées. The territorial dimension is quite evident in this project.

Figure 4 Eugène Freyssinet, Albert Louppe Bridge, Plougastel, 1930, arch form moving for reuse on the construction site

Figure 5 Arab black tents, from Horst Berger, *Light Structures, Structures of Light* (1996)

Figure 6 Skidmore, Owings & Merrill, Haj Pilgrim Terminal, Jeddah, 1981, from Berger, *Light Structures, Structures of Light*

recent results of structural mechanics, that seemed without equivalent in the architectural domain. Another way to put it is to say that engineering was able to speak both *before* language and *after* language, at the prelinguistic level of physical need and sensation and at the postlinguistic level of advanced computation. Engineering discourse and practice thrived on this dual positioning.

This strange linkage between the primitive and the hyperadvanced, or between the phenomenological and the computational, is still characteristic of engineering discourse today. A typical structural or civil engineering book will thus make reference to traditional as well as advanced artifacts as if they were actually one and the same. Horst Berger's *Light Structures, Structures of Light* opens with the evocation of ancient Arab tents and then presents large membrane roofs such as that of the Haj Pilgrim Terminal in Jeddah as their natural inheritors.[6] [Figures **5, 6**]

The ambition to merge the primitive and the ultracivilized informs the claim that civil and structural engineering constitutes an art totally distinct from architecture, what David Billington has called the "art of structural engineering" in books such as *The Tower and the Bridge*.[7] In late-nineteenth-century France, Gustave Eiffel (1832–1923) was among the major proponents of this claim. The tower that bears his name can be interpreted as a manifesto on just such a belief.[8] There, again, the challenge to architecture was direct and without ambiguity. The linkage between the primitive and the advanced was thought to elude architecture, to deprive it of both true natural roots and a direct relation to cutting-edge progress.

Another fascinating characteristic of engineering realizations lay in their capacity to adjust to the site in a dynamic way, often by revealing its hidden potential or by reshaping it. This capacity had been theorized in the late eighteenth century through the emergence of the "technological sublime," a transposition to engineering works of the aesthetic category of the sublime. Engineering was sublime insofar as it both fought and revealed nature. Nineteenth- and twentieth-century engineering was to retain this capacity to react dynamically, and often in a dramatic way, to the geography of the site.[9]

On a broader scale, engineering projects still retained the territorial dimension they had acquired in the eighteenth century. Through this territorial dimension, epitomized in constructions such as highways, bridges, and dams, the engineering field belonged to a world of flows and networks that contrasted once again with the more static world of architecture.

Last but not least, technology and technological realizations seemed to address one of the most fundamental problems of industrial society, namely, a simultaneous fracturing and aspiration toward collective identity. Major accomplishments such as the Eiffel Tower and the Brooklyn Bridge spoke to everyone, thus mollifying all kinds of political and social unrest, the full extent of which was visible in the recurring revolutions, demonstrations, and strikes that were taking place throughout the industrial world.

Fascinating technological accomplishments such as the great liners that crossed oceans and connected continents seemed to indicate the path toward possible reconciliation between the growing individualism of modern life and the notion of a shared destiny. Toward the middle of the nineteenth century, Victor Considérant (1808–1893), the main

Figure **7** Le Corbusier, *Vers une architecture* (1923)

disciple of utopian thinker Charles Fourier (1772–1837), had already identified the ocean liner as an example of collective life that seemed to prove the viability of harmonious communities.[10] [Figure **7**] Liners would later become a source of inspiration for various experiments in collective housing. It is probably for that reason that the sinking of the *Titanic* in 1912 was symbolically so important.

Technology was thus intimately linked to utopian aspirations at the dawn of European industrialization, in the 1820s and 1830s, aspirations that would remain active during a large part of the nineteenth and twentieth centuries. In France, around 1830, utopian movements such as Saint-Simonianism, for example, attracted hundreds of engineers, many of whom later became pioneers of modern transportation infrastructures, from railways to shipping lines.[11] More generally, technology and technological progress were seen as fundamentally socially cohesive. Could architecture perform this same function? Such speculation was to haunt architects in the nineteenth and twentieth centuries.

Modern Architecture and Concrete

An understanding of the complexities of the relation between architecture and technology helps in assessing what is at stake in the adoption by architecture of newly engineered technologies and building materials. Their impact is directly related to the fact that such an adoption is influenced by more than purely objective factors. Materials derive neither from nature alone nor from the mere progress of science and technology. Recent histories of science and technology stress the existence of complex cultural determinates that interact strongly with natural constraints as well as with the intrinsic strengths and weaknesses of an innovation. The term "social construction of technology" is often used in this context.[12]

In the case of concrete, one finds a series of decisive steps that seem to follow the straightforward path to innovation described by traditional histories of science and technology. But the development of the material owes also to more circuitous routes, such as those leading to the definition of its properties. Indeed, the properties of materials are never determined by nature only. What does it mean for concrete to be resistant to penetration? This kind of property is established through tests and is given credence by a community of engineers and builders. Part of the contribution made by engineer Louis-Joseph Vicat (1786–1861) to the early development of modern concrete resided in the definition of such tests. [Figure **8**]

In the social construction of a material and its properties, practices such as advertising often play a great role. The diffusion of the Hennebique system for building with concrete, for instance, was inseparable from a media strategy involving advertisements and the sponsorship of publicity events as well as the publication of a journal, *Le Béton armé*.[13] [Figure **9**] This socially constructed dimension of materials accounts for radical shifts in their conceptualization and usage, such as the transformation of reinforced concrete into a full-service building material at the turn of the twentieth century. Whereas concrete was indeed perceived as a material in the 1880s, reinforced concrete appeared as a set of competing structural systems, such as Hennebique's and others. Some twenty-five years later, through systematic normalization practices but also through intense lobbying from its promoters, reinforced concrete appeared as a material fit for various types of use.[14]

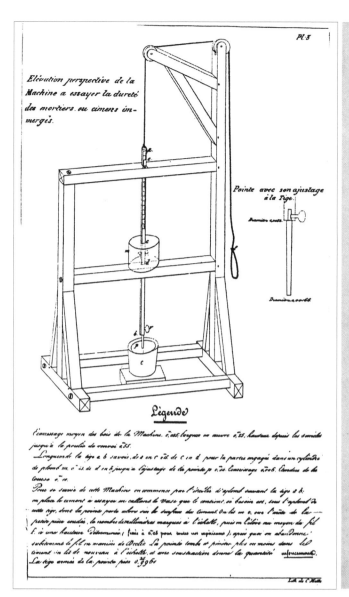

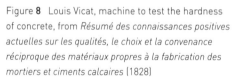

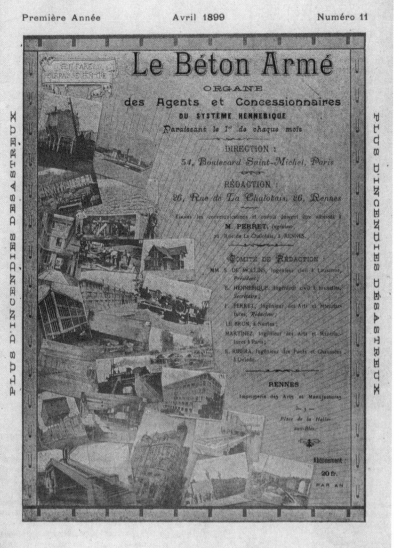

Figure **8** Louis Vicat, machine to test the hardness
of concrete, from *Résumé des connaissances positives
actuelles sur les qualités, le choix et la convenance
réciproque des matériaux propres à la fabrication des
mortiers et ciments calcaires* (1828)

Figure **9** Cover of *Le Béton armé*, the journal published
by François Hennebique

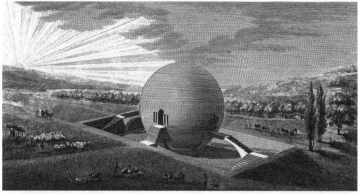

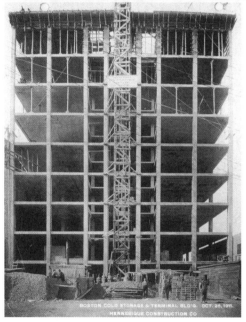

Figure **10** Claude-Nicolas Ledoux, guardhouse for the Château de Maupertuis, circa 1784, from *Architecture de C. N. Ledoux* (1847)

Figure **11** Victor Poirel, use of prefabricated concrete blocks for the construction of the new port of Algiers, 1840, from *Mémoire sur les travaux à la mer* (1841). The port of Algiers was among the first large-scale civil engineering realizations based on the use of prefabricated concrete elements.

Figure **12** Shoe Factory, Boston, realized using Hennebique patents, 1911

In the adoption of concrete by architecture, cultural factors were clearly at play. From the late eighteenth century, architects had been looking for a material that would enable design to free itself from the traditional constraints of masonry, a desire well conveyed by the famous project of Claude-Nicolas Ledoux (1736–1806) for a spherical guardhouse at the Château de Maupertuis. [Figure **10**] In the eyes of many nineteenth-century architects, iron construction represented only a partial solution, for it lacked the plastic nature of traditional materials. As one German theorist summarized it, "with its slightness iron can never offer sufficient form."[15] This explains the unease expressed by so many nineteenth-century designers, even if realizations like the Crystal Palace, London (1851), generally found favor with them.

Concrete was all the more welcomed toward the end of the nineteenth century as its use provided a possible answer to some of the challenges raised by other new technology. First, through techniques such as prefabrication, which had been associated with concrete early on, the material seemed capable of reconciling architecture with the rapid pace of industrial progress. [Figure **11**] For the better, and unfortunately often for the worse, the dream of a true industrialization of construction was to remain associated with concrete for a very long time.

Second, as Peter Collins was among the first to point out in his pioneering work on Auguste Perret, concrete implied a reconceptualization of the built object well in accordance with the quest for a new, self-evident status of architectural production.[16] Building on this insight, Canadian architectural historian Réjean Legault has further analyzed the relation between concrete and photography, showing how the latter provided the built work with a new, enhanced objectivity.[17] [Figure **12**] In other words, concrete became associated with the notion of an architecture as powerfully self-evident as are technological artifacts. This ambition was present in photographs published by Walter Gropius (1883–1969) of American grain silos, later retouched by Le Corbusier for the 1923 publication of *Vers une architecture*.

As a result, modern concrete architecture was, from the start, marked by a quest for a style and emotion somewhat reminiscent of what was to be found in the technological realm. As Le Corbusier was to state, architectural projects were kinds of machines, even if their primary function—to move the mind—was not to be confused with the role of engines in technology.

Appearing both as the direct successor of stone and as the result of sophisticated industrial logic, concrete was also seen as a material that enabled architecture to position itself—like engineering—at opposite poles: those of direct contact with natural forces and of technological advancement. From the textile blocks in his California houses to the groundbreaking cantilevers of Fallingwater, the use of concrete by Frank Lloyd Wright (1867–1959) was permeated by this polarity. Wright's concrete is both somewhat telluric, asserting the forceful presence of man's creations alongside the natural elements, and pointing toward modernity and all its resources of mechanization. More generally, key features of modern architecture such as the terrace roof were to be interpreted in a

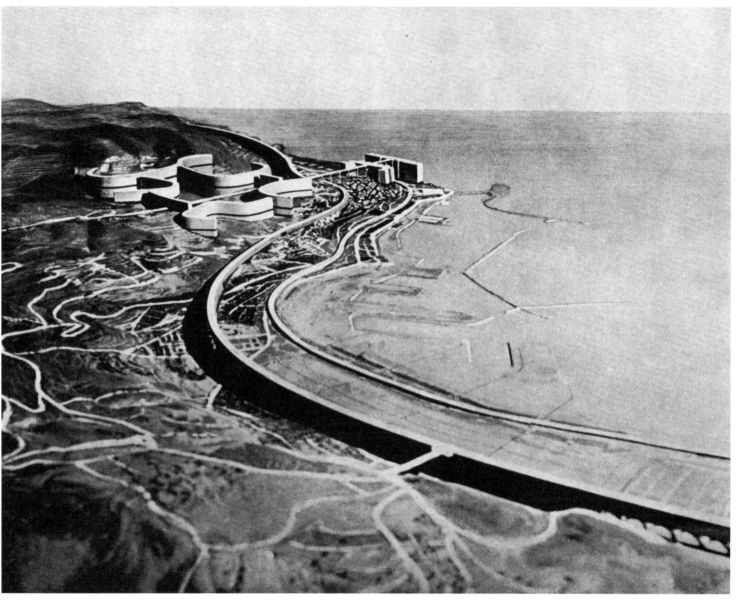

Figure **13** Le Corbusier, Plan Obus, 1932, from his
Oeuvre complète, 1929–1934 (1935)

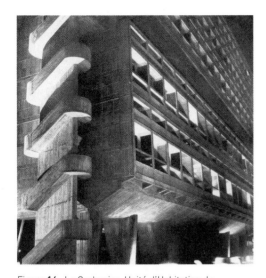

Figure **14** Le Corbusier, Unité d'Habitation de Marseille at night, from his *Oeuvre complète, 1946–1952* (1953)

similar light. The terrace roof related man to the natural elements while connecting him to technological modernity. On the one hand, the modernist terrace roof was reminiscent of hanging gardens or an observatory; on the other hand, it was comparable to the deck of a powerful vessel, thus suggesting the idea of a journey made possible by technology.[18]

Because of its telluric connotations and its ability to form plastic, daring masses, concrete also seemed especially fit for an architecture that inserted itself dramatically into the site, in a way somewhat reminiscent of engineering works. Le Corbusier's Obus Plan for Algiers (1932) was among the most striking examples of this capacity. [Figure **13**] Through projects such as this, architecture, like engineering infrastructures, seemed furthermore capable of ordering the territory. Following Le Corbusier, architects such as Vittorio Gregotti (b. 1927) took a similar path with the use of concrete.

The territorial dimension of concrete construction expressed itself not only in spectacular statements, but also through relatively modest programs, such as water towers, for instance. In a country like France, concrete water towers were the most visible consequence of a large-scale effort aimed at supplying water throughout the country.

Concrete also appeared as one of the key materials that enabled architecture to realize monuments of public significance—as with engineering feats, despite the political and social conflicts that divided industrial societies. Above all, because of its intimate association with social housing programs all over the world, concrete became inseparable from the issue of reconciling individual and collective life. Le Corbusier's Unité d'Habitation in Marseille (1952) is emblematic of this concern, just like so many later projects. [Figure **14**]

The overall argument could be summarized as follows: concrete played an emblematic role in the development of modern architecture insofar as it seemed to address in a straightforward way some of the major technological challenges that the architectural discipline was confronting in the twentieth century.

Toward a New Concrete Architecture?
Here in the twenty-first century, new tensions and new challenges are arising from a situation of rapid cultural and technological evolution. What consequences will these have on the way we envisage a material like concrete?

First, in a world totally saturated with machines, systems, and networks, technology no longer appears a heroic adventure. It seems, rather, akin to the very substance of our everyday existence. Another way to put it is that an environmental dimension has gradually replaced the territorial one that had characterized technology since the eighteenth century. In past decades, technology has become synonymous with a pervasive environment. This environment not only includes artifacts, machines, systems, and networks; it comprises also the techno-nature that surrounds them. Indeed, nature has become totally permeated by technology. Its present condition appears as an extension of the one that characterizes national parks all around the world, with their artificially preserved scenery that may be considered the ultimate artifact.

In such a context, a new challenge raised by technology may very well have something to do with a more radical limitation of architectural form than the territorial one traditionally implied. Everything around us leans toward the environment, its uses and misuses. How is architectural design to adapt itself to such a context? Despite the attempts of Rem Koolhaas (b. 1944) to make sense of the new global condition by referring

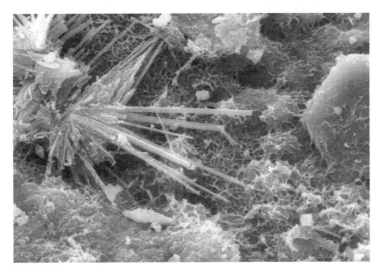

Figure **15** Crystallization in a crack inside Portlandite, photographed by the Laboratoire Central des Ponts et Chaussées, Paris

to the fluidity of the generic city and the necessity for architecture to accept the harsh requirements of massive built-space production,[19] the architectural discipline still seems stuck in the production of static and sparse objects.

The rapid development of digital technologies is adding to this tension, that is, the digital world is eminently mobile, populated with flows and events rather than structured around objects. The world has indeed become, as Paul Virilio puts it, "ce qui arrive," what happens.[20] Can architecture be fully conversant with such a world? The question remains to be fully addressed.

The architect is not the only professional threatened by such an evolution; the engineer is also implicated. In a world completely permeated by technology, he can no longer see himself as a mediator between man and technology; neither can he see himself as a hero fighting nature for the good of society. Nature—or rather, the techno-nature that surrounds us—is totally social from the start, thus precluding this type of attitude. In this world, can he escape the cyborg condition that both the existence of a techno-nature and the generalization of prosthetic possibilities seem to foster?[21]

In this new world, materials are no longer sharply distinct from structures. Indeed, they are becoming more and more complex, hybrid, capable of reconciling seemingly contradictory properties. [Figure **15**] Even if they are not yet of common use in the building industry, composite and "smart" materials oblige us to reconsider what we call a material and what we can expect from it. In other words, hybridization may very well be replacing more traditional processes as the fundamental dynamic at work in the technological realm. This hypothesis is well supported by recent developments in fields such as molecular biology and genetic engineering.

Will this situation involve a total redefinition of design procedures in their relation to technology? This is what an author like Cecil Balmond suggests in his book *Informal*.[22] One may actually wonder whether the design strategies that he describes at length represent such a fundamental departure from existing practices in structural engineering.

What is profoundly new, on the other hand, is the intimate understanding of materials that we have acquired.[23] This understanding of their properties extends the realm of design.[24] In many ways, future evolution can be anticipated through the numerous possibilities created by the shift from structural to material design. The best example of this is perhaps the transformation of automobile bumpers; in less than a decade, we have advanced from the design of a structural component to the use of a composite that absorbs part of the energy of deformation generated during a crash.

In such a situation, a material like concrete is certainly, once again, on the forefront. Indeed, concrete is an integral part of the technological environment within which we are immersed. Its use is assured by its fundamental, hybrid nature and the capacity for variation and customization that goes with it. Today more than ever, concrete appears as a socially constructed material, the characteristics of which are as much the result of complex economic and social strategies as the outcome of pure research.

This strategic position bears with it new challenges. For instance, until now, the use of concrete was governed by the distinction between structural and non-structural uses. Concrete was clearly on the structural side. Given the general evolution of technology as

well as the increasingly hybridized types of concrete that are being developed daily, this distinction might very well lose its significance in the future. What will the new scope of architecture be in a world that no longer functions on clear-cut frontiers like the distinction between structural and nonstructural resources? The relation between architecture and technology will probably remained marked by tensions—productive tensions since they have always represented a powerful incentive for architectural innovation. The shift from territory and moving forces to environment and hybridization is full of promise.

Notes

1 Sigfried Giedion, *Building in France, Building in Iron, Building in Ferroconcrete*, introduction by Sokratis Georgiadis, trans. J. Duncan Berry (Santa Monica, Calif.: The Getty Center for the History of Art and the Humanities, 1995), 151; originally published as *Bauen in Frankreich, bauen in Eisen, bauen in Eisenbeton* (Leipzig and Berlin: Klinkhardt und Biermann, 1928).

2 Augustin Charles D'Aviler, *Dictionnaire d'architecture civile et hydraulique* (Paris: C.-A. Jombert, 1755), "Système figuré de l'architecture."

3 See Antoine Picon, *French Architects and Engineers in the Age of the Enlightenment* (1988, English translation Cambridge: Cambridge University Press, 1992).

4 Manfredo Tafuri, *Architecture and Utopia: Design and Capitalist Development* (1973, English translation Cambridge, Mass.: MIT Press, 1976).

5 On this essential dimension of the relations between modern architecture and technology, see Jean-Louis Cohen, "Architecture et technique au XXe siècle: Bilan international," research report presented to the Délégation à la Recherche et à l'Innovation, Ministère de l'Équipement, Paris, École d'Architecture de Paris-Villemin, 1990.

6 Horst Berger, *Light Structures, Structures of Light: The Art and Engineering of Tensile Architecture* (Basel: Birkhäuser, 1996).

7 David Billington, *The Tower and the Bridge: The New Art of Structural Engineering*, rev. ed. (Princeton, N.J.: Princeton University Press, 1985).

8 See the texts of three of his lectures, republished in Gustave Eiffel, *L'Architecture métallique* (Paris: Maisonneuve & Larose, 1996).

9 On the emergence of the technological sublime in the eighteenth century, see Picon, *French Architects and Engineers*, esp. 229–38. On its later expression in the American context, see David E. Nye, *American Technological Sublime* (Cambridge, Mass.: MIT Press, 1994).

10 Victor Considérant, *Description du phalanstère et considération sociales sur l'architectonique* (1848, reprinted Paris: G. Durier, 1979).

11 See Antoine Picon, *Les Saint-Simoniens: Raison, imaginaire et utopie* (Paris: Belin, 2002). For a more general perspective on the question, see Antoine Picon, "Technique," in *Dictionnaire des utopies*, ed. Michèle Riot-Sarcey, Thomas Bouchet, Antoine Picon (Paris: Larousse, 2002), 216–21.

12 See, for instance, Wiebe E. Bijker, Thomas P. Hughes, Trevor Pinch, eds., *The Social Construction of Technological Systems*, rev. ed. (Cambridge, Mass.: MIT Press, 1993).

13 See Gwenaël Delhumeau, *L'Invention du béton armé: Hennebique, 1890–1914* (Paris: Norma, 1999).

14 See, for example, Cyrille Simonnet, *Le Béton: Histoire d'un matériau* (Marseille: Parenthèses, 2005).

15 Adolf Göller, quoted in Sokratis Georgiadis's introduction to Sigfried Giedion, *Building in France, Building in Iron, Building in Ferroconcrete*, 18.

16 Peter Collins, *Concrete: The Vision of a New Architecture. A Study of Auguste Perret and his Precursors* (London: Faber & Faber, 1959).

17 Réjean Legault, "Material and Modernity," *Rassegna* 49 (March 1992): 58–65; Réjean Legault, "La Circulation de l'image," in *Le Béton en représentation: La Mémoire photographique de l'entreprise Hennebique, 1890–1930* (Paris: Institut Français d'Architecture and Hazan, 1993), 77–94.

18 For a more detailed exploration of this theme, see Antoine Picon, "L'Invention du toit-terrasse: Imaginaire architectural, usages et techniques," in *De Toits en toits: Les Toits de Paris*, ed. Frédéric Leclerc and Philippe Simon (Paris: Pavillon de l'Arsenal and Hazan, 1994), 35–44.

19 Rem Koolhaas, "La Ville générique," in *Mutations*, ed. R. Koolhaas et al. (Bordeaux: Actar and Arc en Rêve, 2000), 721–42.

20 Paul Virilio, *Ce qui arrive* (Paris: Fondation Cartier pour l'art contemporain and Actes Sud, 2002).

21 On the cyborg perspective, see, for example, Donna Haraway, "Manifesto for Cyborgs: Science, Technology, and Socialist Feminism in the 1980s," *Socialist Review* 15, no. 2 (1985): 65–107; Chris Hables Gray, *The Cyborg Handbook* (New York and London: Routledge, 1995); Antoine Picon, *La Ville territoire des cyborgs* (Besançon: Les Éditions de l'Imprimeur, 1998); and William J. Mitchell, *Me++: The Cyborg Self and the Networked City* (Cambridge, Mass.: MIT Press, 2003).

22 Cecil Balmond with J. Smith, *Informal* (Munich: Prestel, 2002).

23 On the "materials revolution," see, for example, Bernadette Bensaude-Vincent, *Éloge du mixte: Matériaux nouveaux, philosophie ancienne* (Paris: Hachette, 1998).

24 See Toshiko Mori, ed., *Immaterial/Ultramaterial: Architecture, Design, and Materials* (Cambridge, Mass.: Harvard Design School; New York: George Braziller, 2002).

Modern Architecture and the Saga of Concrete

Jean-Louis Cohen

In the 1980s, dissidents fighting against the late Communist regime in Poland nicknamed the group of sinister men who were sticking to power *"beton,"* or concrete. In the same area of Europe, the industrial system created in East Germany in the 1960s to deal with the postwar housing shortage, which relied heavily upon the use of large precast French- or Soviet-born concrete components, remains known to this day as *"die Platte,"* the panel, a pun on *"die Pleite,"* the bankrupt. Concrete today is often dismissed as the mundane workhorse of repetitive, mass-produced, large-scale developments that are the indices of urban crisis on every continent. Forgotten is the heroic, almost epic, dimension this material took in its early days.

The amazing politicization of a simple building technology reveals how much it has functioned in the symbolic, imaginary sphere, as well as in the practical realm of building construction, since the late 1890s. A seemingly innocuous and ingenious combination of inert substances had become highly loaded with diverse and controversial meanings. The identification of concrete with nationalist and political agendas nearly coincided with the invention of the material itself and has taken many shapes since.

Modernist Manifestoes in Concrete

Only a few months after his arrival in Paris in 1908, having started work in the office of the Perret brothers, Charles-Edouard Jeanneret (1887–1965; known by the pseudonym Le Corbusier from 1920), wrote to his professor, Charles L'Eplattenier (1874–1946), describing what he saw on the firm's construction sites: "ce qu'est le béton, les formes révolutionnaires qu'il exige."[1] From this early experience onward, and through a series of more or less vexing episodes that included the collapse of a small society he created with a friend, the engineer Max Du Bois, to produce concrete components,[2] Le Corbusier constantly equated architectural innovation with the use of concrete.

This equation is nowhere more obvious than in the "Five Points of a New Architecture," which Le Corbusier devised as a commentary on the houses built at the Stuttgart Weissenhofsiedlung Exposition of 1927.[3] [Figure 1] Every point relates to a particular property of concrete frame structures: the lifting of the building above the ground, thanks to *pilotis*; the non-load-bearing character of the facade, which allowed for the free disposition of windows, including long ribbon-shaped openings; the suppression of walls; and the use of flat roofs—all were new features made possible by concrete technology. The "Five Points" have significant implications in light of the polemical issues separating Le Corbusier and his mentor, Auguste Perret (1874–1954). At the center of their heated exchanges of the mid-1920s was the issue of the window—long and horizontal for Le Corbusier and necessarily vertical for Perret, who saw in this building element nothing less than the "frame of Man."[4] Although he never systematized the thoughts he collected in the unfinished manuscript "The Aesthetics of Reinforced Concrete,"[5] Perret drew entirely different conclusions than did his former draftsman regarding the effects of the new technology, conclusions that pointed him toward a renewed classicism.

When, in 1932, Philip Johnson and Henry-Russell Hitchcock defined the fundamentals of the new "International Style" in relationship to the modern architecture exhibition they curated at New York's Museum of Modern Art, most of the principles they affirmed were also directly related to concrete: their definition of "architecture as volume" was grounded in "contemporary methods of construction" that "provide a cage or skeleton of supports"; "regularity," the second principle, depended on "the regularity

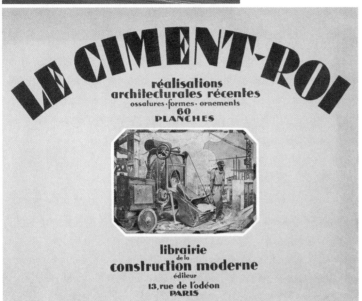

Figure 1 Le Corbusier and Pierre Jeanneret, two houses at the Weissenhofsiedlung, Stuttgart, 1927

Figure 2 Cover of *Le Ciment-roi: Réalisations architecturales récentes. Ossatures, formes, ornements* (1927)

typical of the underlying skeleton of modern construction." The third principle, "avoidance of applied decoration," was partially grounded in the new material: "in ferroconcrete construction rounded forms are aesthetically, and usually technically, superior, since they remain visually quite separate from the wall surface."[6]

Around these two articulations of a modernist agenda dealing with concrete, critics and historians on both sides of the Atlantic as well as on both sides of the Rhine labored intensely to conceptualize the material, drawing it either toward art or toward science. After a cycle of publications dedicated exclusively to the technical and economic aspects of concrete construction, new treatments emerged, spurred on, no doubt, by the broad presence of concrete worldwide after World War I. Three books published in 1928 exemplify their interpretive strategies.

Writing on the "ferro-concrete style" in 1928, American critic Francis S. Onderdonk, Jr., underlined the aesthetic qualities of the material, relating buildings erected in Europe to their North American contemporaries.[7] His interpretation deals essentially with a consideration of the new possibilities of concrete, with a particular emphasis on "surface treatment and sculpture" and a certain passion for parabolic arches. His view is comprehensive and catholic, as opposed to more engaged and critical views of the design and building processes shaped by European theorists.

In *Bauen in Frankreich, bauen in Eisen, bauen in Eisenbeton*, his first book dealing with modern architecture, also published in 1928, Swiss art historian Sigfried Giedion studied the sequence of innovations leading from the metallic structures of the nineteenth century to the latest concrete buildings.[8] Concrete is presented as a "laboratory material" developed in stages and revealing the extent of the new scientific component of architecture. It is also considered the best expression of what Giedion calls the French "constructional temperament." It is true that, beyond the innovative structures of Tony Garnier (1869–1948), Perret, and Le Corbusier, concrete was widely used in France in the reconstruction of regions devastated during World War II. The title *Le Ciment-roi* (Cement King) given to a 1927 portfolio of recent buildings provides clear evidence of this situation.[9] [Figure 2]

Giedion's book was published in Berlin, and this points to the fact that concrete had been an issue in the troubled French-German relationship from the early twentieth century. A 1950 publication celebrating the centennial of the experiments of gardener Joseph Monier (1823–1906) with elementary cement objects such as flower pots and pipes identifies concrete with "the radiation of French thought and creativity throughout the world."[10] [Figure 3] But Perret's Théâtre des Champs-Élysées in Paris had been dismissed in 1913 by the conservative press as being exceedingly "Germanic." Jeanneret's interest in the material had been boosted before World War I by his reading of Emil Mörsch's book *Der Eisenbetonbau* (1909; in a French translation by Du Bois).[11] This German source added a theoretical layer to the practical experience he had acquired with Perret and evidenced the intense communication between both sides of the Rhine. [Figure 4]

Remote precedents that led to the invention of concrete have garnered support for the "Frenchness" of the material. It is true that the development of concrete, rooted

Figure 3 From *Cent ans de béton armé, 1849–1949* (1950)

Figure 4 Daimler Factory, Untertürckheim, published in Emil Mörsch, *Der Eisenbetonbau* (1909)

in the region of Lyon and Grenoble in southeastern France, owed much to precedents such as the 1818 invention of a form of cement by the engineer Louis-Joseph Vicat (1786–1861) and the late eighteenth-century experiments of the architect François Cointereaux (1740–1830) with adobe cast in a type of wooden form called a *"betum,"* which provided the etymology for *"béton"* in French.[12] This did not prevent adversaries of modernism such as rabid anti-Corbusier critic Camille Mauclair (1872–1945) from warning French readers against "an international *pan-bétonnier* conspiracy," supposedly devised by the Huns and the Bolsheviks to house his compatriots in *"termitières bétonnées"* (concrete termite colonies).[13]

But with the astonishing development of consulting firms such as the Paris-based one headed by the engineer François Hennebique (1842–1921) in the years before 1900, concrete took on a different character, contributing to the creation—in real terms, rather than imagined ones—of a truly international and intercontinental technological network, even if the more experimental approach of the French firm was in conflict with the more mathematics-grounded method of their German competitor Wayss & Freytag, who developed Monier's system.[14] Hennebique declared in 1899 that he felt *"une sainte horreur de tout le ce fatras de science,"* affirming:

> [T]he factors which intervene in our formulas are the loads..., the strength of the materials used, the height of the couples formed by the solids and the lever arm of the strength of the materials; this constitutes a small and very simple kitchen, in which all the elements are comprehensible and sufficient to compose, in concrete of cement and iron, combinations of reinforcements and solid and economical floors.[15] [Figure 5]

Concrete, which relied far less than iron or wood building methods on the transportation of massive loads by boat, was embraced in the colonial empires. Thanks to the creation of consulting firms, concrete could be used without the exportation of machinery or capital but simply of (relatively immaterial) technical expertise. The Hennebique model would be based on the expert analysis of architectural designs, their transposition into concrete structure, the delivery of working drawings, and mere supervision of construction.[16]

Concrete Dichotomies

The development of consulting firms at the service of architects added to the weight of the book by Julius Vischer (1882–?) and Ludwig Hilberseimer (1885–1967) on concrete as *Gestalter*, or "form-maker," also published in 1928. Echoing previous analyses dealing with industrial buildings, the authors attempt to delineate not so much a vocabulary of aesthetics as one of structural types; they discuss the strategies of "architectural form-giving" used to shape series of objects, which seem, in retrospect, to announce a taxonomy of form similar to that catalogued in the systematic photography of Bernd (b. 1931) and Hilla Becher (b. 1934).[17]

The analysis of Vischer and Hilberseimer and, to a lesser extent, that of Giedion make clear that two main structural models were competing in the realm of concrete construction by the end of the 1920s. Each dealt to some extent with one particular aspect of the organic analogy that had become popular in the nineteenth century. The first model used finite vertical and horizontal elements assembled to produce a rigid

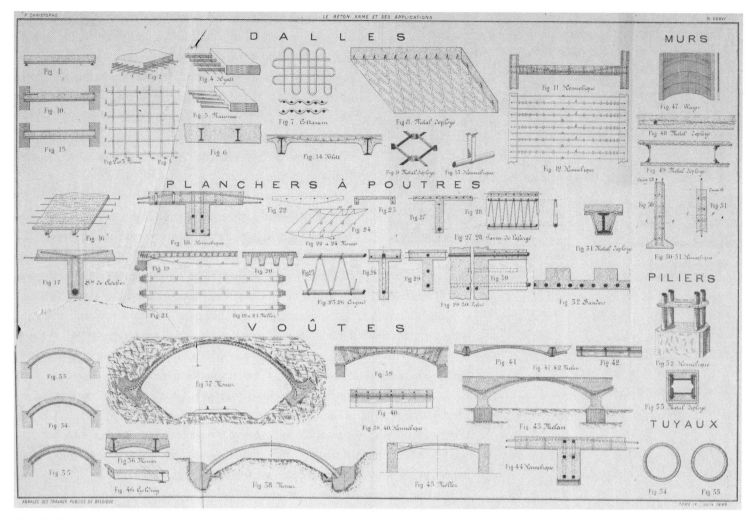

Figure **5** Competing concrete structural systems, from
Le Béton armé (July 1889)

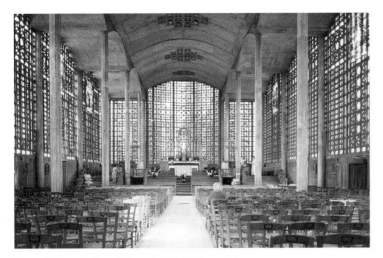

Figure **6** Auguste Perret, Church of Notre Dame de la Consolation, Le Raincy, 1922, interior

concrete frame that evoked animal skeletons or vegetal stems. The second model used continuous single- or double-curvature surfaces to produce thin vaults that evoked shells or membranes. It would be simplistic to identify the former with the rational approach of Perret and the latter with the more lyrical approach of Latin American designers such as Oscar Niemeyer (b. 1907) or Félix Candela (1910–1997); together, they created significant alternatives to earlier construction technologies. Perret's Notre Dame de la Consolation church at Le Raincy of 1922—with its forest of columns covered by one main longitudinal and two lateral vaults—along with many other highly publicized projects combined the two structural models in one building. [Figure **6**]

One could narrate the saga of concrete focusing on a series of dichotomies that seem to be consubstantial with the material itself. Dichotomy is, so to speak, built from the very beginning into the assembly of iron rods and concrete, but also into concrete itself, being a mixture of a solid substance and water. The design of the components takes into account the fundamental structural dichotomy between compression and tension, which had led since the origins of construction to the parallel development of masonry and wooden components.

Concrete also stretches the dichotomy between engineers and architects, generating from the 1890s onward several new forms of professional and business practice. Concrete has generated since its earliest development what could be called a competitive plurality of systems. In this competition, the importance of experimentation is evidenced by the quantity of patents filed to protect the various inventors' ideas. But, as the ill-fated experiments of inventor Thomas Edison (1847–1931) to develop complete cast-concrete houses reveal, patenting was by no means a secure path to mass production; rather, it was only the first step in acknowledging systemic proposals. It is not surprising in this context that the Dom-ino scheme of Jeanneret of 1914 was first of all conceived as a patent and not as a house, as it is often misrepresented in the literature.[18] The key importance of patents is confirmed, for instance, by the rapid move by the French state to buy Hennebique's patents, in order to give open access to their solutions to the large audience of builders, thus guaranteeing the hegemony of the system.

Plurality is not only a characteristic of reinforced concrete as a material or process, if we follow the line of reasoning presented by Adrian Forty in the present volume; it also appears in the postures taken by designers and builders involved in its diffusion. Concrete is a product around which new types of firms are created. If Jeanneret's attempt at shifting from design to production in conjunction with the Société des Applications du Béton Armé led to rapid failure between 1917 and 1920, there are some equally dramatic success stories, such as that of Eugène Freyssinet (1879–1962). After his early career as a consulting engineer gave way to his becoming manager of the powerful Limousin contracting firm, Freyssinet not only pioneered the concept of prestressed concrete but also the organization of massive civil engineering sites. [Figure **7**]

Concrete also presents yet another dichotomy, allowing for the transgression of the limit between technical and "artistic" buildings. Perret used systems imported from the world of bridge building when he designed the Théâtre des Champs-Élysées using four bowstring arches similar to those of the Saint-Pierre Bridge to carry the roof. And

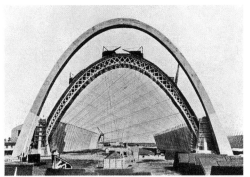

Figure **7** Eugène Freyssinet, dirigible hangars, Orly, 1917, under construction

Figure **8** Le Corbusier, competition project for the Palace of the Soviets, Moscow, 1932, elevation of the main auditorium with sketches

Le Corbusier would mimic this strategy, for instance, in his Palace of the Soviets design of 1931, combining two shapes borrowed from Freyssinet: the parabolic arch of the Orly dirigible hangars and, again, the bowstring arches. [Figure **8**]

Concrete and/as Media

Concrete was propagated in specific media such as Hennebique's *Le Béton armé*, published monthly from 1898 to 1939. The firm, which became one of the earliest multinationals, systematically organized the photographic documentation of the production with which it was associated.[19] The magazine consistently featured images of concrete structures triumphantly surviving fires and earthquakes. And, through the erection of demonstration structures, concrete itself became a type of medium, as evidenced in the production of Hennebique. The firm's headquarters on rue Danton demonstrated the ability of concrete to emulate stone-faced apartment buildings, whereas the house that the founder of the firm built for himself in Bourg la Reine exemplified the multiplicity of available finishes. (The house also boasted a flat roof featuring a vegetable garden.) [Figure **9**] Perhaps the most spectacular demonstration of the material's versatility was achieved, however, with the extravagant Cambodian-style mansion of Alexandre Marcel (1860–1928) in Heliopolis, a new suburb of Cairo.

The popularity that concrete achieved through publications, exhibitions, and even films devoted to the erection of heroic structures had unexpected effects. Buildings made of stuccoed bricks would sometimes be mistaken for concrete ones, as in the case of the Einstein Tower of Erich Mendelsohn (1887–1953), built in Potsdam in 1921.[20] And worshipers of Perret's cult of structural "honesty" would resent buildings masking the dialectics between structure and masonry in-fill, such as the Maison Bomsel in Versailles of 1926 by André Lurçat (1894–1970), condemned by critic Marie Dormoy (1886–1974) as an example of "faux concrete": "En quoi est cette maison? En carton, en plâtre? Elle est, parait-il, en béton. Pourquoi ne serait-elle pas en pans de fer, qui permet les mêmes portées?"[21] [Figure **10**]

Concrete and Historical Architecture

Born with modern metallurgy and chemistry, concrete was, however, used in a context still loaded with historical examples. The quest for legitimacy of this new material required the mobilization of tradition. Giedion clearly affirmed that in France "the thread leads backward" to the Gothic:

> The same soil produced the cross-ribbed vault. The same urge to lighten matter, to demand of stone what apparently goes beyond the strength of stone, has returned. The strains lead from the almost fragile, slender arches in the choir of Beauvais to the enormous concrete parabolas of the Orly hangar.[22]

The desire to emulate Gothic structures was represented most notably by Eugène Emmanuel Viollet-le-Duc (1814–1879), who was still, it is true, imagining iron systems, along with his rationalist followers such as Anatole de Baudot (1834–1915). Other

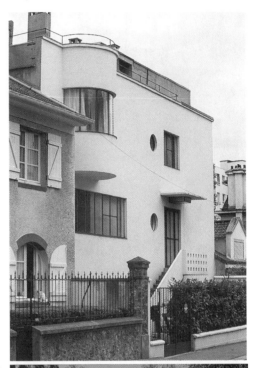

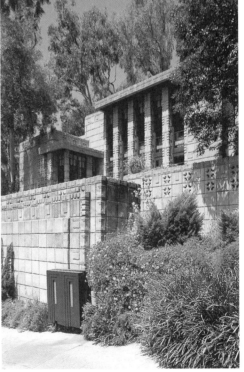

Figure 9 François Hennebique, Hennebique House,
Bourg-la-Reine, 1903

Figure 10 André Lurçat, Bomsel House, Versailles,
1926, an example of "faux" concrete

Figure 11 Frank Lloyd Wright, John Storer House, Los
Angeles, 1923

engineers revisited Roman structures that used massive concrete and documented them with striking images that would not be lost on designers. The views of vaults reproduced in Auguste Choisy's *Art de bâtir chez les Romains* of 1873 belong to this body of images, but when Max Berg (1870–1947) built his Jahrhunderthalle in Breslau (now Wrocław, Poland; 1911–13), the 220-foot- (67-meter-) diameter space was shaped by concrete arches and not by a continuous cupola.

A more exotic relationship with history is suggested in the experiments with concrete carried out by Frank Lloyd Wright. After having used concrete cast in situ in structures such as Oak Park's Unity Temple (1906) and in several houses, and having discovered European experiments in the use of the new material, Wright used concrete extensively in constructing Tokyo's Imperial Hotel (1915–22). Of greater interest is the role Wright gave to concrete in his research for a purer definition of American architecture. In four houses he built in Los Angeles in the early 1920s and in other projects of that decade, he used "textile blocks" with geometric patterns drawn from the elaborate stonework facing of Mayan structures in Chichén Itzá and Uxmal. [Figure 11]

Concrete Skins

The tectonic effects that Wright achieved through the assembly of discrete elements on the walls of his houses, the very terminology of which seems to echo the analogy made by Gottfried Semper (1803–1879) between buildings and textile,[23] would be sought out by architects attempting to dispel the impression of dullness associated with the new material. Two main problems arose as soon as the illusion of imitating stone structures was abandoned; the first had to do with the exterior expression of the interior structure, and the second dealt directly with the surface of the building.

Perret's ethos forbade the dissimulation of load-bearing elements, and consequently his buildings and those of his students and epigones became a sort of *architecture parlante*, one that would boldly exhibit the structural role of its elements. Their facade became not only an indispensable part of their load-bearing scheme but also an outward projection of it. Differentiated methods were used to give form to this structurally transparent cladding. Less monumental programs would be treated simply with rather abstract orthogonal shapes, whereas stately structures such as the Musée des Travaux Publics would be brought to a higher level of nobility through the use of columns and architraves.

Dealing directly with the surface of concrete structures led to contrasting attitudes. For the elementary school he built in the Paris borough of Grenelle (1908–10), Louis Bonnier (1856–1946) decorated the exterior of concrete window lintels with a motif representing the hidden reinforcing bars as in an X ray. Perret's contemporary François Le Cœur (1872–1934) unfolded on the exterior of his rue du Temple Telephone Exchange in Paris (1914) the entire spectrum of surface solutions: polished, washed, and hammered concrete and also projections of cement drops, which provided visual relief. [Figure 12] And in projects such as the rue Raynouard Apartment House (1932) and the Le Raincy Church (1922), Perret finally dropped the solution used in his famed rue Franklin apartment house, where the frame and the infilling panels were all clad in delicate enameled terra-cotta pieces, using instead a large range of finishes.

Of course, a major breakthrough occurred when architects began leaving the concrete skin of their buildings not only bare but also still scarified by the traces of the

24-25
Plattenmontage in der Siedlung Wefthaufen (s. S. 57) · Mounting of slabs in Westhausen colony (see p. 57) · Montage de dalles dans la colonie de Westhausen (voir p. 57)

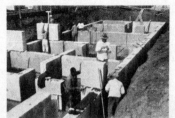

Figure **12** François Le Cœur, Telephone Exchange, rue du Temple, Paris, 1914

Figure **13** Ernst May, concrete panel construction for the Westhausen Siedlung, Frankfurt am Main, 1928

Figure **14** Andrei Burov and Boris Blokhin, apartment block, Moscow, 1940

casting process. It took some time for rough concrete to be not only accepted in structures other than military bunkers but also promoted as a document of the labor process. Exactly ten years before the completion of Le Corbusier's Unité d'habitation in Marseille (1942), the building that perhaps best promoted the infamous *béton brut*, the courtyard facades of the mammoth Pentagon Building designed by G. Edwin Bergstrom (1876–1955) and David Witmer boldly displayed the horizontal lines of its formwork.

Building with Systems

Concrete played a leading role in the development of one of the twentieth century's most enduring utopian endeavors: the creation of building "systems" allowing for the mass production of industrial, commercial, and residential structures. The systems emerged from the encounter between technical ingenuity and entrepreneurial savvy. An affiliate of Hennebique would write to the Swiss engineer Wilhelm Ritter (1847–1906), "we have often said that this organization which functions so well is almost as beautiful as the invention of the system."[24] The search for "systems" using concrete took many shapes, from Edison's cast-concrete house to Wright's textile blocks. A topical history of concrete construction could be devoted to the specific contexts in which these experiments took place, from Southern California, where the work of Irving Gill (1870–1936) preceded Wright's attempts and where the material was used in scores of decorated theaters and other buildings,[25] to the new industrial towns of Siberia.

In the 1920s, German experiments led to huge programs such as the Siedlung Törten in Dessau, conceived by Walter Gropius (1883–1969), who wanted to transfer to the building industry the rationality of Scientific Management pioneered by Frederick W. Taylor (1856–1915) and the economy of scale of the assembly line developed by Henry Ford (1863–1947). The most extensive of such programs supported by specific funds from the Berlin *Reichsforschungsgesellschaft* would be the Frankfurt Siedlung Westhausen by architect Ernst May (1886–1970). [Figure **13**] Its building systems, based on panels of ever-increasing scale, would be exported by May after 1930 to the Soviet Union, where it led to further experimental projects—for example, the housing block on the Leningrad Avenue in Moscow by architects Andrei Burov (1900–1957) and Boris Blokhin (1896–1972)—and to massive postwar programs. [Figure **14**] These programs took on a different scale, focusing on tooling that allowed for fast, on-site casting of walls and floors—the French "coffrage tunnel" system—or for the factory-based production of heavy panels—the Russian system.

An ideal material for use in fortifications, concrete developed quickly in warfare. The interaction between military and civilian uses of concrete would prove a fruitful one, even in metaphorical terms. Le Corbusier rhapsodized on gunite in the 1920s and about the Ingersoll-Rand cement gun that would allow him to build his Pessac housing scheme near Bordeaux (1926) with great speed.[26] [Figure **15**]

The military uses of concrete had been widespread, from the bunkers housing infantry or artillery to lighter structures often related to aeronautics. The diffusion of dirigibles and large air- and seaplanes led to the invention of new spatial types, only possible thanks to new and ingenious systems. After Freyssinet's spectacular parabolic

AUTREFOIS

POUR ENDUIRE UN MUR, IL FALLAIT

UN ÉCHAFAUDAGE COUTEUX
PRÉPARER LE CIMENT
LE MONTER
L'APPLIQUER SUR LE MUR,
LE TALOCHER ETC...
A GRAND RENFORT DE TEMPS
ET DE MAIN D'ŒUVRE...

Reconstitution de Tokio

AUJOURD'HUI

POUR FAIRE LE MÊME TRAVAIL, IL SUFFIT DE :

UN ÉCHAFAUDAGE LÉGER

un « **Cement-Gun** »

QUI PRÉPARE, MONTE ET APPLIQUE
UN MORTIER ADHERENT, ETANCHE,
ET PEU COUTEUX

Cᴵᴱ INGERSOLL-RAND
33, Rue Réaumur, Paris

Figure **15** Ingersoll-Rand cement gun, advertised in
L'Almanach d'architecture moderne, 1926

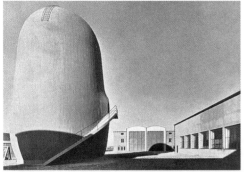

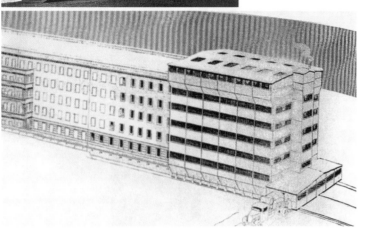

Figure **16** Hermann Brenner and Werner Deutschmann, Versuchsanstalt für Luftfahrt, Berlin-Adlershof, 1939, in Werner Rittich, *Architektur und Bauplastik der Gegenwart* (1938)

Figure **17** Hausbaumaschine, in Ernst Neufert, *Bauordnungslehre* (1943)

dirigible hangars in Orly (1917), the seaplane hangar in Orbetello by Pier Luigi Nervi (1891–1979) stretched the limit of imagination in this respect, as did buildings devoted to aerodynamic research such as the Versuchsanstalt für Luftfahrt in Berlin-Adlershof (1939) by Hermann Brenner and Werner Deutschmann. [Figure **16**]

One of the most interesting chapters in this chronicle deals with the encounter of military technical expertise and civilian programs in housing. The *Hausbaumaschine* featured in the *Bauordnungslehre* published in 1943 by Ernst Neufert (1900–1966), then Albert Speer's main deputy at the German Ministry of Armament, fulfilled the dream of the ultimate mobile factory. Running on a continuous rail track, it was meant to extrude all over occupied Europe a continuous ribbon of multistory housing.[27] [Figure **17**] Even if Neufert's plan never left the drawing board, the continuity between wartime concrete construction and postwar rebuilding campaigns—through the recycling of airplane technology, for instance—cannot be ignored. French firms building coastal defenses along the Atlantic for the Nazis would later be involved in the massive rebuilding of cities damaged during the war and subsequently in the production of state-funded housing projects.

After 1945: New Territories and Renewed Concepts

Although concrete is identified with mass-produced housing and other public building programs constructed in war-torn countries after World War II, it also constitutes a fundamental building material of non-European, non–North American and non-Japanese modernization campaigns. Light structures such as Candela's pre-war restaurant in Xochimilco (1958) bear witness to the popularity of concrete in Latin America. As Henry-Russell Hitchcock affirmed in 1955, "more innate sympathy for the vault-like structures of concrete construction" could be found south of the Rio Grande than everywhere else.[28]

Beginning with his Church of Saint Francis of Assisi in Pampúlha, near Belo Horizonte (1943), Niemeyer initiated an extraordinary series of light structures with engineer Joaquim Cardozo (1897–1978). [Figure **18**] In the stately palaces built in Brasília in the late 1950s, an encounter between the flexible shapes of Pampúlha and the theme of the porticoes took place. Concrete allowed for the introduction of elegance and fantasy in programs dealing with political representation.

At the same time, concrete was used for renewed architectural metaphors in buildings such as the TWA Terminal in Queens, New York (1962) by Eero Saarinen (1910–1961), which evokes the experience of flying, or the Centre National des Industries et Techniques at La Défense, near Paris (1958) by Nicolas Esquillan (1902–1989), Bernard Zehrfuss (1911–1996), Robert Camelot (1903–1992), and Jean de Mailly (1911–1975), a lightweight parachute of monumental scale. [Figure **19**] But concrete was not merely the vehicle of expressionist heroism nor of monotonous mass production. In this period, a notable pragmatism emerged in the use of concrete elements, now integrated in more conventional structures. Le Corbusier's maisons Jaoul in Neuilly (1954) and Sarabhai in Ahmedabad (1956) used concrete vaults supported by thick brick walls, in complete opposition to the image of the flying roof built for his chapel at Ronchamp. And Louis I. Kahn (1901–1974), who deployed advanced prestressed and precast elements in his

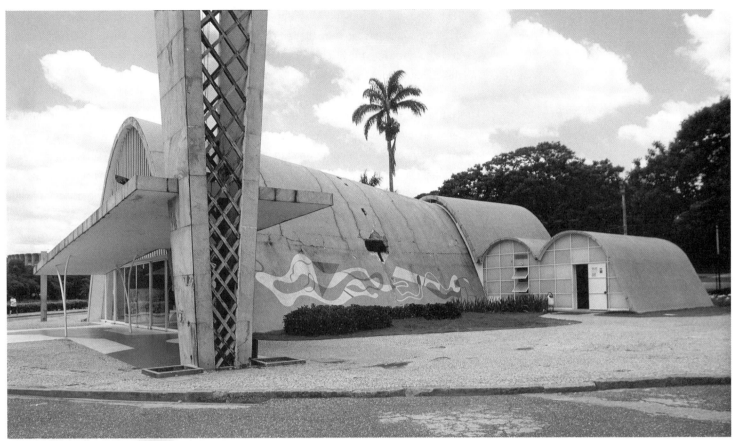

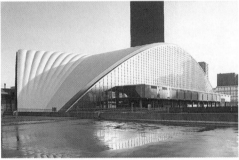

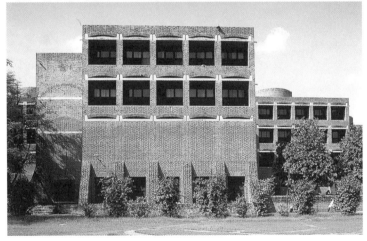

Figure **18** Oscar Niemeyer, Church of Saint Francis of Assisi, Pampúlha, Belo Horizonte, 1943

Figure **19** Nicolas Esquillan et al., Centre National des Industries et des Techniques, La Défense, 1958

Figure **20** Louis I. Kahn, Indian Institute of Management, Ahmedabad, 1967

Richards Laboratories in Philadelphia of 1961, relied for his Indian Institute of Management buildings, also in Ahmedabad (1967), on extremely limited tensile elements of concrete inserted into the brick walls of the scheme, acknowledging the current condition of the building industry in India. [Figure 20]

The social construction of concrete—as a technology, as a design ethos, and, last but not least, as a material shaping the surface of everyday architecture—has been a complex process, now better documented but still open to an infinite number of creative interpretations. The ability of a technology, alternatively hyped and maligned, to represent change or stubborn stasis, historical continuity or brave innovation, sophisticated, scientifically grounded production or coarse handiwork remains astonishing. There is no such thing as a single, legitimate architecture of concrete, at least not following the patterns that took shape in the 1920s.

Notes

1 "[W]hat concrete is, the revolutionary forms that it demands." Charles-Edouard Jeanneret to Charles L'Eplattenier, 22 November 1908. Bibliothèque de la Ville, La Chaux-de-Fonds.

2 Tim Benton, "From Jeanneret to Le Corbusier: Rusting Iron, Bricks, and Coal and the Modern Utopia," *Massilia* 3 (2003): 28–39.

3 "Fünf Punkte einer neuen Architektur," in Alfred Roth, *Zwei Wohnhäuser von Le Corbusier und Pierre Jeanneret* (Stuttgart: F. Wedekind & Co, 1927).

4 Bruno Reichlin, "the Pros and Cons of the Horizontal Window: The Perret-Le Corbusier Controversy," *Daidalos* 13 (September 1984): 71–82.

5 Manuscript held in the Perret Archive, Institut Français d'Architecture, Paris.

6 Philip Johnson and Henry-Russell Hitchcock, *The International Style: Architecture since 1922* (New York: W. W. Norton & Co, 1932): 40, 58, 72.

7 Francis S. Onderdonk, Jr., *The Ferro-Concrete Style: Reinforced Concrete in Modern Architecture* (New York: Architectural Book Publishing Co., 1928).

8 Sigfried Giedion, *Building in France, Building in Iron, Building in Ferroconcrete*, introduction by Sokratis Georgiadis, trans. J. Duncan Berry (Santa Monica, Calif.: The Getty Center for the History of Art and the Humanities, 1995); originally published as *Bauen in Frankreich, bauen in Eisen, bauen in Eisenbeton* (Leipzig and Berlin: Klinkhardt und Biermann, 1928).

9 *Le Ciment-roi: Réalisations architecturales récentes. Ossatures, formes, ornements* (Paris: Librairie de La Construction moderne, 1927).

10 *Cent ans de béton armé, 1849–1949* (Paris: Science et industrie, 1950), inside back cover.

11 Emil Mörsch, *Le Béton armé, étude théorique et pratique*, translation by Max Du Bois (Paris: C. Béranger, 1909); originally published as *Der Eisenbetonbau: seine Theorie u. Anwendung* (Stuttgart: Wittwer, 1902).

12 See Peter Collins, *Concrete: The Vision of a New Architecture. A Study of Auguste Perret and his Precursors* (London: Faber & Faber, 1959).

13 Camille Mauclair, *L'Architecture va-t-elle mourir?* (Paris: Éditions de la Nouvelle Revue Critique, 1933), 75.

14 Cyrille Simonnet, *Le Béton, histoire d'un matériau* (Marseille: Parenthèses, 2005).

15 Hennebique would declare in January 1899 at the Third Concrete Conference that he was "dead shocked by all this accumulation of science," affirming:

 Les facteurs qui interviennent dans ces formules sont les charges, les portées qui forment les bras de levier de ces charges, les résistances des matériaux employés, la hauteur des couples formés par les solides et le bras de levier de la résistance des matériaux; cela constitue une petite cuisine bien simple, dont tous les éléments sont bien compréhensibles, et nous suffisent pour composer en béton de ciment et fer des combinaisons de charpentes et planchers solides et économiques.

 François Hennebique, speech at the 3rd Congrès du béton de ciment armé, 24 January 1899, in *Le Béton armé* 11 (1899), 4.

16 Gwenaël Delhumeau, *L'Invention du béton armé: Hennebique, 1890–1914* (Paris: Norma, 1999).

17 Julius Vischer and Ludwig Hilberseimer, *Beton als Gestalter* (Stuttgart: Julius Hoffmann, 1928). See *Reinforced Concrete: Ideologies and Forms from Hennebique to Hilberseimer*, thematic issue, *Rassegna* 13, no. 49 (March 1992).

18 Eleanor Gregh was the first to clarify this issue. See her "The Dom-Ino Idea," *Oppositions* 15–16 (Winter-Spring 1979): 61–75.

19 Gwenaël Delhumeau, *Le Béton en représentation, la mémoire photographique de l'entreprise Hennebique* (Paris: Norma, 1999).

20 Onderdonk, Jr., presented it as such in his *The Ferro-Concrete Style*, 243–44.

21 "What is this house made of? Carboard, plaster? It is said it is in concrete? And why wouldn't it be in steel frame, allowing the same span?" Marie Dormoy, "Le Faux béton," *L'Amour de l'art*, April 1929, 128.

22 Giedion, *Building in France*, 152.

23 Kenneth Frampton, *Studies in Tectonic Culture* (Cambridge, Mass.: MIT Press, 1995): 106–20.

24 S. de Mollins to Wilhelm Ritter, 14 March 1899, quoted by Simonnet, *Le Béton*, 67.

25 Onderdonk, Jr., published several concrete theaters built in Los Angeles, including Grauman's Metropolitan Theater. See his *The Ferro-Concrete Style*, 74–77.

26 He himself designed an advertisement in his *Almanach d'architecture modern* (Paris: G. Crés & Cie, 1926), n.p.

27 Ernst Neufert, *Bauordnungslehre* (Berlin: Volk und Reich Verlag, 1943).

28 Henry-Russell Hitchcock, *Latin American Architecture since 1945* (New York: Museum of Modern Art, 1955), 26.

The Material without a History

Adrian Forty

"A casual glance at history," wrote the American architect S. Woods Hill reviewing a new book about concrete in 1928, "will show conclusively that a new architecture invariably comes with a new constructive material and here we are with practically none."[1] Hill's disappointment voiced a recurring twentieth-century anxiety about the architectural use of concrete: why, when other materials had developed their own distinctive aesthetic, had concrete not? Concrete, so it seemed, had failed to fulfill its destiny. The idea that each material should find its own proper form is a natural outcome of the principles of structural rationalism, for if you believed, following Eugène Emmanuel Viollet-le-Duc (1814-1879), that the history of architecture lay in the continuing development of structural technique, then it followed that the introduction of a new material could not but generate a new style of building. Widely accepted though this argument has been, concrete does not conform to it. Looking back over a century and a half of concrete construction, no definitive style has emerged, and there has been nothing but disagreement as to what it should be. If, as Adolf Loos (1870–1933) wrote, "every material possesses its own language of forms, and none may lay claim for itself to the forms of another material,"[2] then concrete, an indiscriminate borrower from the forms of every other material, turned out to be without a language of its own. Concrete betrayed the law of materials.

By the end of the twentieth century, the situation had changed from the one described by Hill; it was not that concrete had no aesthetic, but rather that it had too many, each one put forward with absolute conviction in its exclusive claim to authority. With so many rival orthodoxies, are we forced to conclude that reinforced concrete does not, after all, have an aesthetic? If this seems uncomfortable, it may only be because we have been too long accustomed to expecting that every material should have its proper form.

A quick sketch of successive ideas about the "correct" use of concrete will indicate the absence of consensus. For the great French exponent of concrete, Auguste Perret (1874–1954), the "oracular formula," as the historian Peter Collins put it, was that "concrete architecture must consist of articulated trabeated structures composed of monolithic columns, beams, and frames, with infilling walls made up of precast blocks."[3] [Figure 1] But for Perret's pupil, Le Corbusier (1887–1965), or his British contemporary Sir Owen Williams (1890–1969), the oracular formula was something quite different—for both it was the cantilevered slab of the Dom-ino system, or of the Boots' factory at Nottingham (1932). [Figure 2]

And for the American engineer Francis S. Onderdonk, Jr., author of the 1928 classic *The Ferro-Concrete Style*, concrete's potential lay neither in trabeated structures, nor in cantilevered slabs; he argued that concrete's true form was the parabolic arch, that concrete was the natural successor to the Gothic, replacing the pointed arch by the more efficient parabolic arch, as, for example, in London's Royal Horticultural Hall (1928). [Figure 3] But the development in the 1930s in Germany of shell structures introduced yet another alternative model for concrete construction, which by the late 1940s came to be widely regarded as the best means of realizing concrete's potential.

The Greek architect P. A. Michelis, author of a book originally published in 1955 and translated into French in 1963 as *Esthétique de l'architecture du béton armé*, argued that it was shell structures, because they fulfilled for the first time the isotropic features of concrete (its capacity to carry loads equally in all directions and so abolish the distinction between load and support) that were the true form of concrete construction. For Michelis, the buildings that best demonstrated concrete's potential were works like the

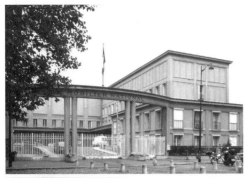

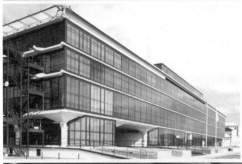

Centre National des Industries et Techniques designed by Nicolas Esquillan (1902–1989) in Paris (1958), or Eero Saarinen's TWA Terminal in Queens, New York (1962). [Figure 4] But at exactly the same time as Michelis was arguing that shells were the correct use of concrete, Le Corbusier was building in *béton brut*, which with its messiness and considerable redundancy of material presented an aesthetic totally at variance with the refinement of shell structures.

Structural rationalist that he was, Michelis acknowledged that concrete might well develop beyond shells. Even so, he would have been surprised by recent events, for—although there have been some developments in strong, slender concrete, like the chicken-bone structures of Santiago Calatrava (b. 1951)—shell construction has been abandoned, and the dominant tendency in architectural concrete has been the emphasis on mass and density, most evident in Swiss architecture. Far from achieving the structural rationalist principle of the maximum effect with the least material, these buildings appear to use, by structural rationalist standards, excessive quantities of concrete. And far from eliminating solidity, which the Zurich historian Sigfried Giedion had thought in the 1920s was what concrete was good for, these recent Swiss buildings exaggerate it.[4]

[Figure 5] Such technical developments as have occurred in recent decades are not the kind that structural rationalism might have predicted, but rather they have been in the refinement of casting and finishing techniques.

This microhistory of concrete architecture draws attention to how very discontinuous each of the major developments in concrete has been. Rather than learning from each development, we seem to develop each new principle just so far and then abruptly abandon it and set off on some wholly new trajectory. The theory of structural rationalism held that architecture developed progressively toward the refinement and perfection of structure—but with concrete, we have a field littered with truncated techniques. Each new generation of constructors seems to have approached concrete as if they were starting from scratch with a material only just discovered, as thought they were dealing with a material without a history.

Peter Collins thought that as far as the appropriate architectural expression of concrete was concerned, the situation at the beginning of the twentieth century was confused, but as even this very short survey shows, it is just as uncertain at the beginning of the twenty-first century. Rather than expectantly waiting for the coming of an agreed aesthetic, we might do better to accept that as far as concrete goes, uncertainty, indecision, and conflict are normal and, indeed, structural to it.

The uncertainty that is such a feature of the aesthetics of concrete undoubtedly has something to do with its common, but mistaken, designation as a *material*. Concrete, let us be clear, is not a material, it is a *process*: concrete is made from sand and gravel and cement—but sand and gravel and cement do not make concrete; it is the ingredient of human labor that produces

Figure **1** Auguste Perret, Mobilier National, Paris, 1936

Figure **2** Owen Williams, Boots' Factory, D-10 Building, Nottingham, 1932

Figure **3** Easton and Robertson, architects, and Oscar Faber, engineer, Royal Horticultural Hall, London, 1928

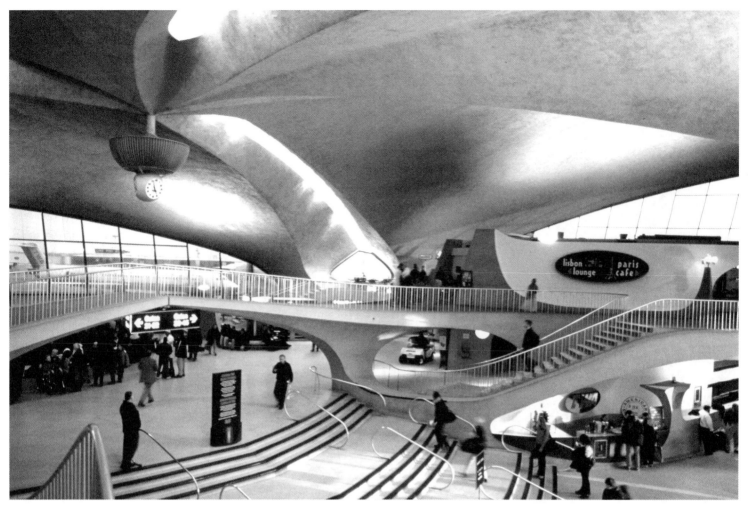

Figure **4** Eero Saarinen, TWA Terminal, John F.
Kennedy Airport, Queens, New York, 1962

Figure 5 Valerio Olgiati, School, Paspels, Switzerland, 1997–98

concrete. Although the cement and concrete industry, whose main interest is to sell cement, sand, and gravel, has tended to encourage the view that concrete is a "material" in the way that stone or timber are regarded as "materials," this is misleading, for concrete exists only when cement and aggregates are combined with labor. Now, the same is true of all other building materials—even naturally occurring materials such as stone, timber, and clay have to be processed before they become buildings; the difference between concrete and these other, so-called natural, materials is only a matter of degree. With concrete, the human labor element is more visible and more immediately apparent in the finished result, but the same element is present in all other materials. Martin Heidegger's notion that a work of architecture is the "bringing forth" of the immanent properties of stone and metal that lie dormant in the ground is difficult to apply to concrete. What, if anything, is "brought forth" in concrete is human invention and skill, and I would be inclined to say that the same is true of all other materials, too, and not just synthetic ones. This feature of concrete—that it is a process, not a material—was well understood by the early concrete pioneers, who were careful to patent their techniques. François Hennebique (1842–1921) succeeded as a producer of concrete buildings because he protected his patents so diligently and made sure that the contractors to whom he licensed the system followed his procedures for concrete construction.[5] What Hennebique guarded was the *process*, not the materials—steel, sand, and cement—which, after all, anyone could buy. Well into the twentieth century, success for the concrete constructor relied upon the possession of a patent.

In various ways concrete has had the effect of either confounding or at least casting doubt upon accepted ideas about construction, the nature of materials, the progressive historical development of structures, and on the other principles that have guided architectural aesthetics over the previous millennia—but without putting anything securely in their place. All that characterizes the aesthetics of concrete is confusion and uncertainty.

The uncertainty generated by concrete connects with what might well be regarded as another structural feature of concrete: its unpopularity. Particularly in Northern Europe, but not only there, concrete has had a bad name. When even a committed champion of modern architecture like Sir Nikolaus Pevsner could write, "Concrete with all the shuttering marks can never be attractive,"[6] it is clear that we are dealing with a material with an image problem. The story of the reaction against concrete in the 1970s is well known, but it is worth pointing out that even before the great period of concrete building, in the late 1950s and early 1960s, there were rumblings of disquiet about concrete from European intellectuals.[7] "I do not dream when in Paris, in this geometric cube, in this cement cell, in this iron-shuttered bedroom so hostile to nocturnal matter," complained the French philosopher Gaston Bachelard in 1948.[8] And others, including Theodor Adorno and Henri Lefebvre, were starting from this time to be critical of the earlier optimism that had surrounded concrete. Even in professional circles, there were reservations about the widespread use of concrete. As one of the British postwar building committees warned in 1946, "A large extension of the use of concrete is inevitable. . . .

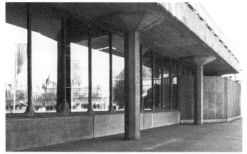

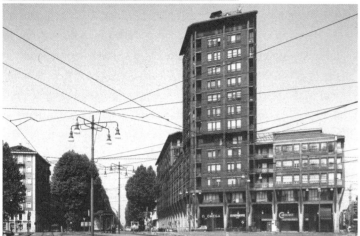

Figure **6** GLC Architects' Deptartment, Queen Elizabeth Hall, London, 1968, river elevation

Figure **7** BPR, Office and residential building, 2–4, Corso Francia, Turin, 1959

In present conditions of design and technique it would be a disaster if in-situ concrete were unrestrictedly used in the rebuilding of our towns and villages....We cannot ask our population to lead a full and happy life in such surroundings."[9]

What are the reasons for the hostility to concrete? When the great reaction against concrete set in during the 1970s, the concrete industry seemed to assume that what was wrong with concrete was that its quality was not good enough, and it concentrated its resources upon eliminating the imperfections of concrete so as to make it smoother, denser, and less prone to staining and cracking. In other words, the industry's strategy for overcoming the repulsion many people had for concrete was to make it less like concrete and more like other materials, most obviously stone. Broadly speaking, the concrete industry in the 1980s rebranded itself as a purveyor of "artificial stone."

Now, while one can see why the concrete industry chose to pretend that what it was producing was not concrete at all, a different—and in the long term, possibly more successful—strategy might have been to look harder at what it was about concrete that repelled people, for it is unlikely that it was the imperfections. It would appear that the objections to concrete were the objections to modernity itself—concrete just happens to be a particularly ubiquitous and vivid symbol of modernity. Like modernity, it brings people together but cuts them off from one another; it overcomes the forces of nature but obliterates nature; it emancipates us but ends up destroying old ways of life and old craft skills. And, like modernity, it is irreversible—there is no turning back.[10] These are not features of concrete that the industry could have done much about.

On the other hand, there are many ways in which builders in concrete can and do affect perceptions of the material. If, as we have suggested, concrete is characterized by ambiguity and indeterminacy—as Frank Lloyd Wright (1867–1959) acknowledged back in 1928, when he called it a "mongrel" material, neither one thing nor another[11]—then architects can choose whether to suppress these ambiguities or to accommodate them. Ambiguity and uncertainty are uncomfortable, and architects and engineers have tended to hide concrete's indeterminacy and to emphasize one property at the expense of others, so as to avoid the discomfort and unease that arise from unresolved ambiguities. Nowhere has this been more true than over the question of whether concrete is a "historical" or an "ahistorical" material.

Writing and discussion about concrete over the last century and a half have always stressed its newness. It was "new" in the 1850s, and it is still, somewhat bizarrely, talked about as "new" today. Over and over, people talk about concrete's "potential," its "possibilities"—in other words, it is seen as a material whose existence lies in the future, rather than in the present or the past. For the modernists, of course, a material without a history had great appeal. Yet it is odd that this notion of concrete as a material without a past, existing only in the future, still persists today, over a hundred years after the invention of reinforced concrete. Quite clearly, concrete *does* have a history, yet even if they have wanted to, architects and engineers have found it extraordinarily difficult to know how to acknowledge this in their use of it. Occasionally one comes across isolated historical references in the medium—the mushroom-head columns of London's Queen

Figure **8** Office and residential building, 2–4, Corso Francia, detail of facade

Figure **9** Office and residential building, 2–4, Corso Francia, portico columns clad in stone

Elizabeth Hall (1968) were a gesture of deference to Sir Owen Williams, the British concrete pioneer—but for the most part, the question of how concrete's history might be reconciled with its supposed existence in future time has not been given much attention. [Figure **6**] Although some of the early users of concrete were aware of the paradox—Auguste Perret noted that "construction in concrete is amongst the oldest of all building methods, and at the same time it is one of the most modern"[12]—they were not generally interested in representing concrete's own history. It was only in postwar Italy that the fact that concrete had a past as well as a future was seriously addressed for the first time.

Italian architects' engagement with historical issues came about through the peculiar circumstances that they found themselves in after World War II—having to distance themselves from fascism without rejecting the architectural modernism that had flourished under fascism. But they needed also to reach back over time, to modern architecture before fascism, to show that the fascist period had been only an episode within the wider history of modern architecture, and that there were other traditions of modernism, uncontaminated by fascism, that could be drawn upon. The general strategy of the Italians, articulated principally by Ernesto Rogers (1909–1969) through the pages of *Casabella-continuità* in the early 1950s, was to situate prewar modernism as a historical phenomenon; rather than proposing an absolute rupture with the fascist era, they emphasized multiple continuities with the past. Seen in these terms, concrete could be both a historical material and yet of the present. If we look at some buildings in northern Italy from the 1950s and early 1960s, we can see how this idea was developed.

Consider, for example, 2–4, Corso Francia in Turin, designed by Belgiojoso, Peressutti, Rogers (BPR, of which Ernesto Rogers was a partner) and finished in 1959, just after the same practice's more famous Torre Velasca in Milan. [Figure **7**] The building has shops at street level, offices in the mezzanine, and then apartments at the upper levels. As a building in which the grid of the frame is expressed externally, it is clearly indebted to Perret (Rogers had written a short book about Perret in 1955), though the many differences it has from Perret's buildings make it clear that the lessons drawn from Perret have been absorbed and modified. The creation of a void at the corner is the very opposite of Perret's usual practice of giving emphasis to corners by thickening up the structure at that point. [Figure **8**] Highly uncharacteristic of Perret are the columns that break two-thirds of the way up and change direction to carry the jettied upper floors, tapering as they do so; Perret would never have countenanced an angled column, but on the other hand, these columns and their tapered shape owe at least something to another tradition of concrete, the work of the Italian master of reinforced concrete, Pier Luigi Nervi (1891–1979). The choice of brick infill for the walls of the apartments is not characteristic of Perret but is an acknowledgement of Turin's traditional building material; unlike Perret, too, is the studied irregularity of the fenestration of the apartments. On the other hand, when we look at the surfaces of the concrete, BPR was clearly following Perret. There are three different surface treatments, each corresponding to a different priority in the structure. The grid of the upper-level frame is bushhammered, and this is continued down into the ribs that merge into the upper part of the ground-floor columns; the roughness of the surface has caused it to hold dirt, making it appear darker than the smooth finish of the

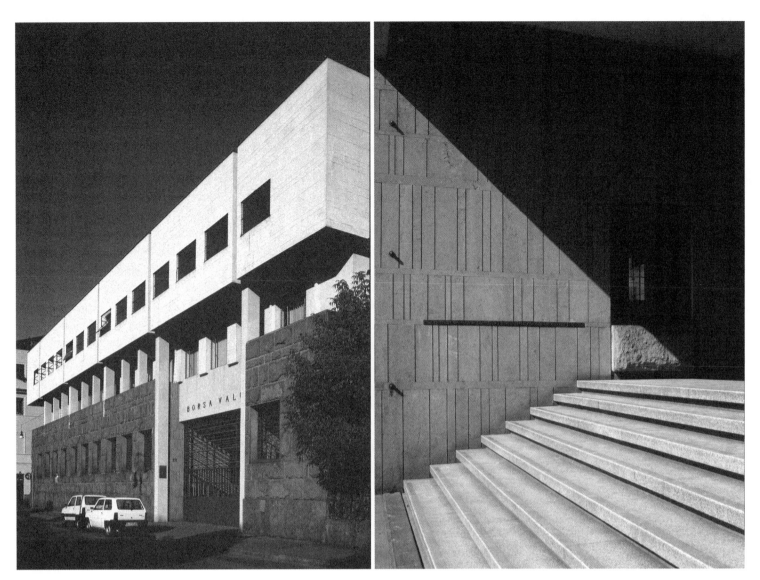

Figure **10** Gabetti and d'Isola, Borsa, Turin, 1956

Figure **11** Borsa, entrance vestibule

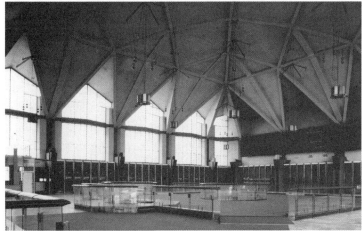

Figure **12** Borsa, interior

Figure **13** Giancarlo De Carlo, Residential building, Spine Bianche, Matera, Italy, 1957, rear elevation

Figure **14** Spine Bianche, rear elevation

columns, the second finish. The third finish is the board-marked concrete of the soffit of the portico. Although this differentiation of the finishes for the different parts of the structure is consistent with Perret, what does not come from Perret is the partial cladding of the columns at pavement level in thin sheets of stone. [Figure **9**] The cladding is arranged so that an area of concrete is left exposed at eye level on the sides of the columns, revealing the true nature of the structural material. Presumably this veneering of the columns was done so as to humanize the portico space and encourage tenants to lease the shops; whatever the reason, BPR chose to clad the columns with a stone whose tone and roughened surface can easily be mistaken for concrete. What we see here is a building that defers to concrete's various histories, yet incorporates these into the time and place of its construction.

Another building in Turin, the Borsa, constructed between 1952 and 1956 and designed by Roberto Gabetti (1925–2000) and Aimaro d'Isola (b. 1928), was a work intended to show that contemporary architecture derived from not one but from many different traditions.[13] [Figure **10**] From the front, there is a neorationalist upper level, supported on concrete columns that rise up out of a Richardsonian rough stone plinth. But the return wall of the entrance reveals an entirely different treatment—a gray surface is marked with fine horizontal lines and an irregular pattern of verticals. [Figure **11**] The gray color, surface texture, and dimensions of the sections suggest that this wall is concrete block—but close examination reveals that it is dressed stone. So we have the unusual experience of expecting a part of the building to be made of concrete, then discovering that it is not. While it is perfectly normal for concrete to simulate other materials, rarely is another material made to imitate concrete. But the real surprise of the Borsa is the interior of the exchange hall, which is a large volume with a roof made up of slender, branching ribs, the ends of which carry a shallow ribbed dome. [Figure **12**] The effect of these slender ribs and paper-thin panels is reminiscent of the Church of St. Jean-de-Montmartre in Paris (1904) by Anatole de Baudot (1834–1915), a correspondence that was almost certainly intentional since Gabetti considered de Baudot's church to be the first work to have shown that reinforced concrete could be given an architectonic function.[14] Here again we see historical references to concrete being incorporated into a modern building to establish the continuity between past and present.

Although located in southern Italy, the Spine Bianche at Matera was designed by the Milanese architect Giancarlo De Carlo (1919–2005) and built between 1954 and 1957.[15] [Figure **13**] It was one of the buildings shown by the Italians at the meeting of the Congrès Internationaux d'Architecture Moderne at Otterlo in 1959, and which, along with the Torre Velasca, provoked the row that led to the break-up of the CIAM. It has a Perret-like exposed concrete frame, but on the rear elevation it is "deviant" in that the intervals between the columns at the lower level are irregular, and at the corners the columns are missing altogether, while some of the first- and second-floor columns are placed over intervals below. [Figure **14**] The haunching of the beams at the column heads on the lower

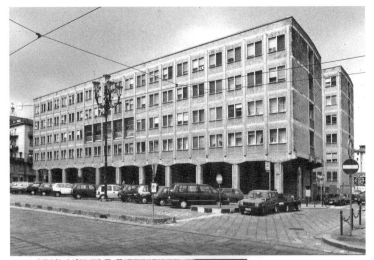

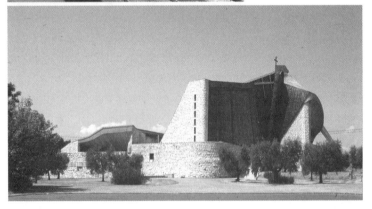

level (though not above) is a feature that refers to the, by then long-expired, Hennebique patent. This same reference occurs again in the next project.

The Turin Municipal Technical Offices were designed by Mario Passanti (1901–1975), a highly respected engineer from the pre-war generation, and built between 1957 and 1961. [Figure 15] Although this project was won as a result of a competition, it was controversial from the start because it faces Turin Cathedral, the home of the Holy Shroud, and more or less from the day it was finished there have been demands for its demolition. Like the Spine Bianche, the main reference is to Perret, with the grid of the frame exposed, but the verticals of the frame alternate with the columns of the portico in a way that Perret would not have sanctioned. The horizontals and the verticals of the frame are both expressed, but whereas the horizontals are flush with the wall, the verticals project slightly, a detail that serves no structural purpose and must therefore be purely decorative—again, shocking to structural rationalist sensibilities. The haunching of the beam over the columns of the portico is another reference to Hennebique, but the cladding of the sides of the columns with stone is decidedly strange. [Figure 16] Seen from the front, this is a reinforced concrete frame building, but seen lengthways under the portico, there is hardly any concrete to be seen at all, and the columns present themselves as stone. This is a curious reversal of the more usual arrangement, which declares that, for propriety, the public face of the building should be clad in traditional materials, but that the inner faces can afford to be less conformist. Here, the public face is aggressively modern, but when you can no longer see the front of the building, it becomes deferentially traditional.

The Chiesa dell'Autostrada, outside Florence, was designed by Giovanni Michelucci (1891–1991) and built between 1962 and 1964 as a memorial to those who died in the construction of the Autostrada del Sole. [Figure 17] The outside is remarkable enough and anticipates Gehry by forty years, but it is the inside that is most extraordinary. This is a place where any idea of concrete construction as being a *rational* affair is completely exploded—columns, struts, and bracing are all crowded together in an utterly chaotic way; it is an affront to the elegant rationality of Nervi's engineering, and indeed of Michelucci's own earlier architecture. But the Chiesa dell'Autostrada is also post-Ronchamp, and Michelucci lets us know this: the taut shell of the roof at Ronchamp here becomes a sagging canopy, barely held in shape by a few bits of inadequate-looking concrete bracing. [Figure 18] There is a complete confusion of almost every known tradition of working concrete: it is neither a frame nor a shell, and with structural members that seem arbitrarily dimensioned, it manages not only to mix together different traditions, but also to question the value of the engineering principles that had up to then dominated concrete architecture. [Figure 19]

All these Italian buildings were composite structures: they mixed concrete with other materials, with brick or with stone. For the doctrinaire minds that concrete has

Figure **15** Mario Passanti, Municipal Technical Offices, Turin, 1961, front elevation

Figure **16** Municipal Technical Offices, portico

Figure **17** Giovanni Michelucci, Chiesa dell'Autostrada (Church of San Giovanni Battista), Florence, 1964

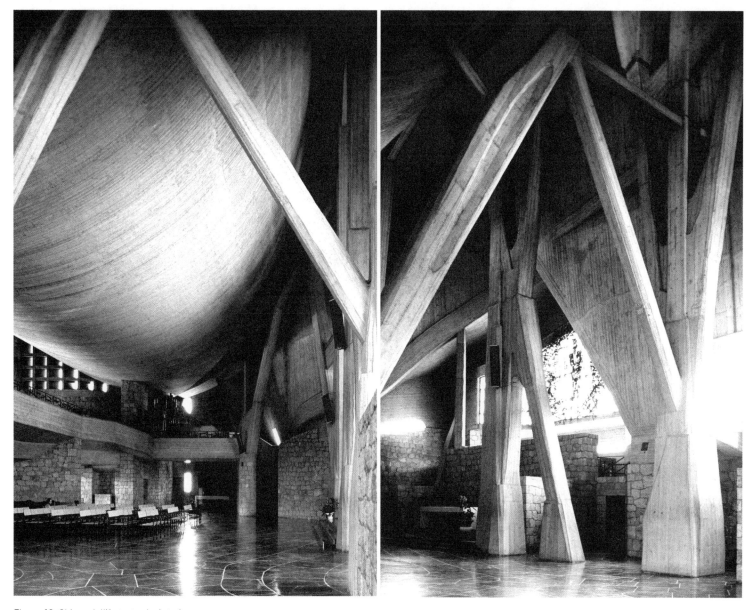

Figure **18** Chiesa dell'Autostrada, interior

Figure **19** Chiesa dell'Autostrada, interior

seemed so often to attract, this was impure and improper, and marked these buildings as inferior. But not only were they composite in the sense of mixing materials, they also mixed histories. Whereas most practitioners of concrete have stuck rigorously to one tradition of construction only—whether monolithic, trabeated, arch, or shell—and would not countenance their combination, what we see here is a willingness to make structures that are *historically* composite. Out of concrete's discontinuous history of truncated developments, these Italian architects created a synthesis that attempted to make the history of the material meaningful.

To call concrete a "mongrel material" is not flattering, nor did Wright intend it to be. Wright put concrete low down in the hierarchy of materials. For the majority of practitioners, the mongrel features of concrete are shameful, and they have generally tried to obscure or disguise them so as to make concrete appear a pedigree material. Yet the reality is otherwise, and it has to be said that the more interesting works in concrete are often those that recognize concrete's ambiguous nature: it can be both liquid and solid, smooth and rough, backward and advanced, worthless and precious, and, as these Italian examples demonstrate, historical and unhistorical. While most designers have tended to exaggerate one property in the hope of suppressing its opposite, works that acknowledge the "neither one thing nor another" properties of concrete may be, while less pure, nonetheless closer to the nature of concrete.

Notes

1 S. Woods Hill, review of T. P. Bennett, *Architectural Design in Concrete* (1928), in *Architectural Record* 63 (June 1928): 597. The same passage is quoted in part at the beginning of Francis S. Onderdonk, Jr., *The Ferro-Concrete Style* (1928; reprinted Santa Monica: Hennessy + Ingalls, 1998), 3.

2 Adolf Loos, "The Principle of Cladding" (1898), in A. Loos, *Spoken into the Void: Collected Essays, 1897–1900*, transl. Jane O. Newman and John H. Smith (Cambridge, Mass., and London: MIT Press, 1982), 66.

3 Peter Collins, *Concrete: The Vision of a New Architecture* (London: Faber & Faber, 1959), 109.

4 See Sigfried Giedion, *Building in France, Building in Iron, Building in Ferroconcrete. A Study of Auguste Perret and his Precursors*, introduction by Sokratis Georgiadis, trans. J. Duncan Berry (Santa Monica, Calif.: The Getty Center for the History of Art and the Humanities, 1995), 169; originally published as *Bauen in Frankreich, bauen in Eisen, bauen in Eisenbeton* (Leipzig and Berlin: Klinkhardt und Biermann, 1928).

5 See Gwenaël Delhumeau, *L'Invention du béton armé: Hennebique, 1890–1914* (Paris: Norma, 1999).

6 The comment relates to the National Theatre on the South Bank in London. Bridget Cherry and Nikolaus Pevsner, *The Buildings of England, London 2: South* (Harmondsworth, Middlesex: Penguin Books, 1983), 353.

7 On the reaction against concrete in Germany, see Kathrin Bonacker, *Beton: Ein Baustoff wird Schlagwort; Geschichte eines Imagewandels von 1945 bis heute* (Marburg: Jonas Verlag, 1996).

8 Gaston Bachelard, *La Terre et les rêveries du repos* (Paris: José Corti, 1948), 96. The original text reads, "Je ne rêve pas à Paris, dans ce cube géométrique, dans cet alvéole de ciment, dans cette chambre aux volets de fer si hostiles à la matière nocturne."

9 Ministry of Works, Great Britain, *Post War Building Studies*, no. 18, *The Architectural Use of Building Materials*, 1946, paragraph 278.

10 For further discussion of the relation of concrete to modernity, see Adrian Forty, "Concrete and Memory," in *Urban Memory, History, and Amnesia in the Modern City*, ed. Mark Crinson (Abingdon, U.K., and New York: Routledge, 2005), 75–95.

11 Frank Lloyd Wright, "In the Cause of Architecture VII: The Meaning of Materials—Concrete" (1928), reprinted in F. L. Wright, *Collected Writings*, vol. 1, ed. B. B. Pfeiffer (New York: Rizzoli, 1992), 297–301.

12 Undated ms. in Perret archives, translated and quoted by Karla Britton, *Auguste Perret* (London: Phaidon, 2001), 244.

13 For a fuller description and illustrations of the Borsa, see *2G* 15 (2000): 78–85.

14 Roberto Gabetti, *Origini del calcestruzzo armato*, part II (Torino: Edizioni Ruata, 1955), 54.

15 See De Carlo's account of this building in Oscar Newman, ed., *CIAM '59 in Otterlo* (London: Tiranti, 1961), 97–91; and *2G* 15 (2000): 44–49.

The Semantics of Exposed Concrete

Réjean Legault

> Concrete is mud. I work with concrete, not against it. I like mud.
>
> —Paul Rudolph

Ever since its appearance on the architectural scene, concrete has been entangled in an unusual semantic proliferation. Writing on the history of the material, Peter Collins recalled the various names given to the new building system—armed concrete, armored concrete, ferro-concrete, hooped concrete, sidero-concrete, concrete-steel, concrete-metal—before reinforced concrete was finally adopted at the turn of the twentieth century.[1] Architects have also toyed with the naming of this hybrid material. From Auguste Perret's "antique material turned modern," to Frank Lloyd Wright's "conglomerate," to Louis I. Kahn's "molten stone," to Paul Rudolph's "mud," architects have often tried to capture the "true" or imagined nature of the material in a suggestive phrase.

The search to uncover the material's true nature has long focused on the issue of form. As Adrian Forty reminds us, the history of concrete is fraught with discourses about the ideal or necessary form concrete structures should take.[2] In their important books, Emil von Mecenseffy (1913), Francis S. Onderdonk, Jr. (1928), and P. A. Michelis (1955) each attempted to tackle the problem of concrete's formal expression.[3] Needless to say, this search proved to be in vain, for in the end the form of concrete structures was shaped as much by the extrinsic forces at play within architectural culture as by the intrinsic properties of the material itself. In short, it revealed that concrete—like all other materials—is not a technical "given" but an architectural "construct."

By the 1950s, another issue had appeared on the architectural agenda: how to treat concrete's external appearance. Moving away from a focus on concrete as structure, a number of publications—such as Wilhelm Künzel's *Sichtbeton im Hoch und Ingenieurbau* (1962)—turned their attention to the aesthetics of exposed concrete.[4] Such concerns were not totally new. As early as the 1920s, Perret (1874–1954) had experimented with the molds, mixes, pours, and finishes of concrete, refining its surface so as to turn it into a kind of modern stone. But the question of exposed concrete—both as an idea and as a practice—became the subject of debate only after the second postwar period.

The American architectural context serves as a case in point. In an editorial in the October 1960 issue of *Progressive Architecture*, Jan C. Rowan wrote, "Today, the profession is awakening to the aesthetic potential of concrete. Almost every architect with whom we have talked recently has on his board a design which he hopes to carry out in exposed reinforced concrete."[5] Well-known examples of the use of exposed concrete in American architecture, such as the Unity Temple by Frank Lloyd Wright (1867–1959), in Oak Park, Illinois (1906), offered historical precedents.[6] Yet, as Burton Holmes noted, after a hiatus of several decades, there was "a tremendous resurgence of interest in the use of exposed concrete."[7]

Holmes's assessment of the situation proved prophetic. From the turn of the 1960s onward, the use of exposed concrete in American architecture became so widespread as to become a true modernist trademark. In a matter of a decade, North American architects were to exploit the full range of possibilities of the material. Exploring the foundational dichotomies of exposed concrete—cast in place vs. prefabricated, handmade vs. machine made, smooth vs. rough—these architects offered the most inventive, most varied, but also most contradictory interpretations of the "essence" of the material.

Figure 1 Le Corbusier, Unité d'habitation, Marseille, 1952, *pilotis* in *béton brut*

Figure 2 Le Corbusier, Monastery of Sainte Marie-de-la-Tourette, Eveux-sur-l'Arbresle, near Lyon, 1960, view of the chapel made with industrial formwork

Le Corbusier and the "Invention" of *Béton brut*

The source of the postwar debate on exposed concrete resides with the Unité d'habitation in Marseille (1952), designed by Le Corbusier (1887–1965). The Unité was made of a concrete skeleton resting on massive pilotis. The project was hampered by shoddy workmanship, and, unable to obtain the desired quality of finishes, Le Corbusier decided that the concrete should be left in its rough state.[8] The strategy was to leave the concrete *brut de décoffrage*, that is, untreated after removal of the wooden formwork. The result was what Le Corbusier called *béton brut*, a concrete whose surface bears the imprint of the molding process.[9] [Figure 1] It was, in the later assessment of Reyner Banham, a concrete that had become a low, earthy, natural material, a substance whose outward surface records "the traces of contingencies and accidents, of human fallibility, and of the human hand."[10] With the "invention" of *béton brut*, Le Corbusier gave a new significance—both architectural and cultural—to a conventional construction practice.

The Monastery of Sainte Marie-de-la-Tourette, near Lyon (1960), provided the stage for further experimentation. Here Le Corbusier employed a technique called *béton banché*, a type of industrial sliding formwork used in public-works construction. [Figure 2] The resulting surfaces were radically different from those obtained at Marseille. Gone are the traces of the human hand; gone is the rustic expression. Most important, the patterns of this exposed concrete were largely the result of decisions made by the building contractor, not the architect.[11] The production process adopted at La Tourette challenged the very idea of architectural prefiguration and intentionality. That some monks read the surfaces achieved by means of quasi-industrial techniques as "stigmata of suffering" is only one of the building's many paradoxes.

Though radically different from the exposed concrete at Marseille, La Tourette's "public-works concrete" was quickly subsumed under the *béton brut* label. Popularized by the debate on the New Brutalism, *béton brut* came for a time to encapsulate the entire aesthetic of exposed concrete.[12] Yet, as we will see, Le Corbusier's *béton brut* proved to be only an early chapter in this little-known history of exposed concrete.

Smooth Concrete

If the October 1960 issue of *Progressive Architecture* is any indication, American architects were eager to explore the aesthetic possibilities of exposed concrete. By this time, architects were well-attuned to the aesthetic but also, to the ideological debate between rough and smooth concrete. Yet for the *PA* editors, the discussion was still framed by the distinction between two techniques, that is, between cast-in-place and prefabricated concrete.

Among the early architects to take up the challenge of cast-in-place concrete were I. M. Pei (b. 1917) and his firm.[13] Their first venture with the material was in the design of the Denver Hilton Hotel (1960), which featured a precast concrete skin enclosing a concrete structure. But Pei's most significant breakthrough was the development of a sophisticated technique of cast-in-place concrete construction making use of fiberglass molds. [Figure 3] With this system, Pei dealt with the fundamental constraints related to making exposed concrete: the mold, the mix, and the workmanship. Varying the material's ingredients, he added quartz crystal to intensify the pristine whiteness of the structural elements. The originality of the technique lay in the exploration of the aesthetic potential of repeatable elements, where structure and envelope were molded into one

Figure 3 I. M. Pei, view of concrete structure mock-up, made with fiberglass molds, constructed for the Kips Bay Plaza project, New York, ca. 1960

Figure 4 I. M. Pei, University Gardens, Chicago, 1961

and the same form, and built in a single operation. Pei used this system in a number of residential projects, among them University Gardens in Chicago (1961). [Figure 4] Combating the contingencies and imperfections inherent to the building site, Pei's cast-in-place concrete was conceived as a smooth, precise, quasi-industrial material.[14]

The alternative to cast-in-place concrete was prefabrication. A noted example at the time was Geddes, Brecher & Qualls's project for the Philadelphia Police Headquarters (1963). Based on the technique developed by the Dutch firm Schockbeton, where the concrete is vibrated on a "shock table," the cast elements reproduced the smooth finish of the mold.[15] Like Pei's cast-in-place technique, precast concrete was conceived as a slick, flawless, machine-made material. Among the many advocates of prefabrication were Minoru Yamasaki (1912–1986) and Gordon Bunshaft (1909–1990) of Skidmore, Owings & Merrill. Yamasaki's Federal Science Pavilion at the Seattle World's Fair (1962) was a skilled demonstration of the structural and ornamental possibilities of prefabricated concrete. [Figure 5] Bunshaft's John Hancock Mutual Life Insurance Company at New Orleans (1962)—his first project in precast concrete—similarly confirmed his rapid mastery of smooth, exposed concrete.[16]

The common denominator of these projects was the smoothness of their concrete surfaces. Yet if Pei, Yamasaki, and Bunshaft were attracted by the pristine, machine-made appearance of exposed concrete, others had started exploring the reverse side of the material's expressive quality: the roughness of architectural concrete.

Rough Concrete

Louis I. Kahn (1901–1974) had already exploited the expressive possibilities of rough concrete in his project for the Yale Art Gallery (1953). While all the concrete surfaces were left in their raw state, the forms—made of narrow floorboards—were crafted with great care, especially the forms for the exposed columns. In this project, the use of raw materials was part of Kahn's ideological critique of contemporary modernist monuments and their industrial materials, which were deemed "too insubstantial, too cool and too machined."[17] [Figure 6]

Kahn was not alone in this quest. Marcel Breuer (1902–1981) had also shown an interest in the aesthetic possibilities of exposed concrete, as revealed in his work for the first phase of the Saint John's Abbey complex in Collegeville, Minnesota (1961).[18] He made an even bolder use of exposed concrete in Begrisch Hall, New York University (1961). Playing with the wooden formwork, Breuer imprinted diagonal patterns and lines on the surface that challenged the horizontality of the cantilevered mass and disrupted the conventional reading of the concrete pours. [Figure 7] For Breuer, exposed concrete was by then the best means to emphasize the sculptural, heroic character of architecture.

Eero Saarinen (1910–1961) also experimented with raw concrete, although with very different aesthetic intentions. His most daring project with visible concrete was the Ezra Stiles and Morse colleges at Yale (1962). Inspired by Italian medieval hill towns, Saarinen conceived the colleges as "citadels of earthy, monolithic masonry."[19] To achieve this, he devised an original technique that combined chunks of granite with high-strength cement mortar pumped into wall forms. [Figure 8] The chiseling away of the excess surface grout revealed the crushed stone as a large-scale exposed aggregate integral with the surface. A metaphorical interpretation of the composite nature of the mix, Saarinen's "masonry made without masons" was a romantic, medievalizing version of modern exposed concrete.[20]

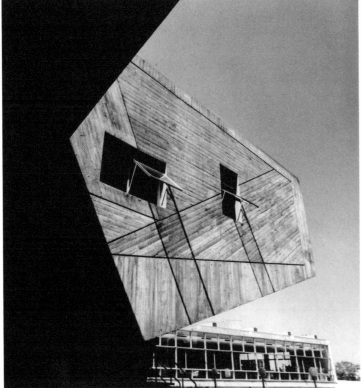

Figure **5** Minoru Yamasaki, Federal Science Pavilion, Seattle World's Fair, 1962, advertisement with a view of the building and its prefabricated elements

Figure **6** Louis I. Kahn, Yale University Art Gallery, New Haven, Connecticut, 1953, detail of rough concrete

Figure **7** Marcel Breuer, Begrisch Hall, New York University, New York, 1961

Figure **8** Eero Saarinen, view of "modern masonry" mock-up for Ezra Stiles and Morse colleges, Yale University, constructed in Bloomfield Hills, Michigan, 1959

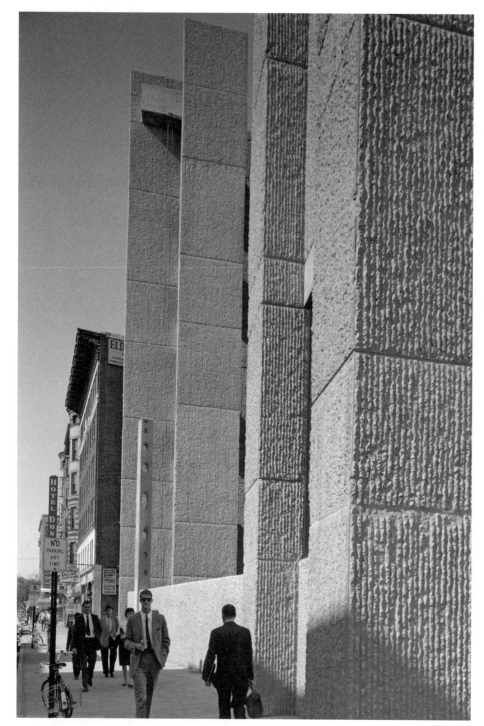

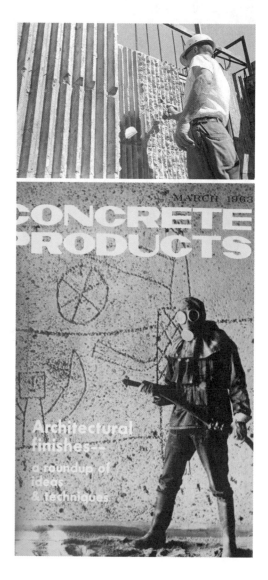

Figure **9** Paul Rudolph, Art and Architecture Building, Yale University, New Haven, Connecticut, 1963, detail of textured concrete

Figure **10** Art and Architecture Building, view of the crafting process

Figure **11** "Architectural Finishes," cover page of *Concrete Products*, March 1963

Figure **12** Paul Rudolph, Endo Laboratories, New York, 1964

Paul Rudolph's Textured Concrete

Until the early 1960s, rough exposed concrete was still largely associated with the late work of Le Corbusier. But Paul Rudolph (1918–1997), in his Art and Architecture Building (1963), also at Yale, was to change all that. A virtuoso response to a complex program, the building was made of a reinforced concrete structure enveloped with one-foot-thick concrete walls. While in early studies the building was depicted with smooth wall surfaces, Rudolph finally opted for a highly textured surface, a finish that became emblematic of the building as a whole.[21] [Figure **9**] The crafting of the striated envelope was achieved by pouring concrete into vertically ribbed wooden forms. After the molds were removed, the ridged surfaces were hand-hammered to expose the aggregate. [Figure **10**] The resulting texture had a tactile quality that created an unexpected effect: that of physical roughness. The architectural historian Vincent Scully was moved to write that its "slotted and bashed surface is one of the most inhospitable, indeed physically dangerous, ever devised by man."[22]

In his own discussion of the building, Rudolph was eager to refer to his experience of Le Corbusier's work: "One of the most humanizing elements in Corbu's concrete is the oozing, dripping and slipping of concrete between poorly placed forms (especially in his work in India). One of the reasons why American architecture has had difficulty using this medium is that our contractors take great pride with the precision of their work, which helps to give so much of it the thin, metallic-like quality."[23] Yet the concrete Rudolph achieved in his Yale building was anything but "oozing, dripping and slipping." Rather, it was a concrete achieved through sustained experimentation, tight control over the production process, and great financial expense.[24]

The experimental phase took five months and some three dozen casting samples.[25] But Rudolph's experimentation with the material was not an isolated phenomenon: it was part of a broader American trend to explore and develop the aesthetic potentialities of concrete. The pages of technical and commercial journals were filled with information about new techniques for treating exposed concrete, techniques that were a far cry from the ones used for making Le Corbusier's famous *béton brut*. [Figure **11**]

If the Art and Architecture Building's architecture was unique, its materiality was not. In fact, most of Rudolph's projects of the mid-1960s sported this unusual brand of corduroy-like concrete, bringing attention to the artificial, highly crafted nature of the exposed material. Yet the textured material could convey different meanings in different contexts, as in the case of his Endo Laboratories in New York (1964), where the craggy, inhospitable concrete surfaces became a synecdoche of the fortress-like structure, complete with turrets and defensive walls. [Figure **12**]

I. M. Pei's Machine-Made Exposed Concrete

Of the many architects who explored the "construction" of exposed concrete, I. M. Pei was one of the most skilled and inventive. Moving away from the ideal of smooth concrete, Pei began to experiment with the material's visual and tactile qualities. His first

Figure **13** I. M. Pei, National Center for Atmospheric Research, Boulder, Colorado, 1967

Figure **14** Mechanical bushhammer in operation

such venture was the National Center for Atmospheric Research in Boulder, Colorado (1967), a complex of laboratories and offices located at the foot of the Flatiron Range before the Rocky Mountains. Taking his inspiration from the region's pueblo architecture, Pei designed the NCAR as a series of vertical towers capped with hoods, a sort of shading device that gave the building much of its sculptural drama.[26] [Figure **13**]

Structurally, the building was based on a module of concrete columns and bearing walls. But it was concrete of a highly evolved kind. To achieve a dark reddish-brown hue close to that of the mountains rising in the background, Pei added sand ground from stone quarried nearby.[27] He then gave the concrete a grooved texture by means of a mechanical bushhammer that combed the surface in vertical striations. [Figure **14**] The resulting color and texture made the concrete look as if it had emerged from the site itself, its surfaces evocative of the erosion process of rock formations.

Pei stressed that his project for Boulder was site-specific. But he did not hesitate to use the same treatment for a contemporary project: the Everson Museum in Syracuse, New York (1968). Composed of four L-shaped cantilevered boxes, the reinforced concrete structure merges with the building envelope in such a way that the sculptural volumes avoid any display of tectonic expression. The walls are bushhammered to reveal an aggregate of warm pink Croghan granite typical of the region. On Pei's drawings for the building, the traces of the necessary joints are not shown, emphasizing the mass, texture and uninterrupted surfaces.[28] [Figure **15**] In the final building, however, the horizontal traces of the pour waver on the surface of the walls, in an architectural version of Freud's "return of the repressed." The concrete was given diagonal grooves made again with a bushhammering machine, creating an unexpected abstract texture. [Figure **16**] Pei exploited both the optic and haptic qualities of the material, the perception of the surfaces varying according to the position of the viewer. From far away, the surfaces look smooth and quasi-industrial; from up close, they appear rugged and handcrafted, revealing the composition and color of the concrete mix.

Exceptional as it may be, Pei's experience with concrete reveals an underlying tension within 1960s architectural culture: the confrontation of the handcrafted and the industrial. In his projects, Pei made every effort to erase the traces of the mold and the pours and, thus, of the production process. And he employed mechanical means to achieve a highly controlled textured surface. As such, Pei may have had shifted from the smooth to the rough, but he did not abandon the ideal of mastery and perfection inherent to the industrial paradigm.

Precast Textured Concrete

By the second half of the 1960s, the use of textured concrete was widespread. But its technique and aesthetic still sometimes took unexpected turns. Place Bonaventure in Montreal (1968) is a case in point. Designed by Raymond Affleck (1922–1989) and the firm later known as ARCOP, Place Bonaventure is a multipurpose building containing a shopping arcade, an exhibition hall, a five-level merchandising mart, an international trade center, and a 400-room hotel on the roof. A distinctive feature of the building is its highly

Figure 15 I. M. Pei, Everson Museum, Syracuse, New York, 1968, drawing

Figure 16 Everson Museum, detail of textured concrete

textured concrete surface. [Figure 17] So close were the visual connections with Rudolph's work that a reviewer called it "Rudolphian corduroy concrete."[29]

Despite the visual similarities, Affleck's textured concrete differs significantly from that of Rudolph. The "fins" of his concrete were sandblasted and smooth rather than bushhammered and rough. But more importantly, the building's external wall was first conceived as a system of prefabricated panels to be lifted and attached to the structure. Based on the "rain-screen principle," this wall was made of a double layer separated by an air space vented to the outside.[30] Though the panels were finally cast in place, their characteristic was that of a cladding rather than of a thick, heavy wall. At Place Bonaventure, the exposed concrete envelope was akin to a new industrial curtain wall.

Yet if Place Bonaventure was a compromise of sorts, another project by the firm—the National Arts Centre in Ottawa (1969)—was to take the concept to its logical conclusion. At the arts center, the wall was not poured in place but was made of precast concrete panels suspended on the structural frame of the building. Moreover, there was not one but three types of panel textures. [Figure 18] Far from the on-site craft techniques used by Rudolph or other architects, the finish of these precast panels was the result of sophisticated production techniques controlled in the factory. Strategically positioned to identify the building's interior functions—smooth for the stage houses, small ridges for the performing areas, and large ribs for the public areas—the precast cladding was charged with conveying the syntax of the entire complex. With this project, the ethos of craftsmanship that presided over the invention of textured concrete had finally run its course, turning the textured surface into a prefabricated, industrial product.

Exposed Concrete Interiors

The enthusiasm for exposed concrete in the 1960s was not limited to exteriors of buildings. In fact, one of the most striking features of American postwar design was the attempt to develop an architecture in which interior and exterior were treated with the same material. And the chosen material for this was concrete. As one architect aptly put it in a 1966 survey, "Concrete is the same as the Gothic tradition—the same material inside and outside."[31]

Some of the main protagonists of this search are the ones whose work we have already discussed: Saarinen, Rudolph, Pei, Affleck. In most cases, the finishes adopted were a variation of the rough—as opposed to smooth—concrete brand. Such "all-over" treatments did much to heighten the experience of, as well as the contrast between, the visual and tactile qualities of the material.

Yet some architects also chose to break with this idea of experiential continuity, turning instead to the exploration of exposed concrete as an art form. A well-noted example at the time were the three high reliefs in concrete designed by artists and placed in the entrance halls of the Administration and News Pavilion at the 1967 World Exposition in Montreal.[32] [Figure 19] Cast in plaster molds, the sculptures were then placed as infill panels on the concrete walls of the building, creating works that dramatized the haptic and optic qualities of exposed concrete.[33]

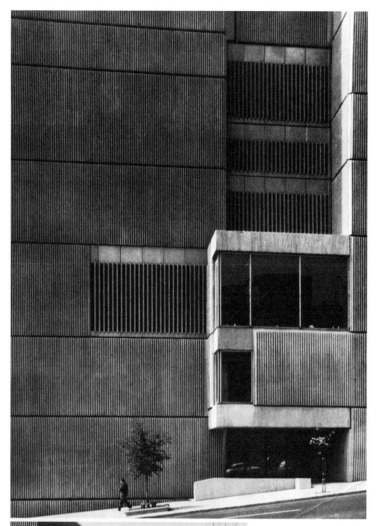

Figure **17** Raymond Affleck of ARCOP, Place Bonaventure, Montreal, 1968, cast-in-place panels with textured concrete

Figure **18** Fred Lebensold of ARCOP, National Arts Centre, Ottawa, 1969, detail of precast concrete panels

Louis I. Kahn and the Celebration of the Molding Process

Though widespread, textured surfaces were not the only idiom of the 1960s, and Louis I. Kahn, among others, was to adopt a very different attitude toward the treatment of exposed concrete. Known for his poetic dialogues with materials, asking them "what they really want to be," Kahn conceived of concrete as anything but one-dimensional. [34] He even flirted with prefabrication in his Richards Medical Research Laboratories in Philadelphia (1961).

Yet by the mid-1960s, Kahn began to focus on the mold and the molding process. This concern was best rendered in his design for the Jonas Salk Institute for Biological Studies in La Jolla (1965), a project where he paid special attention to the on-site crafting of the concrete. First, Kahn played with the mix, blending several types of California concrete with volcanic ash to impart a warmer hue to the surfaces. He also closely monitored the inspection of the concrete as it was colored, mixed, poured, and cured.[35] Second, he made sure that the concrete was molded and patterned exactly as intended. The forms were made with three-quarter-inch plywood that was filled, sanded, and finished with coats of catalyzed polyurethane resin. Rather than try to hide the joints between the formwork panels, Kahn chose to accentuate them, chamfering the edges of the panels so as to produce a V-shaped groove along the wall surface. Accepting the inevitable bleeding of the concrete at the juncture of the forms, the V-joints allowed the surplus to be molded into relief elements. [Figure **20**] The conical holes left by the ties holding the formwork together were also treated with care. Instead of being buttered in, as was common practice, these holes were plugged with lead with a quarter inch recess from the wall surface.[36] Their spacing was also carefully measured so as to create a regular pattern.

The originality of Kahn's approach lay precisely in the way the concrete surface was crafted to register the traces of the production process. Unlike Rudolph's and Pei's production techniques, Kahn's concrete was left "rough" after the removal of the formwork, the surface still covered with its cement film. As such, the concrete of the Salk Institute was conceptually closer to Le Corbusier's ideal of *béton brut*, for if Kahn's wooden forms were more carefully crafted, and the concrete mix, more refined, the resulting surfaces were also a more direct record of the molding process. Kahn's concrete was also unique in that it could not fit easily in the accepted categories of smooth and rough, being at once one and the other.

The story of this type of cast concrete did not stop there. Its reappearance in Kahn's project for the Kimbell Art Museum in Fort Worth (1972) is telling of the evolving meaning of architectural materials. While using the same casting technique as the one developed for the Salk Institute, Kahn insisted on the complementary nature of the light gray on-site concrete and the honey-colored travertine. With this project in mind, it was clear for Kahn that in the end "concrete really wants to be granite."[37] Though poured and molded between formworks, the status of his exposed concrete was really that of a lithic, stone-like, ancient material.

Reading Exposed Concrete

"A 'natural' expression is now common in concrete design. Regardless of the building processes involved, there is a tendency for designers to express themselves in a persistent handicraft tradition," wrote the architect Melvin Charney (b. 1935) in 1968.[38] He continued: "The result is an exaggerated tribal gesture, as if the designers were pretending that the building was cut out of concrete, the vertical striations being chisel marks; or that the shuttering for the concrete was made by themselves by cutting trees and sawing the lumber by hand." Charney's shrewd comment encapsulates the metaphoric but also ideological nature of the search around exposed concrete in the 1960s. For if the "natural" look—whether treated in terms of the mix, the color, the mold, or the surface—was indeed in fashion, it was also often at odds with the quasi-industrial character of some of the techniques employed.

The real impact of this seeming contradiction between means and ends is difficult to assess. But by the end of the decade, the excitement for originality was beginning to wane. In the July 1969 issue of *Progressive Architecture*, the author of "Discrete Concrete" began his article with the rhetorical question: "Tired of texture?" Reviewing a recent work, he recounted how the architect, "after considering the true nature of the liquid medium," rejected bushhammering, sandblasting, acid etching, and rough board forming, choosing instead the "usual process," that is, "to build a wooden building with rough planks, pour it in concrete, and then throw away the wooden building."[39] This call for a return to origins, even if only a myth, is telling of the state of affairs as architecture entered the 1970s. "Natural" concrete of various types certainly continued to be used extensively, but the intense period of exploration and invention was by then largely over.

Figure **19** Expo '67, Administration and News Pavilion, Montreal, 1967, view of Ted Bieler's high relief in concrete

Figure **20** Louis I. Kahn, Jonas Salk Institute, La Jolla, California, 1965, detail of concrete surfaces with raised joints

Notes

1 Peter Collins, *Concrete: The Vision of a New Architecture* (1959), 2nd ed. (Montreal: McGill-Queen's University Press, 2004), 77.

2 See Adrian Forty, "A Material Without a History," contained in this volume.

3 Emil von Mecenseffy, *Die Künstlerische Gestaltung der Eisenbetonbauten* (Berlin: Wilhelm Ernst & Sohn, 1911); Francis S. Onderdonk, Jr., *The Ferro-Concrete Style: Reinforced Concrete in Modern Architecture* (New York: Architectural Book Publishing Co., 1928); P. A. Michelis, *Esthétique de l'architecture du béton armé* (1955; translated into French from the Greek, Paris: Dunod, 1963).

4 Wilhelm Künzel, *Sichtbeton in Hoch und Ingenieurbau* (1962); also published in French as *Le béton apparent dans la construction* (Paris: Eyrolles éditeur, 1965).

5 Jan C. Rowan, "Introduction," *Progressive Architecture*, October 1960, 142.

6 See Ada Louise Huxtable, "Historical Survey," *Progressive Architecture*, October 1960, 144–49.

7 Burton H. Holmes, "Exposed Concrete Today," *Progressive Architecture*, October 1960, 151–57.

8 *Le Corbusier, Oeuvre complète 1946–1952*, vol. 5, ed. Willy Boesiger (Zurich: Girsberger, 1953), 190.

9 For a discussion on the "other" origin of *béton brut*, see Peter Collins, "The New Brutalism of the 1920s," in Collins, *Concrete*, 315–40.

10 Reyner Banham, *The New Brutalism: Ethic or Aesthetic?* (New York: Reinhold Publishing, 1966), 16.

11 See Sergio Ferro et al., *Le Corbusier, le couvent de la Tourette* (Marseille: Parenthèses, 1987).

12 Banham, *The New Brutalism*.

13 "Cast-In-Place Techniques Restudied," *Progressive Architecture*, October 1960, 158–75.

14 The production of exposed concrete often required the architect to take extreme measures, such as forbidding workers to smoke or eat on the building site, to make sure that no cans or cigarette butts inadvertently thrown into the concrete pour could ruin the surfaces left exposed to the eye.

15 "Precasting Makes New Strides," *Progressive Architecture*, October 1960, 176–91.

16 Carol Herselle Krinsky, *Gordon Bunshaft of Skidmore, Owings & Merrill* (Cambridge, Mass.: MIT Press, 1988), 129–30.

17 Sarah Williams Goldhagen, *Louis Kahn's Situated Modernism* (New Haven, Conn.: Yale University Press, 2001), 41.

18 Isabelle Hyman, *Marcel Breuer, Architect* (New York: Harry N. Abrams, 2002), 198.

19 "New and Old at Yale," *Architectural Record*, December 1962, 95.

20 Saarinen commented: "They are masonry walls without masons, masonry walls which are modern." Quoted in Aline B. Saarinen, *Eero Saarinen and His Work* (New Haven, Conn.: Yale University Press, 1962), 84.

21 Timothy Rohan has convincingly argued that the surface of the Yale building can be interpreted as a form of ornament that has been literally pressed (or repressed) into the concrete. Timothy M. Rohan, "Rendering the Surface: Paul Rudolph's Art and Architecture Building at Yale," *Grey Room* 1, no. 1 (2000): 85–107.

22 Vincent Scully, "Art and Architecture Building, Yale University," *Architectural Review* 135 (May 1964): 332.

23 Richard Pommer, "The Art and Architecture Building at Yale, Once Again," *The Burlington Magazine* CXIV, no. 837 (December 1972): 860.

24 According to contemporary assessments, bushhammering of concrete surfaces was an expensive technique. "Architectural Finishes: A Roundup of Ideas & Techniques," *Concrete Products*, March 1963, 33.

25 Marshall Burchard, "Yale's School of Art and Architecture, 3, The Builder," *Architectural Forum*, February 1964, 81.

26 Peter Blake, "Towers in the Sky," *Architectural Forum*, October 1967, 31–43.

27 Earlier in the century, Auguste Perret would add stone aggregates from the region where his buildings were built, changing the color of his concrete and giving it the status of a local material.

28 In the words of an early commentator, the exterior surfaces were to be treated "as a product of a sculptor's tool. "Museum of Art," *Progressive Architecture*, November 1962, 128.

29 "Place Bonaventure," *Architectural Design* 38, no. 1 (January 1968): 42.

30 Raymond T. Affleck, "Recent Canadian Experience in Wall Design," *Architecture Canada* 2 (1969): 51.

31 "Concrete: Where Do We Go from Here?" *Progressive Architecture*, October 1966, 215.

32 The variety in the use of concrete at Expo '67 was well noted by promoters of the material: "Concrete's greatest show on earth has just begun a spectacular six-month engagement at Canada's Expo '67 in Montreal." "Concrete at Expo 67," *Concrete Products* 70 (May 1967): 35.

33 "Concrete: Where Do We Go from Here?" 217.

34 Louis I. Kahn, "I Love Beginnings" (1972), in *Louis I. Kahn. Writings, Lectures, Interviews*, ed. Alessandra Latour (New York: Rizzoli, 1991), 288.

35 David B. Brownlee and David G. De Long, *Louis I. Kahn, In the Realm of Architecture* (New York: Rizzoli, 1991), 99.

36 William Huff, quoted in Kenneth Frampton, *Studies in Tectonic Culture* (Cambridge, Mass.: MIT Press, 1995), 241.

37 Louis I. Kahn, "I Love Beginnings," 288.

38 Melvin Charney, "Concrete: A Material, a System and an Environment," *Architecture Canada* 45, no. 6 (June 1968): 58.

39 A. R., "Discrete Concrete," *Progressive Architecture*, July 1969, 101.

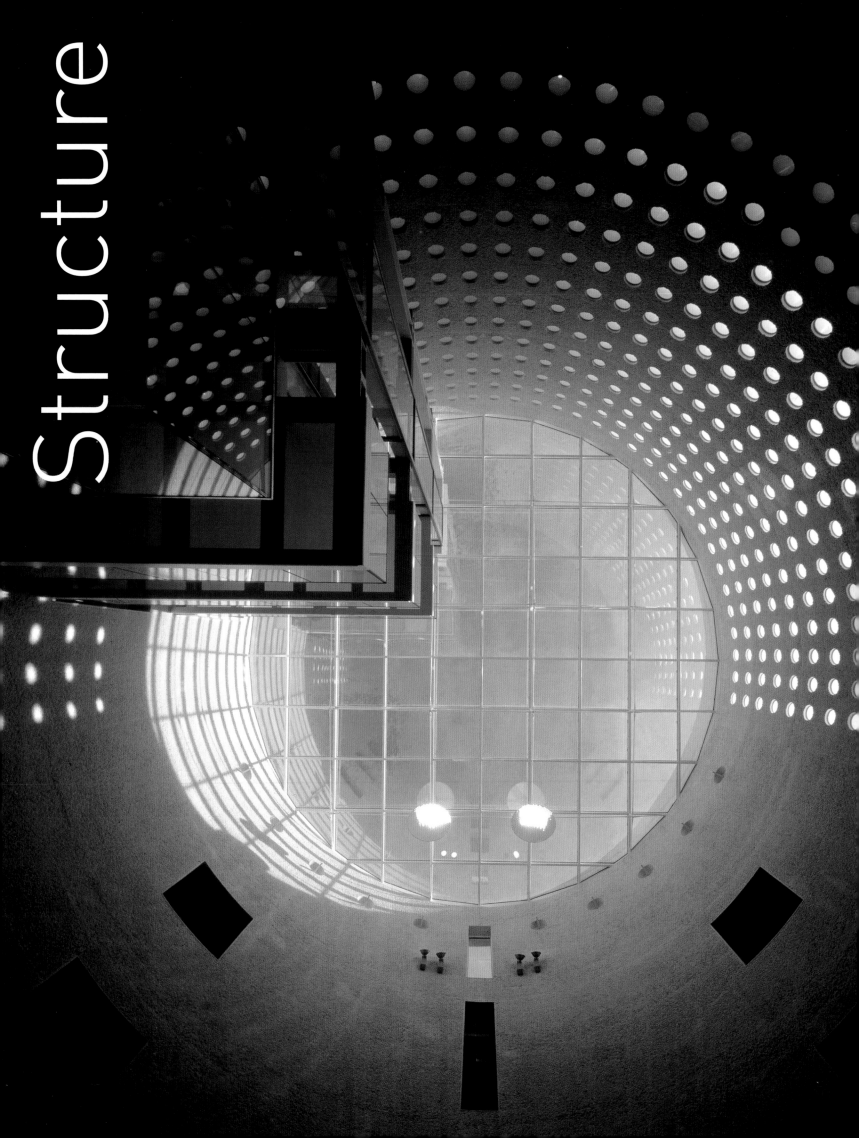

Structure

[Robert Maillart] respected the function of every element of the structure, through the monolithic forming of the material.

—Max Bill

Concrete structures are either cast in place or prefabricated off site, for assembly in place. The concrete work of Robert Maillart (1872–1940) and Le Corbusier (1887–1965), two quite different designers, was always cast in place. The concrete work of Pier Luigi Nervi (1891–1979) was always precast, sometimes off and sometimes on site, and assembled. Cast-in-place concrete is a plastic art; the assemblage of prefabricated concrete is, like steel and timber work, an art of framing and joint-making.

Across this difference of plastic gesture and assemblage there is the opposition of empirical and formalist practices. Maillart closely monitored the cracks in his bridges to learn from his structures and adapt his craft. For Le Corbusier concrete was the material of an art of sculpture and the massive ground for the play of light and color.

Louis I. Kahn (1901–1974) designed both with precast and cast-in-place concrete. The Richards Medical Research Laboratories at the University of Pennsylvania in Philadelphia (1961) and parts of the Jonas Salk Institute in La Jolla, California (1965) are precast. The Yale University Art Gallery in New Haven, Connecticut (1954) and Kimbell Art Museum in Fort Worth, Texas (1972) are cast in place. The difference is that the precast projects seem—like timber architecture—transient, and the cast-in-place structures seem monumental. This is ironic since the jointing of precast concrete structures, by separating and freeing the elements, often improves the durability of structures, whereas the monolithic nature of cast-in-place structures makes them susceptible to unforeseen crack patterns and decay.

Concrete is always, after all, a composite material. It is *reinforced* concrete. The placement of steel—size, length, location, detailing—is critical. Thanks to the great engineer and amateur philosopher Hardy Cross (1885–1959), the techniques of "moment distribution," or "relaxation," allowed engineers to calculate on which side (top or bottom of a beam; near, left, far, or right side of a column) an element saw tension and so, place the steel where it was needed. Contemporary computer-based analysis methods speed this analysis, but the issue remains the correct placement of steel. The proof is in the cracking.

The plasticity of concrete makes for monolithic structures. They are, to use Cross's term, "continuous" structures. All the elements are joined in one whole, the likely behavior of which can only approximately be known. As Maillart is quoted as saying in Max Bill's *Robert Maillart* of 1955, "the calculation results can either undergo direct application or on the other hand modification, and the latter will be the case when not a calculator, but a constructor is at work."

Freedom and indeterminacy are antecedent to and larger than order.

—Donald Judd

It makes a difference whether a structure is a monolithic totality or an assemblage of parts separated at joints. It also makes a difference whether the work expresses the will of one artist or somehow the joint idea of several collaborators; there is no analog, however. The monolithic Penguin Pool ramp structure at the London Zoo (1935) was the work of the architect Berthold Lubetkin (1901–1990) and the engineers Ove Arup (1895–1988) and Felix Samuely (1902–1959), though how their ideas came together is not known.

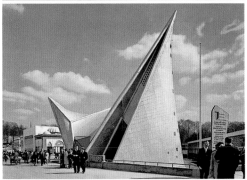

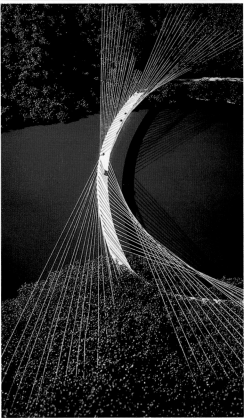

Figure **1** Berthold Lubetkin, Ove Arup, and Felix Samuely, Penguin Pool, London Zoo, 1935

Figure **2** Le Corbusier and Iannis Xenakis, Philips Pavilion, Brussels, Belgium, 1959

Figure **3** T. Y. Lin and Myron Goldsmith, Ruck-A-Chucky Bridge project, Auburn, California, 1977

[Figure **1**] Thanks to landscape historian Marc Treib's research, Le Corbusier's Philips Pavilion in Brussels, Belgium (1959) is well understood as the assembled (precast) structure conceived (mostly) by Iannis Xenakis (1922–2001) and the Dutch contractor Strabel and its engineer/director Hoyte C. Duyster (b. 1937), who created an exuberant *poeme electronique*—multi-media and multi-authored. [Figure **2**] The impossibly thin and numerous hyperbolic paraboloid shells of Félix Candela (1910–1997) are, on the other hand, the sole invention (form, calculation, construction—the works) of Candela, made possible by the freedom of operation he found for a limited, golden decade (1950 to 1961) in Mexico. Similarly, the extraordinary work of the Swiss engineer Heinz Isler (b. 1926), a lyrical successor to Candela, found realization (only) in Switzerland.

As proponents of the New Criticism—or rather, practical criticism—might see it, the work stripped bare of authorship may be composite or singular—assembled or monolithic. This does not follow from whether it is precast or cast in place, or singly or collectively authored. Either it is good, or not, and that's all.

Aesthetic of the Engineer, Architecture. —Le Corbusier

The "miracle" of concrete is now old. That isn't to say that its monuments—the works of Le Corbusier, Nervi, Kahn, Candela, and Isler, and of Eduardo Torroja (1899–1961) and Christian Menn (b. 1927) as well—no longer thrill. In fact, like the work of great old actors, theirs is stronger for its unexpected presence. It remains new.

Today, the best works of concrete are the bridges: the Sunniberg Bridge near Klosters, Switzerland (1999), by Menn; the Oresund Bridge connecting Sweden and Denmark (2000), by Jorgen Nissen (b. 1935); the Millau Viaduct in Millau, France (2005), by Michel Virlogeaux (b. 1946) and Norman Foster (b. 1935); and the great Ruck-A-Chucky Bridge design proposal for the American River in Auburn, California (1977), by T. Y. Lin (2003) and Myron Goldsmith (1918–1996). [Figure **3**] These are, for the most part, segmentally precast concrete decks suspended on cable stays from slip-formed concrete towers—part precast, part cast-in-place.

In buildings, the most interesting work is arguably performative. The Menil Collection in Houston, Texas (1986), by Peter Rice (1935–1992) and Renzo Piano (b. 1937), inaugurated a practice of experimentation in precast concrete (or ferrocement, in this case) that led to a remarkable series of refined precast concrete projects by John Thornton, in conjunction with Michael Hopkins (b. 1935) and Patty Hopkins (b. 1942), from their Inland Revenue buildings in Nottingham, England (1995) to their recent Parliament Portcullis House office building in London (2001). In the spirit of Rice's motto "*la trace de la main,*" these projects fashion precast slab panels, formed with industrial precision, into structure, light reflector, and thermal sink. Their refinement is a humanist retort to the contemporary scenography of neo-conservative historicism.

In the works of these practitioners, and in the best work of contemporary engineers and architects, concrete is made performative. This theatricality sometimes manifests itself in baroque expressions: concrete forced into fluid expression, seldom recognizing the actual force flow. Most often, though, the limits of contemporary cast-in-place craftsmanship lead to prefabrication, which in turn sometimes becomes theatrical in its execution and leaves a trace of its production in joints and texture. This turn within the concrete theater opens to a more democratic space of expression, which is welcome.

White Temple

The White Temple is a three-dimensional expression of fundamental Zen principles: supremely simple and free of distracting patterns or ornament, it is an abstract oasis of calm and contemplation. Standing in stark contrast to the other, far more traditional buildings in the Zuisen-Ji Buddhist temple complex, the new structure seems to hover just above a sea of black gravel as if it were somehow immune to the laws of the physical world.

Built of poured-in-place concrete, the structure is essentially monolithic—a simple, rectangular form the unity and purity of which reflect the reductivism that is characteristic of Japanese aesthetic culture. Conceptually, the temple could not have been built of any other common material, inasmuch as wood, steel, or masonry construction would have yielded a building composed of countless discrete pieces. The exterior is finished in white stucco to enhance the structure's apparent uniformity.

The interior of the temple is a sacred space for honoring maternal ancestors and therefore was consciously designed as a "womb-like" chamber. The minimalist structural envelope creates a sense of comforting enclosure and allows natural light—which enters subtly through hidden skylights placed at the edges of the ceiling and an etched glass window located behind the stepped altar—to become the dominant architectural feature. A statue of Buddha, the only figural element in the building, presides over the space from a platform at the top of the altar.

Near Kyoto, Japan
Completed 2000
Architect: **Takashi Yamaguchi & Associates**
Structural Engineers: **Taiki Maehara; SD room**
Contractor: **Kyoritsu Komuten**

1
2

3

1 Exterior view of entrance
2 Entrance at dusk, with interior visible
3 Site plan of temple complex, with White Temple indicated in gray
4 Exterior view with older temple at left
5 Roof plan
6 Ground-floor plan

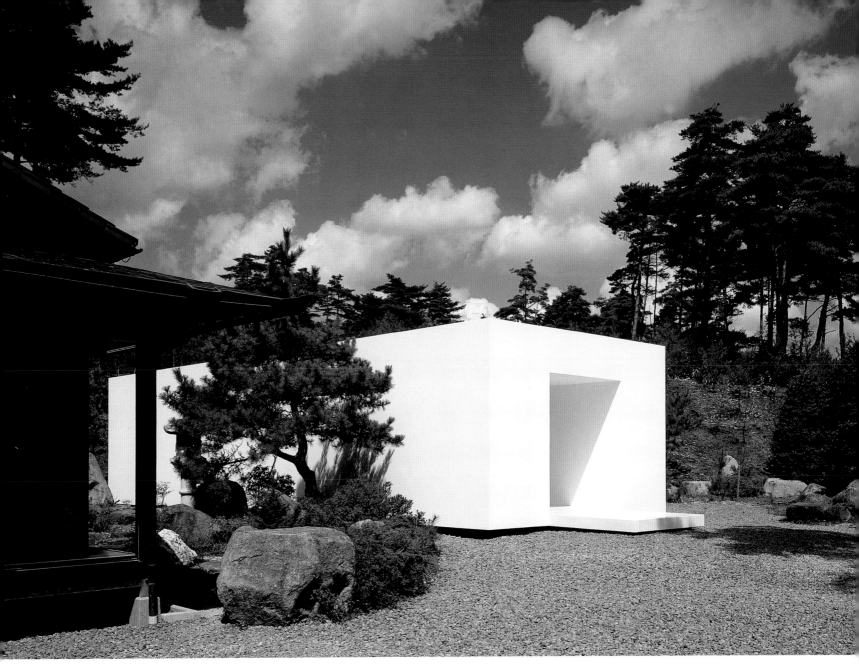

4

5

6

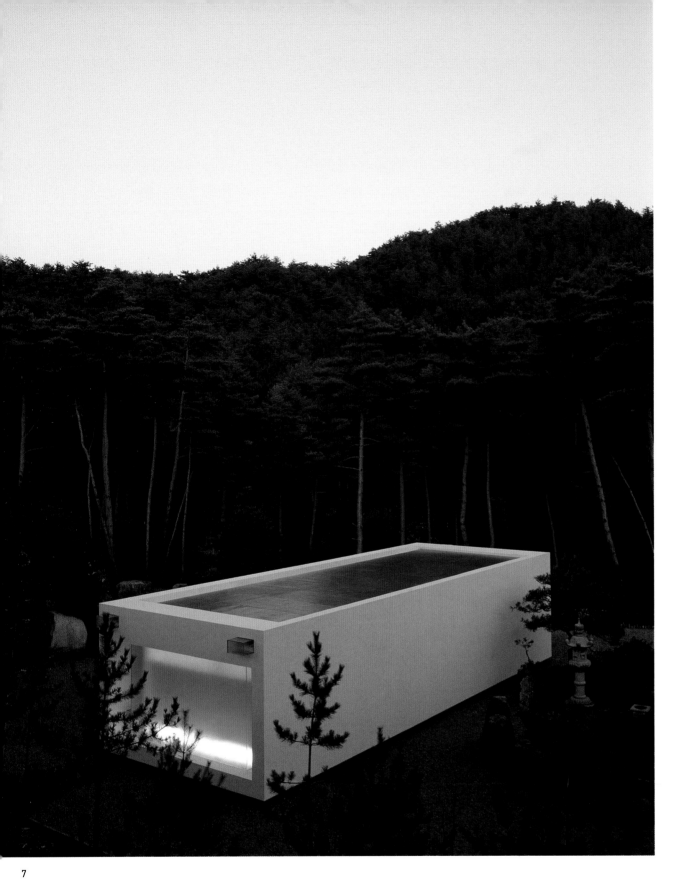

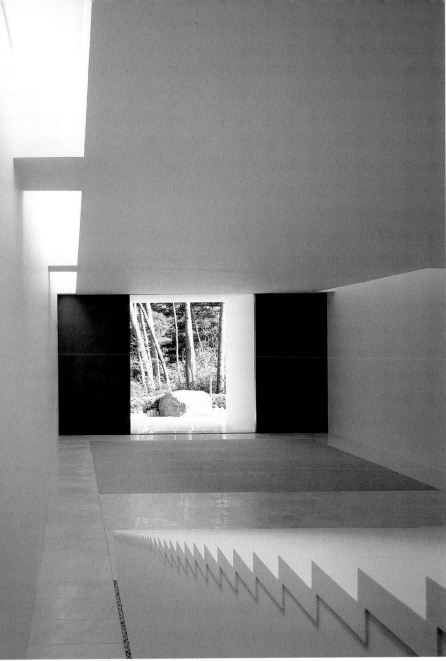

8

9
10

11

12



Rohner Office Building

The bold gesture of a 26-foot- (8-meter-) long cantilever belies the small size of this administrative building and control center for a privately owned marina on Lake Constance, in Austria. Drawing inspiration from the image of an aquatic bird standing effortlessly on one leg, the architects dramatically raised the main structure off the ground—a decision that was both aesthetic and pragmatic, since the site is prone to minor flooding. The building rests on a single pier containing the entrance, a lavatory for boaters, and a staircase leading to offices above. From certain angles, the building appears to be suspended in mid-air above the waterfront.

Structurally, the cast-in-place cantilevered tube behaves, in effect, as a single beam, allowing the concrete planes that constitute the tube to remain quite thin in cross-section. Steel reinforcement in the sides of the tube absorbs the primary tensile stress created by the cantilevers. Horizontal slit windows emphasize the structure's linearity, as do the parallel planks of larch wood on the interior, which line not only the floor but also the walls and even the ceiling. The exterior of the concrete structure is left unfinished, lending both pattern and texture to the building's surface.

Fussach, Austria
Completed 2000
Architect: **Baumschlager-Eberle Ziviltechniker**
Architects of Record: **Rainer Huchler**
Engineers: **D. I. Ernst Mader**
Contractor: **Oberhauser & Schedler Bau GmbH & Co.**

1

2

1 East elevation
2 Interior view from balcony
3 West elevation, showing subtle grid pattern left after removal of formwork

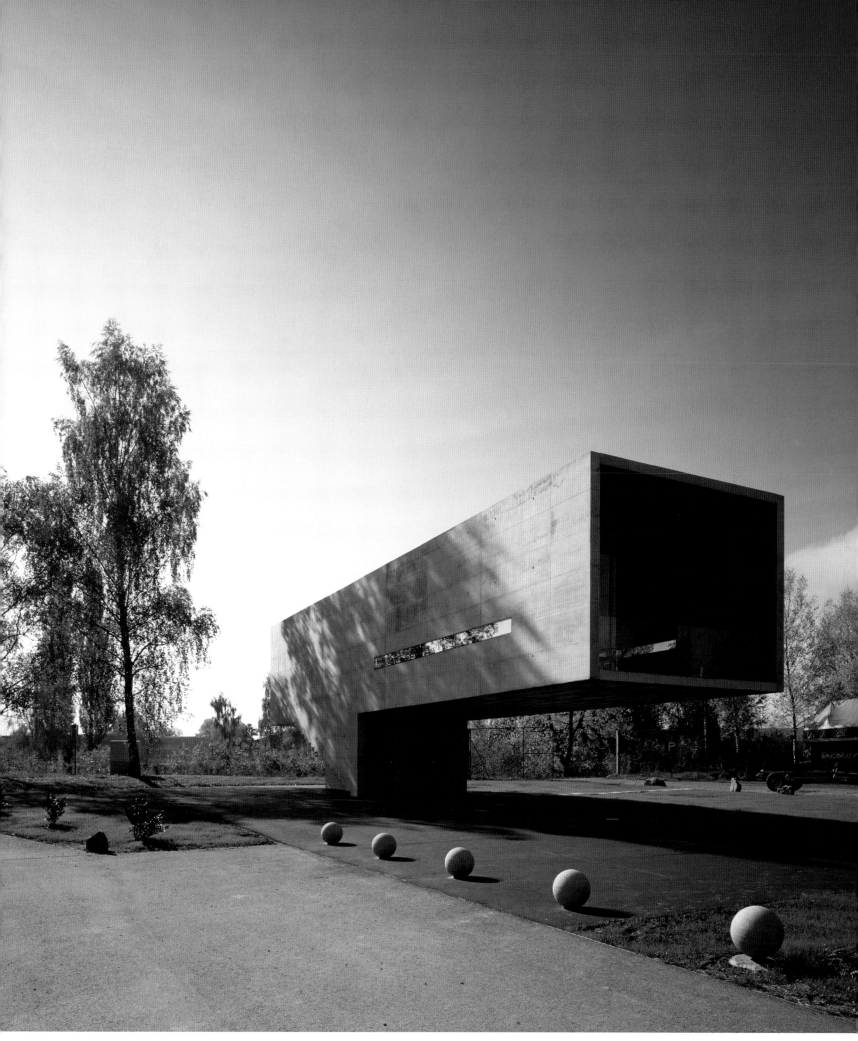

3

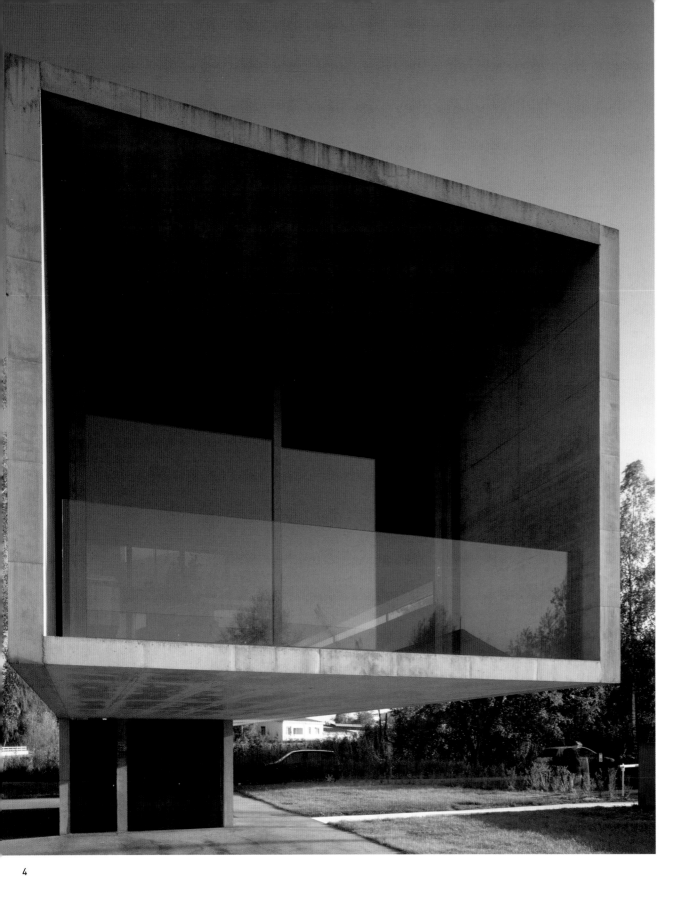

Structure

4 Balcony at south end of cantilevered tube
5 Transverse sections
6 Staircase form, expressed on the exterior
7 Interior detail, showing grain of wooden formwork
8 View of wood-lined interior, looking toward balcony
9 Longitudinal sections
10 Upper-level and ground-floor plans

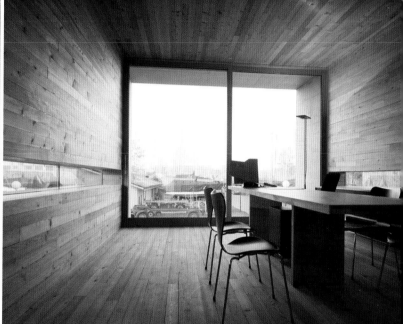

6

7

8

9

10

Longitudinal House

Conceived as a conjoined pair of vacation houses for fraternal twin brothers, one just starting a family and the other single at the time of the commission, this project is organized around a folded ribbon of concrete that alternately serves as floor, wall, and ceiling. The insistent linearity of the roughly 10,000-square-foot (929-square-meter) structure derives from the narrow site, with dense woods on one side and a 100-foot- (30-meter-) high bluff overlooking Lake Michigan on the other: the design, featuring expansive windows on the longitudinal elevations of the houses, is intended to encourage occupants to enjoy views of these natural features. Private areas for each of the brothers are located at opposite ends of the thin bar, with a pool, guestrooms, and other shared elements in the middle.

The concrete band is engineered as a straightforward structure of cast-in-place, reinforced concrete, supported by slender steel columns, the caps of which will be carefully concealed in the ribbon. The concrete will be left exposed in some areas, while in others it will serve as an armature for a variety of potentially changeable finish materials.

After this design was completed, one brother who commissioned the house bought out the other's interest in the project. He is currently planning to proceed with a smaller version of the structure.

Southwestern Michigan, United States
Proposed 2001
Architect: **VJAA**

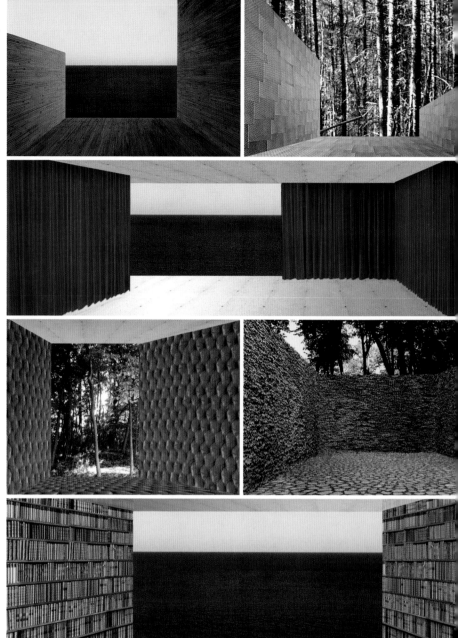

1

1 Renderings of interior and exterior spaces, showing various materials applied to concrete planes
2 Diagram showing modules inserted into concrete structure
3 Diagram showing fundamental structural components
4 Third-, second-, and first-floor plans

2

3

4

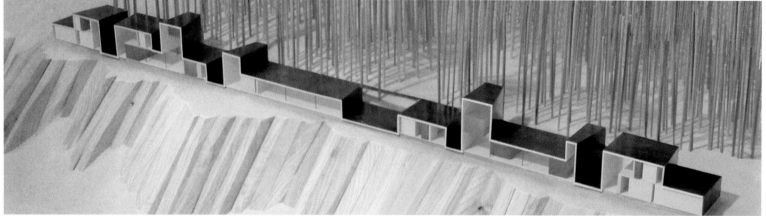

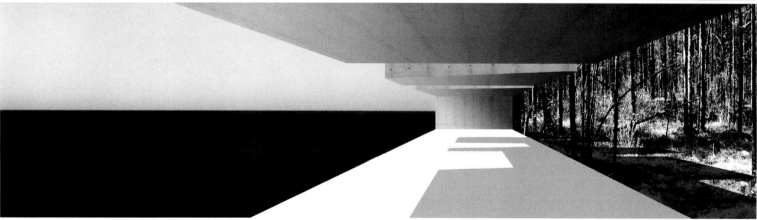

8

10

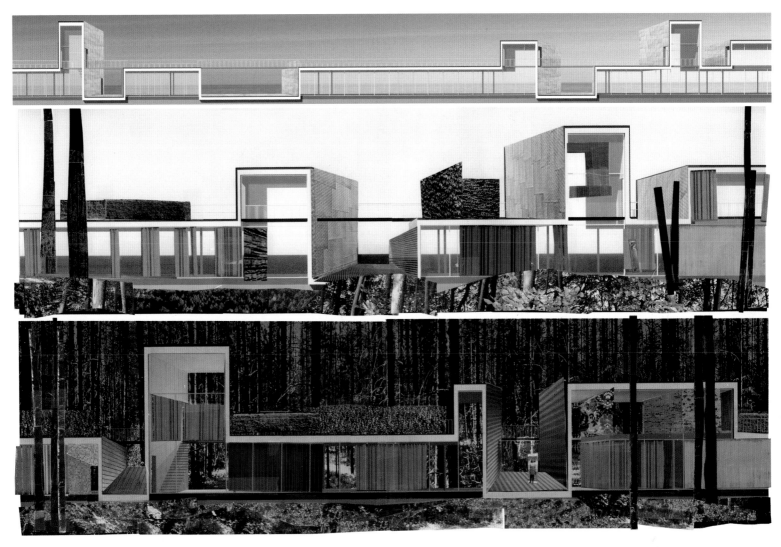

11

12

13

Longtitdunal House(s)

Yerba Buena Lofts

Though located in one of the most expensive cities for construction in the United States, the Yerba Buena Lofts project was built on a surprisingly modest budget. Ironically, cost savings were achieved in part through a reliance on relatively expensive, high-quality concrete for the building's structure—the poured-in-place concrete frame was designed to be left exposed, thus reducing the need for a number of distinct building trades, such as carpenters and painters, normally required to finish a building. The use of repetitive concrete formwork also reduced construction time and, therefore, costs. Moreover, by designing apartments with substantial double-height areas, architect Stanley Saitowitz was able to provide a sense of "generosity" of space without excessive per-unit square footage.

In lieu of the more typical grid of columns, the project is supported by an array of bearing walls, dubbed "wallumns" by the architect. The floor slabs are post-tensioned, allowing them to have a thin cross-section to match that of the walls. On the primary facades, this structural system results in an egg crate–like pattern, with each apartment unit expressed as its own chamber in the grid. Thanks to an apparently random pattern of setbacks, the facades abstractly recall the rows of bay-fronted Victorian houses for which San Francisco is famous.

The building also incorporates a 200-car garage that is entirely above grade. It forms the central spine of the first four levels and is bracketed by apartments on both sides, so that many owners can park their cars in spots that are almost immediately adjacent to their units—a rare perk in an urban apartment building

San Francisco, California, United States
Completed 2002
Architect: **Stanley Saitowitz/Natoma Architects Inc.**
Structural Engineers: **Watrey Design Group**
Contractor: **Pankow Residential Builders**
Developer: **Ed Tansev**

1

2

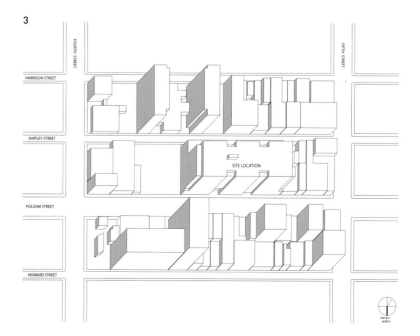

3

1 Entrance and lobby
2 Typical sleeping loft
3 Axonometric of building in context
4 Primary building facade

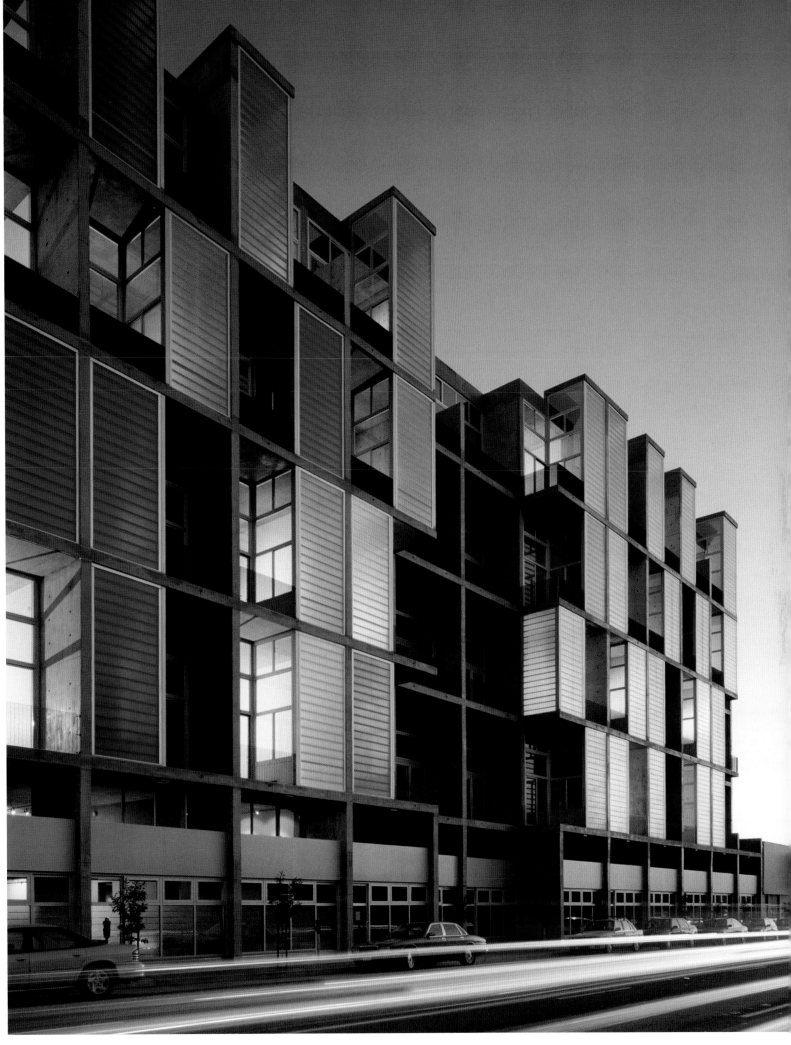

4

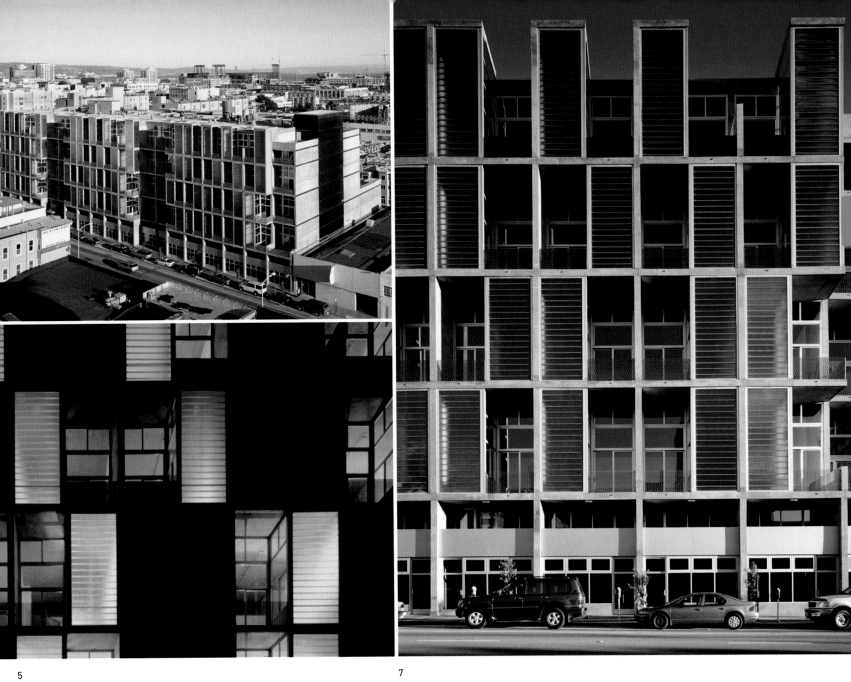

5

7

6

8

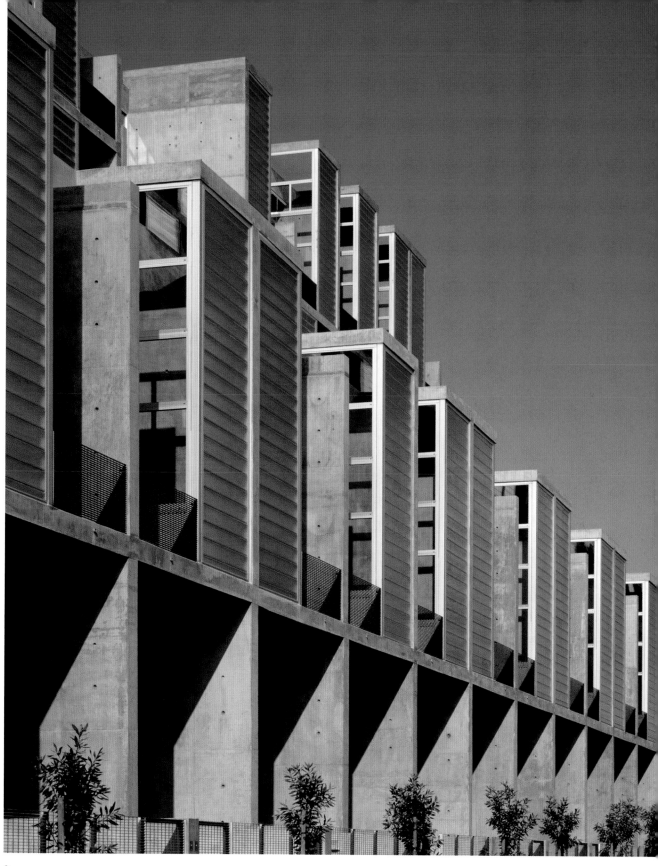

9

Yerba Buena Lofts

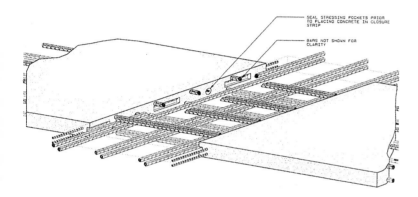

11

10 Plan details, isonometric view of floor slab reinforcement, and wall elevations

11 Second-floor plan, showing parking spaces adjacent to apartments

12 Interior view of typical apartment, showing window detailing

13 View of interior with exposed concrete wall

14 Building section

Structure

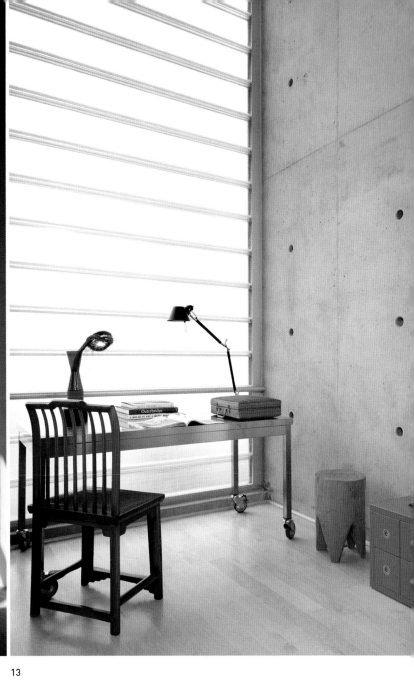

12

13

14

Simmons Hall, MIT

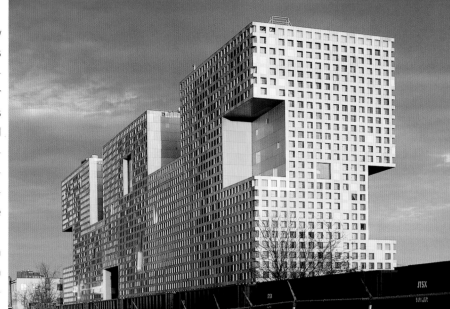

Commissioned to design a large dormitory on a narrow site at the edge of MIT's campus, Steven Holl Architects sought to diminish the building's potentially overwhelming scale by making it visually "porous." Another goal was to keep the interior as flexible and open as possible, in order to avoid the stultifying double-loaded corridors typical of such buildings and to allow for indoor plaza-like spaces that would foster social interaction among residents. A sponge—permeable and containing myriad, free-form internal chambers—became the conceptual metaphor for the building.

Engineer Guy Nordenson responded to these twin challenges by devising a gridded structural system informally known as "PerfCon," an acronym for "perforated concrete." The system comprises precast concrete units, weighing an average of about 10,000 pounds each, which were assembled to form a kind of exoskeleton—in effect, a giant Vierendeel truss—to carry the building's primary structural forces. The steel reinforcing bars in the separate precast units were grouted together on site so that they would behave as continuous elements.

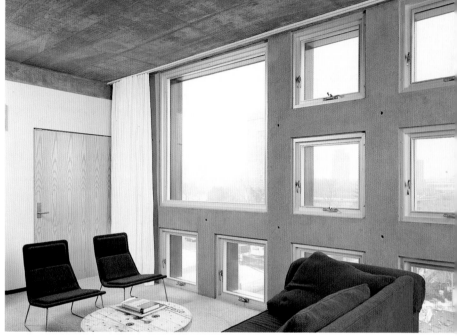

The exterior of the concrete grid is sheathed in aluminum cladding. The apparently fanciful, decorative pattern of bright colors on some of the window surrounds is actually a meaningful graphic device. The colors reflect the relative structural stresses being carried by adjacent columns and beams—the warmer the color, the greater the stress. Thus, the building can be read as a kind of engineering diagram superimposed on the structure itself.

The geometrical regularity of the facade is relieved by occasional curvilinear openings, which hint at more elaborately sculptural elements inside. The main lobby, for instance, contains a sinuous staircase of board-formed concrete. The most astonishing interior spaces, however, are the amorphous, multi-story "plazas," which quickly became favored gathering places for residents and visitors alike.

Cambridge, Massachusetts, United States
Completed 2003
Architect: **Steven Holl Architects**
Associated Architects: **Perry Dean Rogers/Partners**
Structural Engineers: **Guy Nordenson and Associates**
Engineers of Record: **Simpson Gumpertz & Heger Inc.**
Contractor: **Daniel O'Connell's Sons**

1 Building exterior, inspired by a sponge
2 Typical interior, with operable windows
3 Partial plans of common spaces
4 One of the surprisingly sculptural interior common spaces

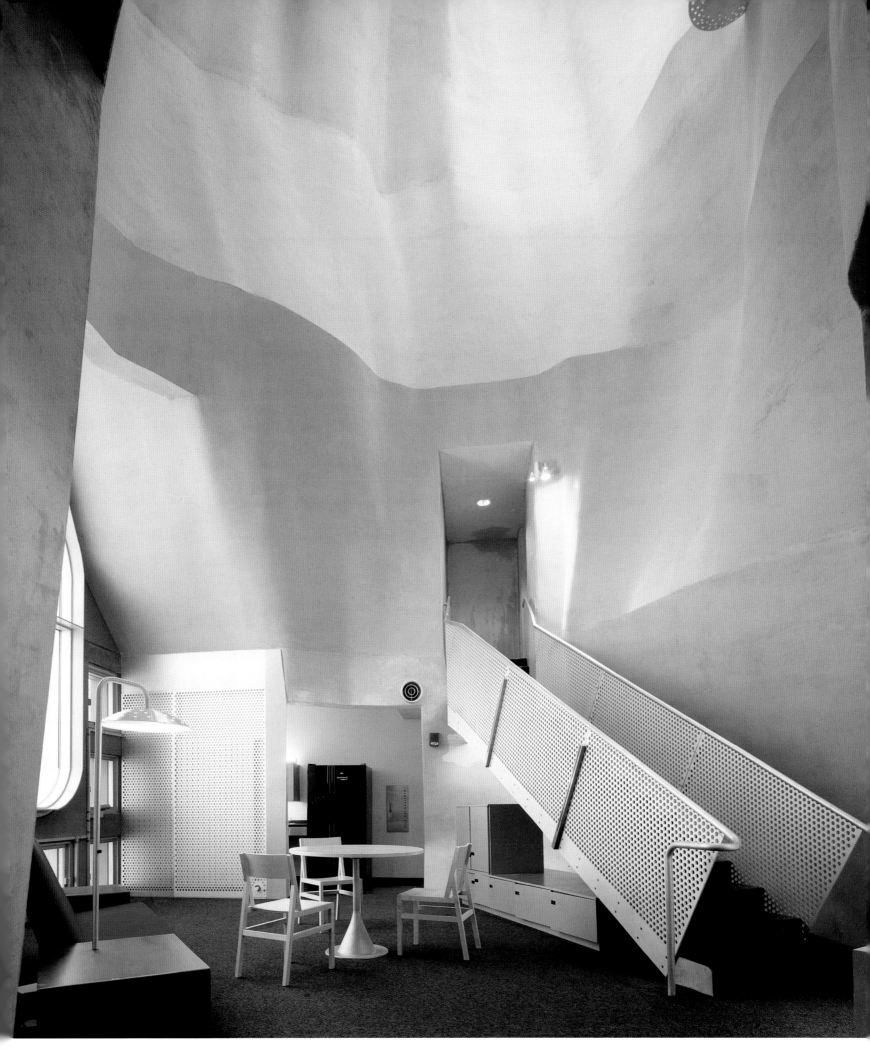

A PerfCon unit is lifted out of its form at a fabrication facility.

A worker finishes a prefabricated PerfCon unit.

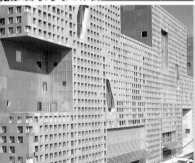
A PerfCon unit is lifted into place by a crane at the building site.

The PerfCon system serves simultaneously as structure and facade.

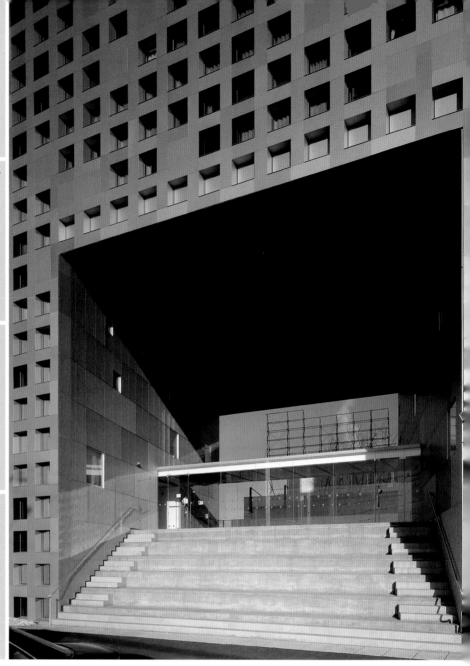

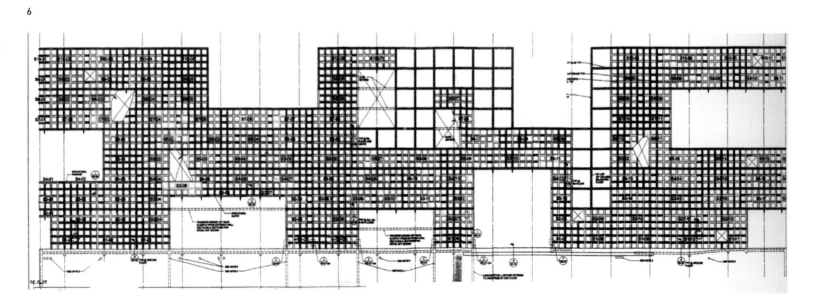

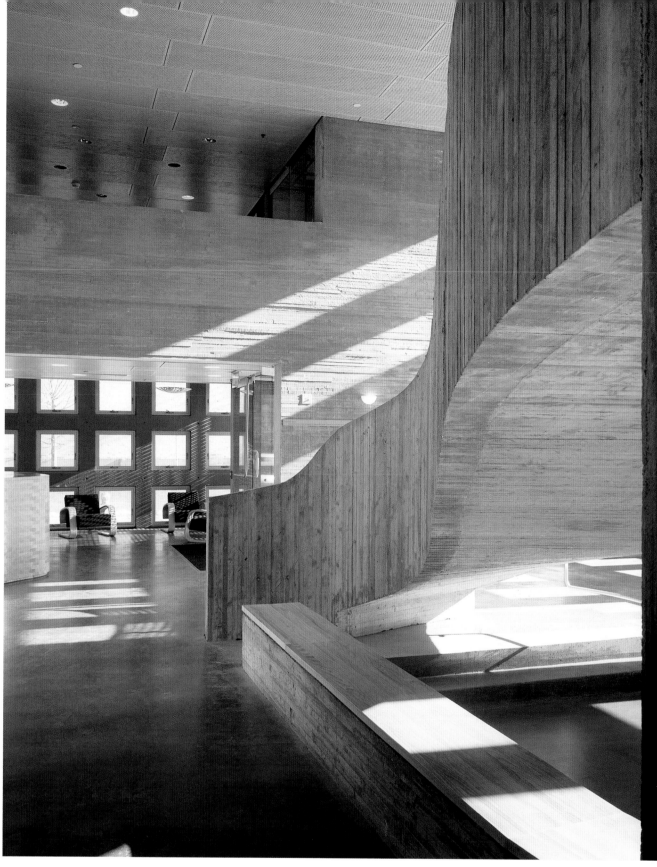

7

5 Main entrance to building

6 Diagram of the PerfCon structure, illustrating relative
 stresses in structural members

7 Lobby, with poured-in-place concrete staircase

Torre Agbar

The shape of this 466-foot- (142-meter-) tall office tower for Barcelona's water company recalls the attenuated spires of the nearby Temple de la Sagrada Família, by Antoni Gaudí, as well as the characteristic rocky knobs of Spain's Montserrat Mountains. The building consists of two concrete cylinders, each slightly oblong in plan, with one placed eccentrically inside the other. The inner cylinder contains typical core elements, such as emergency stairs and elevators (though the main bank of elevators is at the perimeter), while the outer cylinder provides the primary structural support. Spanning between them are floors constructed of simple metal decking and reinforced concrete.

The outer tube is perforated with hundreds of rectangles, creating an irregular composition reminiscent of a pixelated computer image. This surface is then covered with a layered skin of metal and glass louvers, providing a high degree of solar and thermal control within the office spaces. Viewed from a distance, the curtain wall reflects light in a scattered fashion much as water does and thus visually dematerializes the building, which might otherwise overwhelm its low-rise context. Augmenting the illusion is a gradation in the color of the glazing from warm red and orange at the bottom to cool blue at the top.

Inside, each space derives its own unique character through the complex patterns and layers of the facade, which frames often spectacular views in unexpected ways. The exterior concrete cylinder stops about four-fifths of the way up the building, yielding to a more typical glass curtain wall; the uppermost floors are set back from this wall, creating an atrium-like space that rises to the tip of the glazed dome.

Barcelona, Spain
Completed 2005
Architect: **Ateliers Jean Nouvel**
Associated Architects: **b720 Arquitectura**
Structural Engineers: **Brufau/Obiol SA**
Developer: **Layetana**

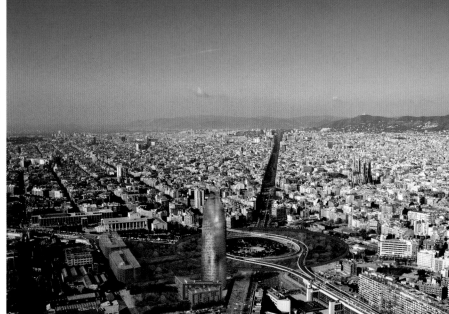

1

2

3

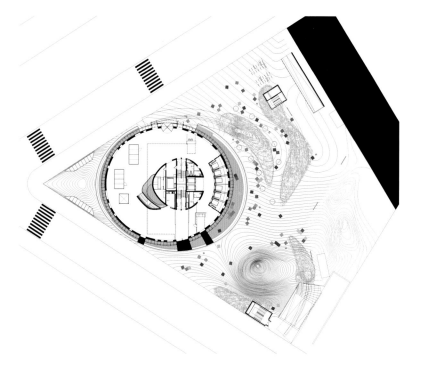

1 Photomontage, showing tower in context
2 Rendering of interior near tower apex
3 Site and ground-floor plan
4 Rendering of tower

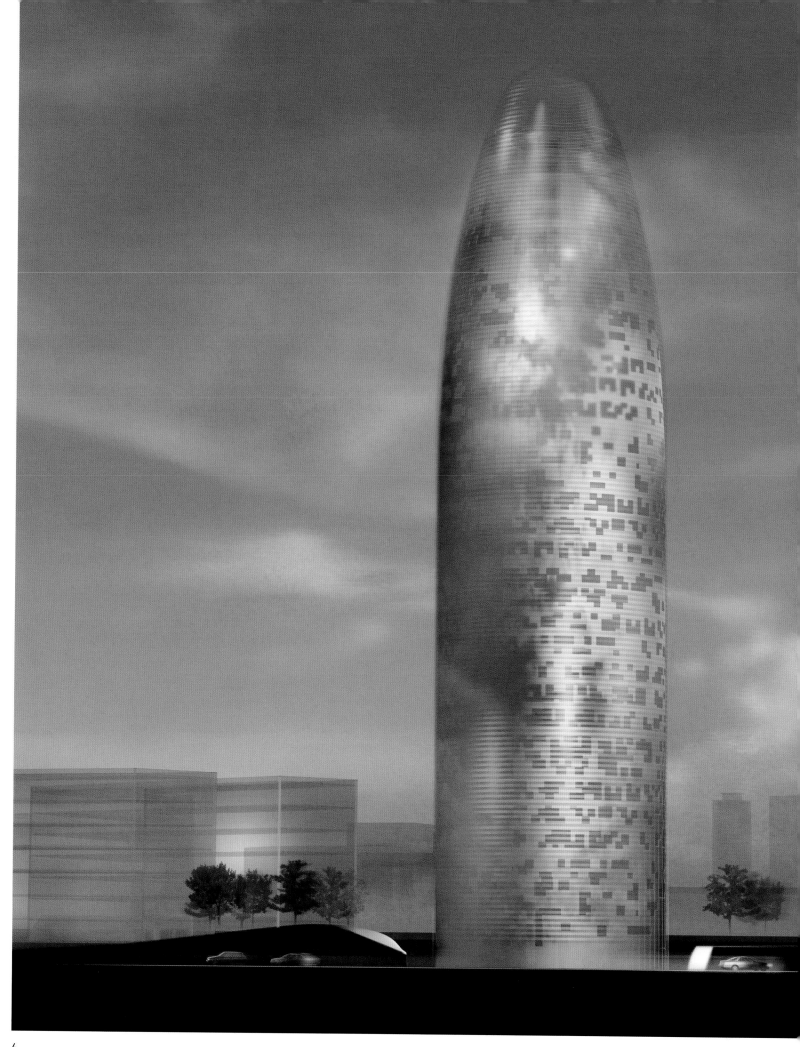

4

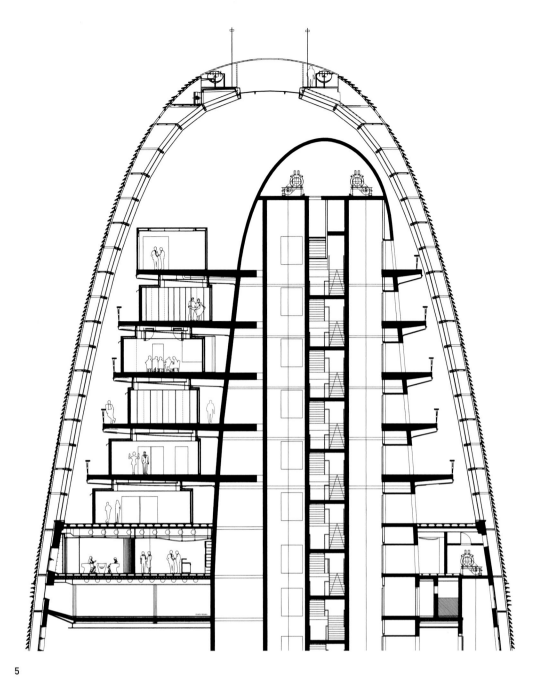

5

6

7

8

9

10

11

12

21/Marzo.
INTENSIDAD DE RADIACIÓN INCIDENTE

12:00h

21/Junio.
INTENSIDAD DE RADIACIÓN INCIDENTE

12:00h

PORCENTAGE
DENSIDAD SERIGRAFÍA

10%

20%

Serigrafía Lamas Cúpula

Torre Agbar

National Theater Okinawa

This facility was designed to promote the traditional performing arts of Okinawa, including komi-odori, a 300-year-old form of musical theater. Okinawa has always been a trading crossroads, and its arts and architecture draw from many Asian sources. Because the island is prone to typhoons, it also has a long history of concrete construction. Architect Shin Takamatsu responded to these cultural and pragmatic traditions by designing a building that evokes the gently curving forms of vernacular Asian architecture made of wood or bamboo, while also taking advantage of up-to-date concrete construction methods.

The screen wall that surrounds the theater building is composed of a series of concrete units that were both precast and post-tensioned at the construction site. They were then lifted into place by crane and joined to the other units. The resulting facade appears quite delicate: when lit from within at night, its Gothic-like pointed arches and diamond-shaped openings suggest a forest of trees with sunlight shining through the leaves.

The interior of the building includes a dramatic, cantilevered concrete staircase. The theater itself is sheathed in warm, natural wood, both for acoustical reasons and as an aesthetic foil to the concrete exterior.

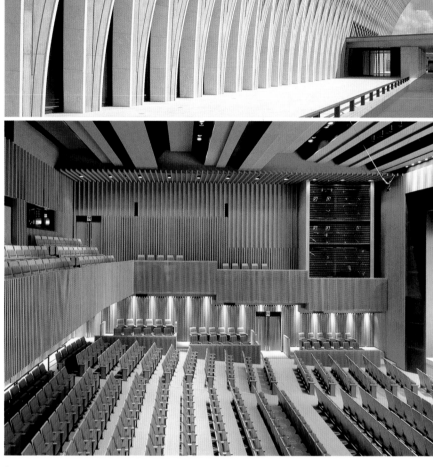

Urasoe, Okinawa Prefecture, Japan
Completed 2003
Architect: **Takamatsu Architect & Associates Co., Ltd.**
Structural Engineers: **Arup Japan**
General Contractors: **Taisei Corporation, Toda Construction, and Nakumoto**

1
2

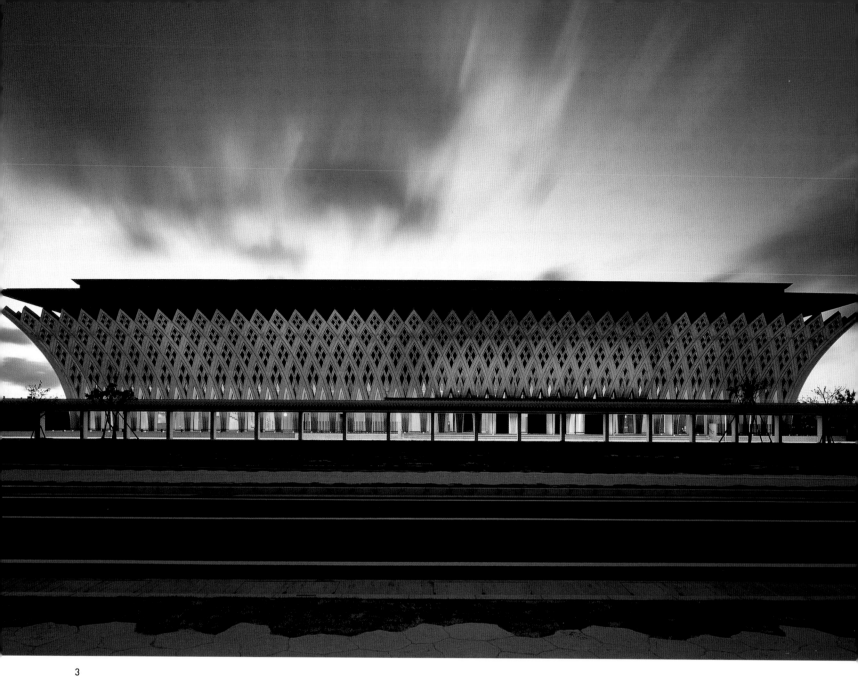

3

1 Exterior, with post-tensioned concrete screen wall

2 Interior of theater

3 Primary facade at dusk

Precast concrete modules for the screen wall are stored on a steel armature at the construction site.

A worker uses a post-tensioning machine to stress cables in a precast module. The spaces around the tensioned cables are subsequently filled with grout to bond the stressed steel cables to the concrete.

A post-tensioned module is maneuvered into place by a crane.

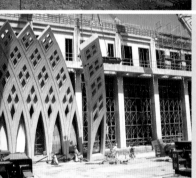

A module is lifted into place. Once in position, its steel reinforcement is tied to that of the adjacent module to ensure structural continuity.

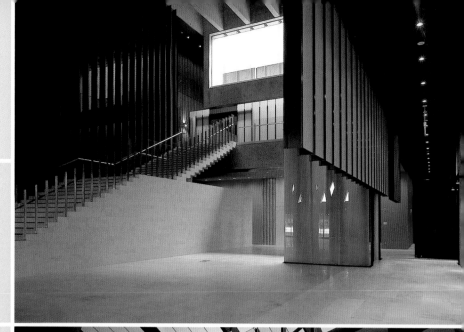

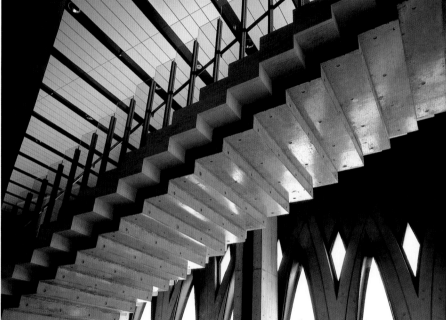

4

5

4 Lobby
5 Concrete staircase in lobby
6 Detailed view of concrete screen wall

6

Mexican Embassy

The typical architecture of Berlin is stolid and formal, with largely opaque facades and discrete, punched windows. The architects of the new Mexican Embassy in Berlin were eager to break from that tradition, while still creating a dignified building befitting its ceremonial function. In this spirit, they conceived the primary facade of the embassy as an abstract, dynamic reinterpretation of a classical colonnade, with a row of precast concrete piers canted at varying angles. Framed by a rectilinear portal reminiscent of a proscenium arch, the tilted pillars suggest a billowing curtain guiding visitors to the building entrance. Because the columns are so closely spaced, the facade seems opaque when viewed from an angle, but it becomes transparent as the viewer moves directly in front of the building.

The exceptionally white concrete used throughout the building results from a formula including white cement, marble chips, and pulverized marble. Emulating a traditional Mexican technique for finishing concrete, the entire surface was chiseled by hand to expose the marble aggregate.

The interior of the embassy is organized around an atrium that, though enclosed, recalls the traditional open courtyards of Mexico. In keeping with contemporary local building codes, the building also has a generously planted roof garden, available for both informal and official gatherings.

Berlin, Germany
Completed 2001
Architect: **Teodoro González de León/Francisco Serrano**
Engineers: **Assmann Beraten & Planen**
Consultants: **Groth Gruppe**
Contractor: **Hochtief**

1

2

3

1 View of primary and secondary facades
2 Interior courtyard
3 Sketch by the architect, showing the primary facade in context
4 Interior courtyard

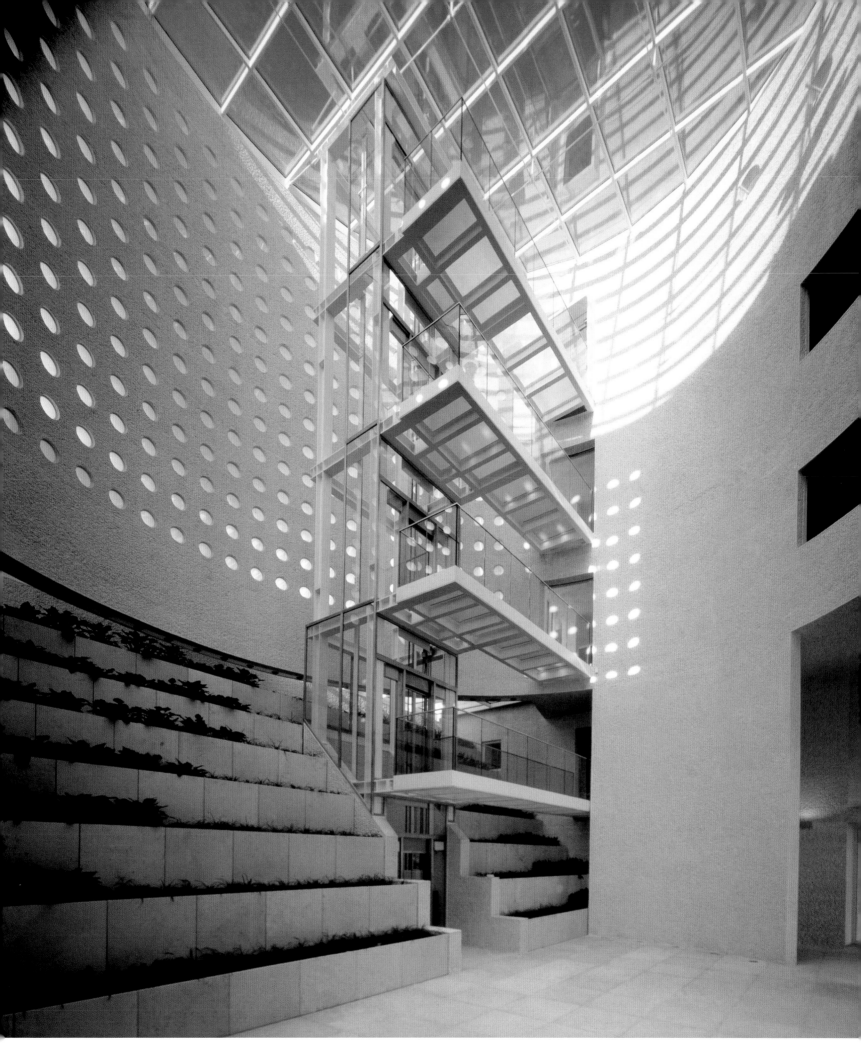

5 Rear view, showing hand-chiseled concrete finish
6 Primary facade, with entrance at left
7 Lobby
8 Primary facade at night
9 Sectional sketch by the architect, showing screen wall
 at right

6

7

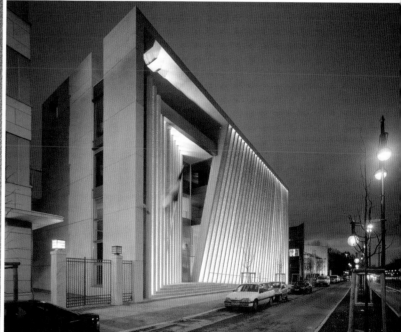

8

9

Millau Viaduct

Infrastructure projects are typically the exclusive province of engineers, but in the case of the Millau Viaduct, a 1.5-mile- (2.5-kilometer-) long highway bridge in southern France, the British architectural firm Foster and Partners worked with engineers Chapelet-Defol-Mousseigne and Ove Arup and Partners to create a structure that has minimal visual impact on its dramatic natural setting but is also beautiful in its own right. Though the project was initially very controversial (many local residents and civic leaders favored a winding, grade-level roadway rather than a single, tall bridge spanning the valley), the structure opened in 2005 to broad acclaim.

A critical link in the highway from Paris to Barcelona, the cable-stayed bridge is supported by extremely slender piers made of heavily reinforced concrete, each of which elegantly splits into two smaller piers—the better to accommodate the expansion and contraction of the steel roadway deck. Measured from ground level to the top of the mast above the roadway, the largest of the towers is more than 1,100 feet (about 340 meters) tall—higher, as the architects like to point out, than the Eiffel Tower. The spans between the piers are approximately the same dimension.

The concrete piers were constructed using climbing platforms, the shape of which could be easily reconfigured to match the taper of the piers as they rose. The deck was placed with the aid of temporary supports. The finished roadway has a gradual slope of about three degrees and a gentle curve in plan, which both keeps drivers more alert and enhances the minimalist elegance of the structure.

Millau, France
Completed 2005
Architect: **Foster and Partners**
Engineers: **Chapelet-Defol-Mousseigne; Ove Arup and Partners**

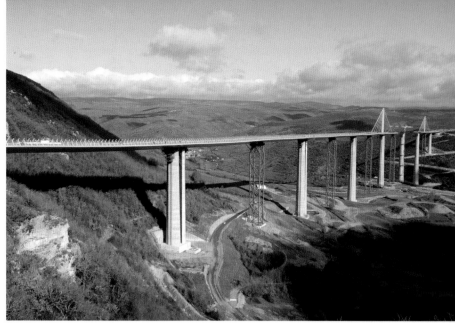

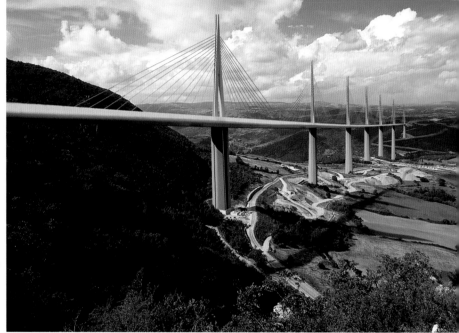

1

2

1 Bridge under construction
2 Photomontage, showing bridge in context
3 The completed bridge

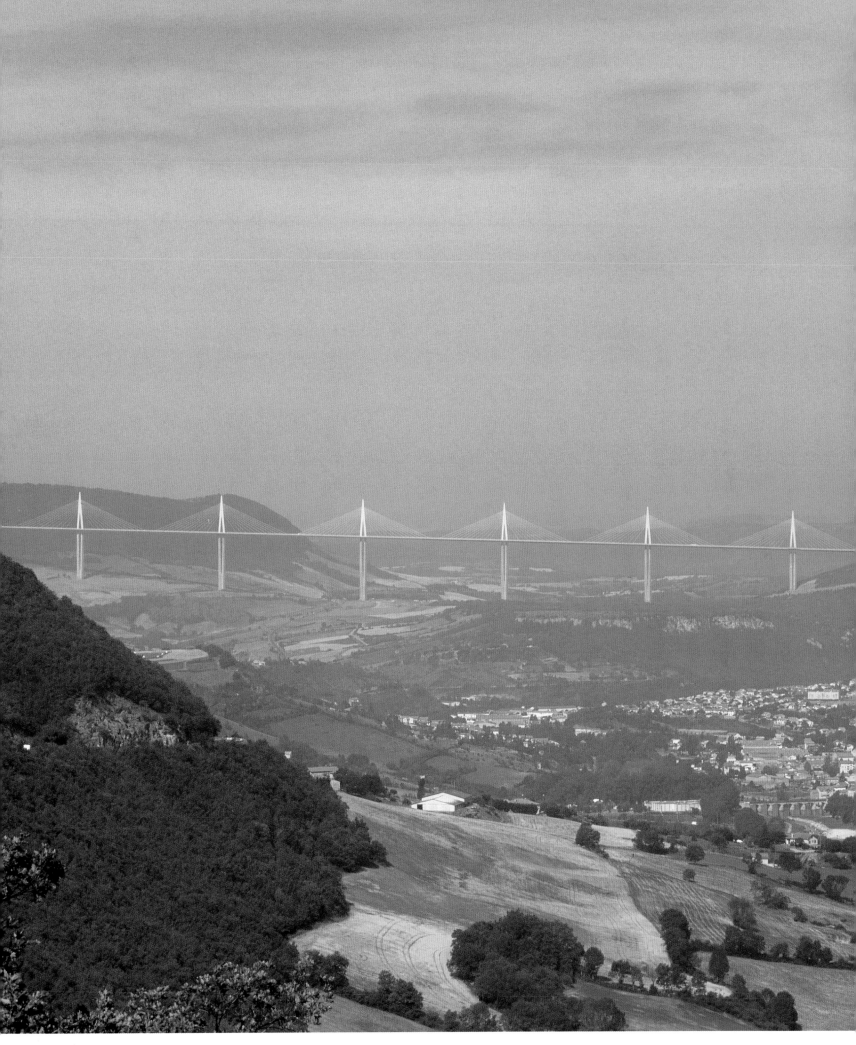

3

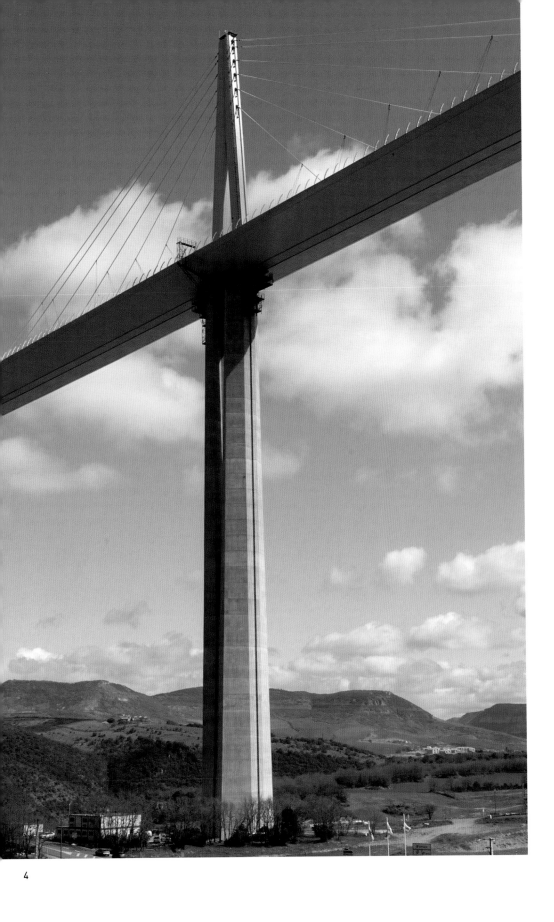

4

4 One of the concrete piers
5 Nearly completed bridge at sunset
6 Longitudinal elevation
7 Site plan

5

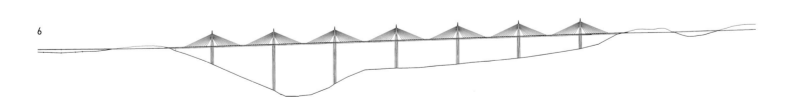

6

7

Steel box beams await installation as the structural supports for the roadway.

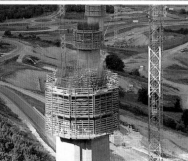

This aerial view of a pier under construction shows the concrete slip form in place. Extremely dense steel reinforcement protrudes from the top of the pier, awaiting the next layer of concrete.

In this view of the bridge under construction, temporary piers support the roadway as the permanent piers are completed.

The guardrail was designed as a visually permeable barrier in order to reduce the profile of the roadway when viewed from a distance.

8

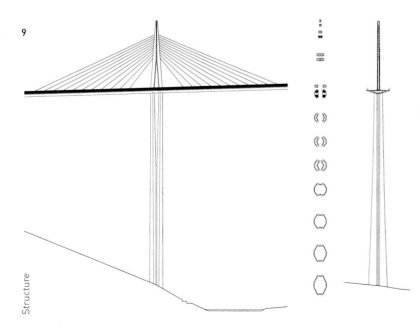

9

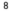

8 View of bridge from deck

9 Longitudinal elevation, progressive sectional plans, and transverse elevation of pier

10 View of bridge from nearby hill

Awaji Yumebutai

Tadao Ando's buildings are generally distinguished by their finely honed concrete surfaces, the result of precise control of the concrete mix and extremely high-quality formwork. In fact, Ando has been known to hire skilled furniture makers to build carefully detailed formwork for his projects, yielding exceptionally smooth and consistent concrete finishes.

Awaji Yumebutai, a conference center on an island near Kobe, Japan, comprises a number of structures sheathed in Ando's characteristically refined concrete but also incorporates landscape elements that depart somewhat from his usual materials palette. The centerpiece of the project is a cascading water garden called the Kai-no-Hama, or "seashore of shells." The bottom of this large, shallow pool is made of concrete covered with an array of one million scallop shells, individually mortared and placed by hand onto the concrete surface. The architect himself visited numerous local canneries to select shells with the range of colors and sizes he desired. The pool is also punctuated by one thousand fountains.

The pathways through the maze-like stepped gardens adjacent to the complex are also of concrete. The lushly planted gardens are intended as a living memorial symbolizing the rebirth of Awaji Island following a devastating earthquake in 1995.

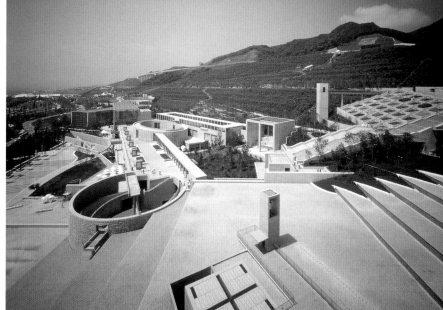

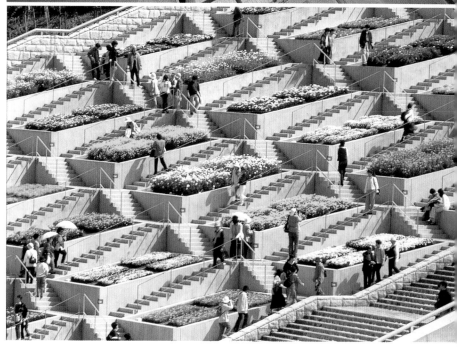

Awajishima, Hyogo, Japan
Completed 2000
Architect: **Tadao Ando Architect & Associates**
Structural Engineers: **Wada Giken, Hokujou Kenchiku Kouzou Kenkyusyo**
Contractors: **Obayashi Corporation, Arai Corporation, Awaji Doken Tokubetsu Kyodo Kigyotai, Takenaka Corporation, Asunaro Aoki Corporation, Zenidaka Corporation, Sato Kogyo Corporation, Kanzakigumi Tokubetsu Kyodo Kigyotai, Shibata Koumuten Tokubetsu Kyodo Kigyotai, Shimizu Corporation, Izumo Kensetsu Tokubetsu Kyodo Kigyotai, Moricho Corporation**

1
2

1　General view of the complex
2　Stepped gardens, housed in concrete planters
3　Detail of the complex, with fountain in the foreground and stepped gardens in the background

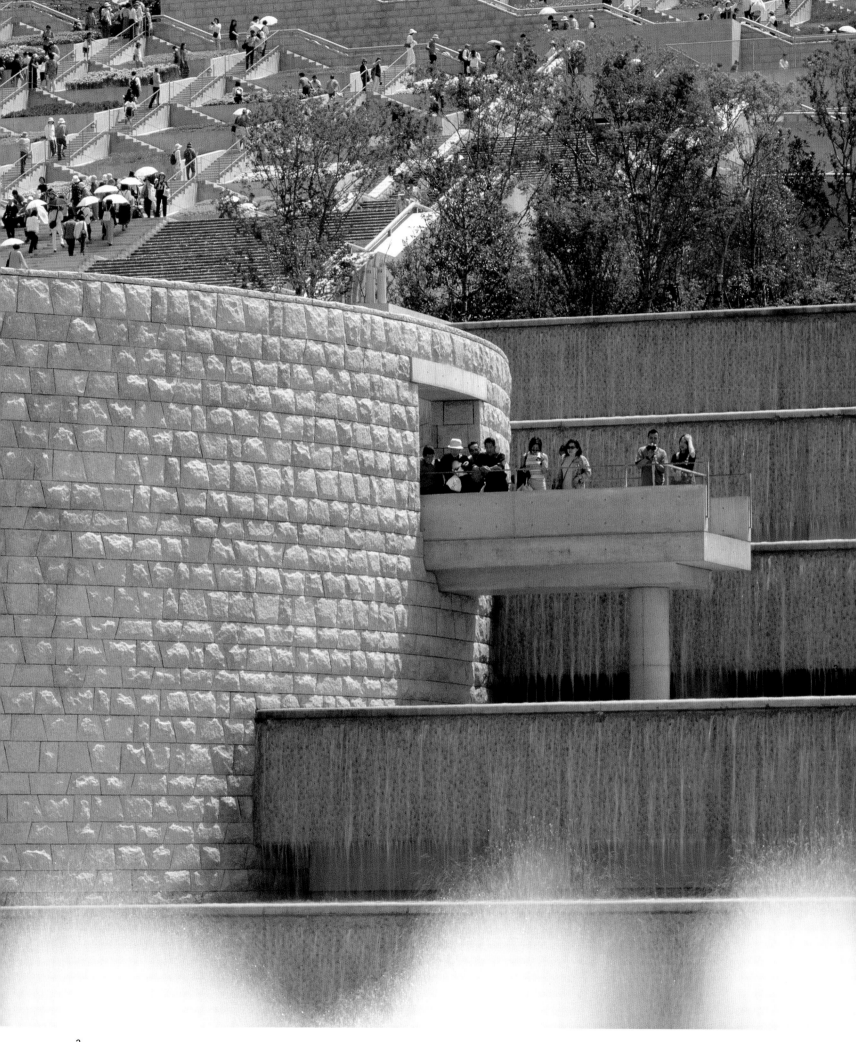

3

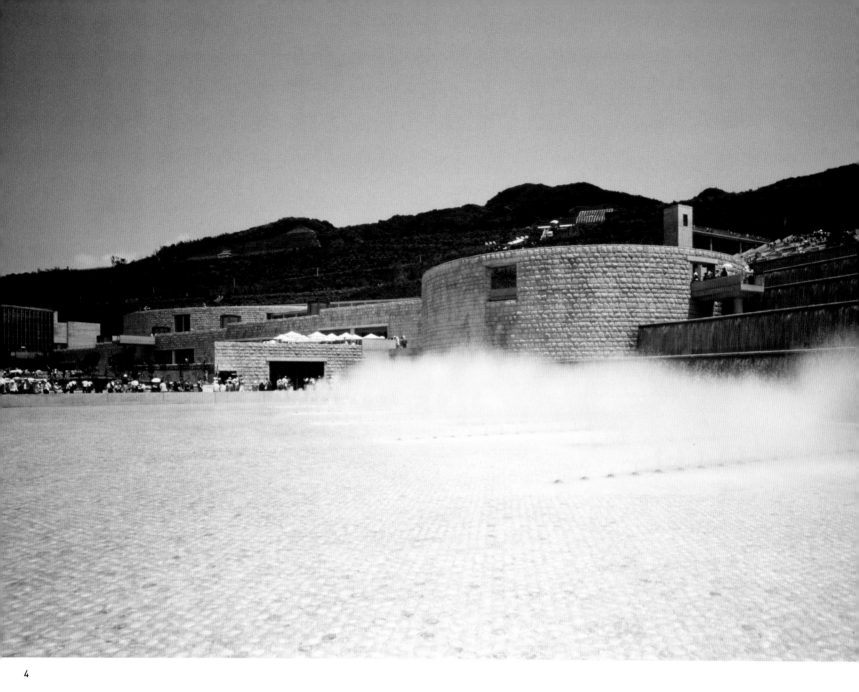

4

4 General view of the complex
5 Detail of shells set into concrete
6 Pool with shell-lined concrete bottom
7 Walkway and tower, standing amid the shallow pool

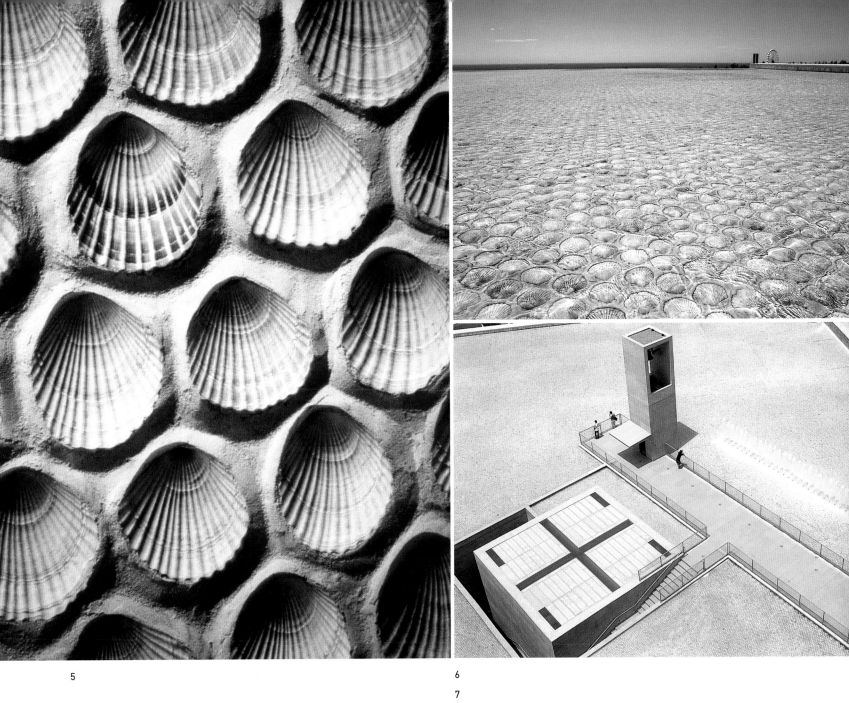

5

6

7

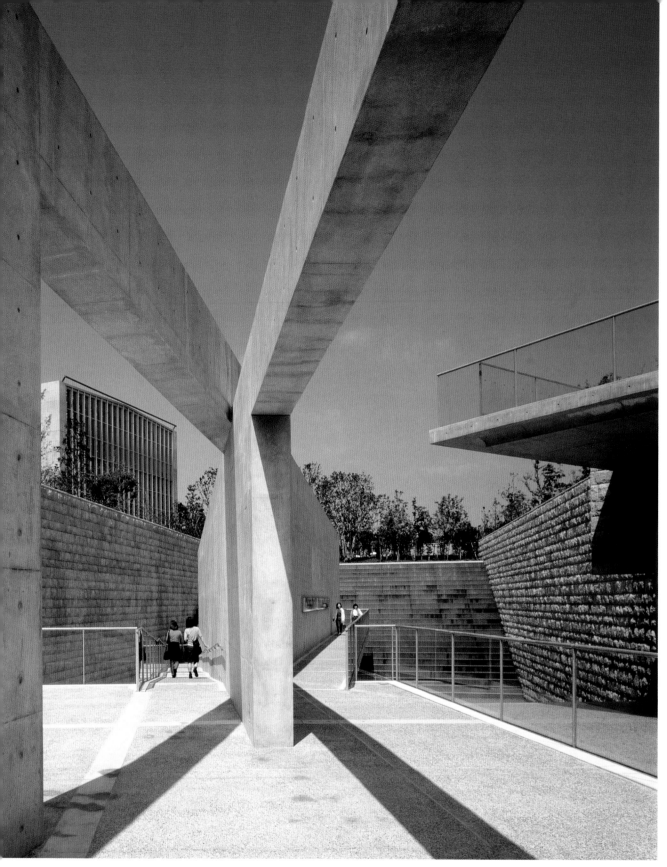

8

8 Freestanding wall elements on terrace

9 Overall view of the complex, with the shallow pool in
 the foreground

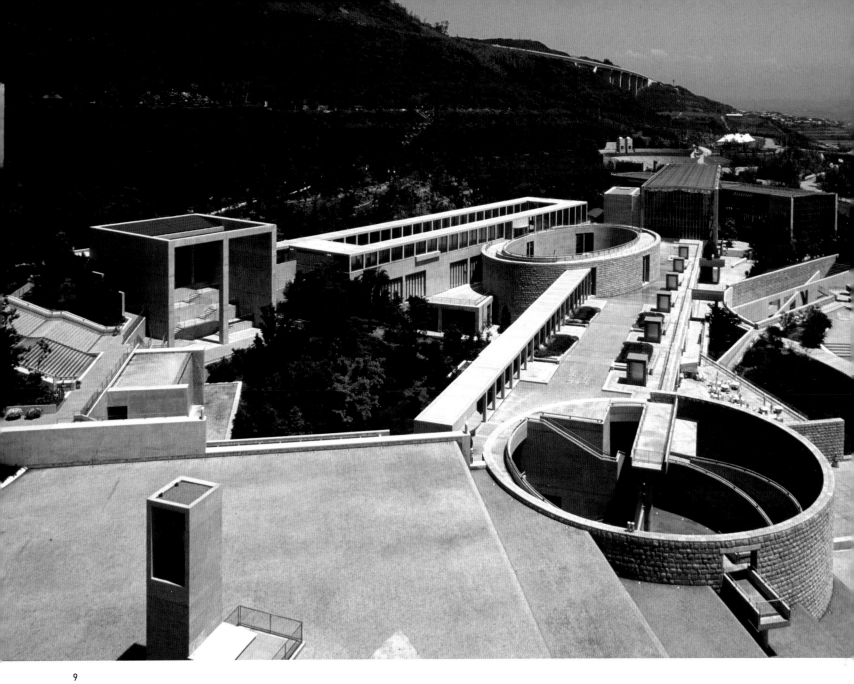

9

Shadow House

Though Antoine Predock has designed buildings all over the United States, his work is strongly associated with the Southwest. He has a particular affinity for the desert—its colors, its textures, and the deep shadows that result from its unrelenting sunshine—and frequently designs buildings in this setting that blur the division between the natural and built environments.

In this spirit, the tawny walls of the Shadow House, made of integrally colored stucco over concrete block, appear almost as if they grew directly out of the desert floor. Key components of the house, such as the tower containing the entrance, are made of cast-in-place concrete of a similar color. The subtle distinction between the texture of the stucco and that of the unfinished concrete abstractly evokes the surrounding landscape, where vast expanses of earth are punctuated by outcroppings of similarly colored rocks and boulders.

The house is organized around a courtyard and two primary axes that focus views toward the landscape, including the nearby Jemez Mountains. The foyer has an earthen floor—again blurring the line between the natural and the human-made—and is enigmatically lit through a prismatic skylight. In the slightly sloping courtyard, water rushes over rough granite pavers imported from China. Opposite the courtyard is a fireplace, also of cast-in-place concrete. The design thus brings together the fundamental "elements" of earth, light, water, and fire within a neutral container of concrete and stuccoed concrete block.

Santa Fe, New Mexico, United States
Completed 2003
Architect: **Antoine Predock, Architect**
Engineers: **Sonalysts**
General Contractor: **Kenderdine Construction Co., Inc.**

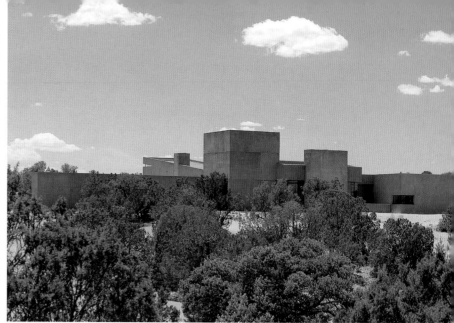

1

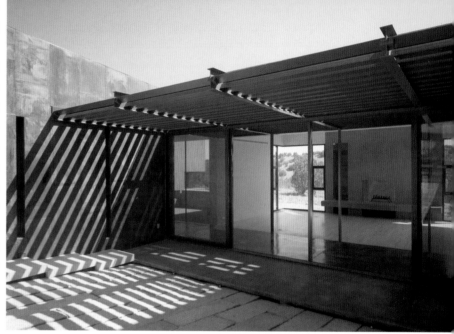

2

1 The house, appearing as if it emerged naturally from the surrounding earth
2 Courtyard, looking toward the living area
3 Entrance tower of cast-in-place concrete

4

4 Sections
5 Corridor, with concrete walls of various textures
6 Interpenetrating rectilinear forms of glass and
 concrete
7 Sculpture by Jorge Yazpik in a courtyard
8 Ground-floor plan

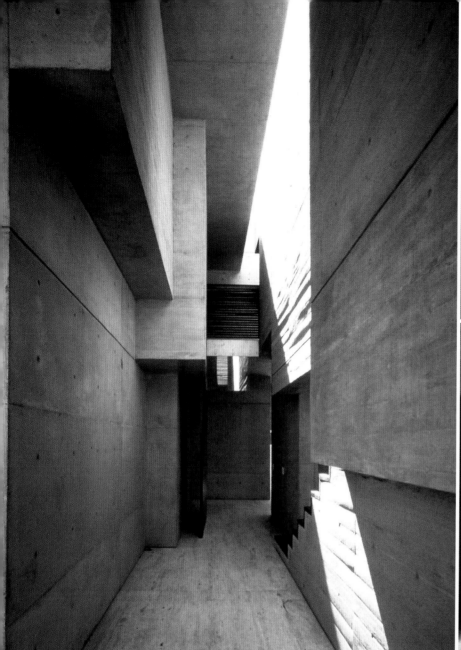

5

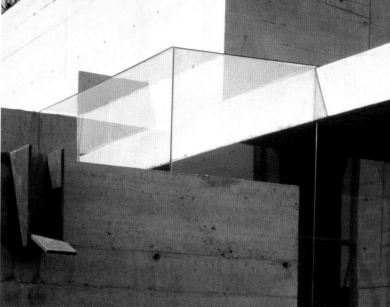

6

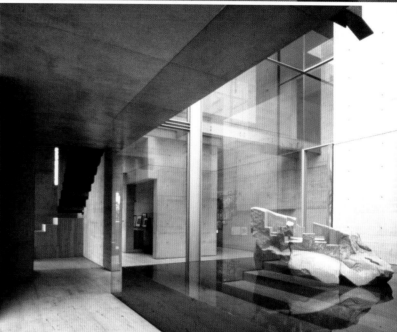

7

8

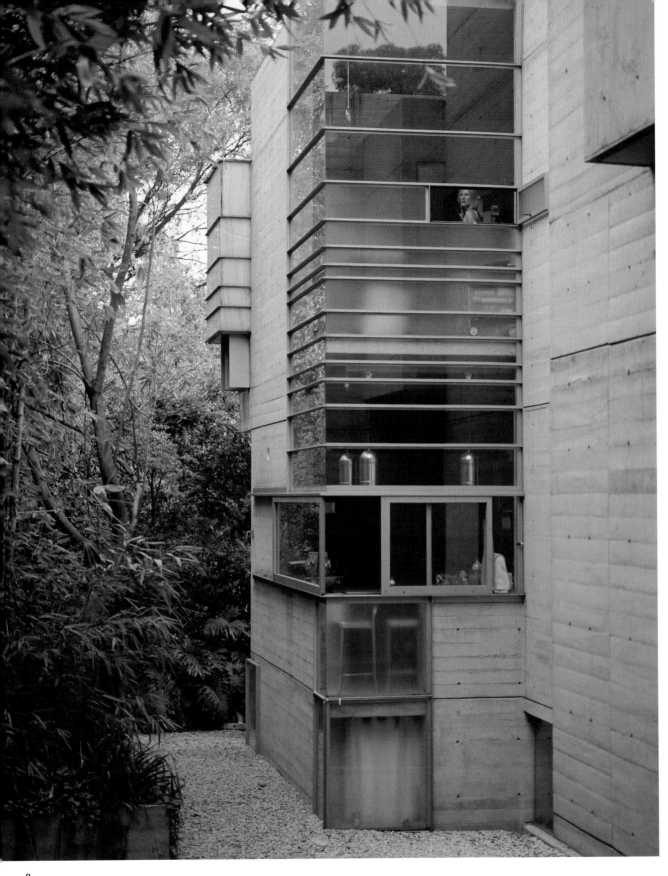

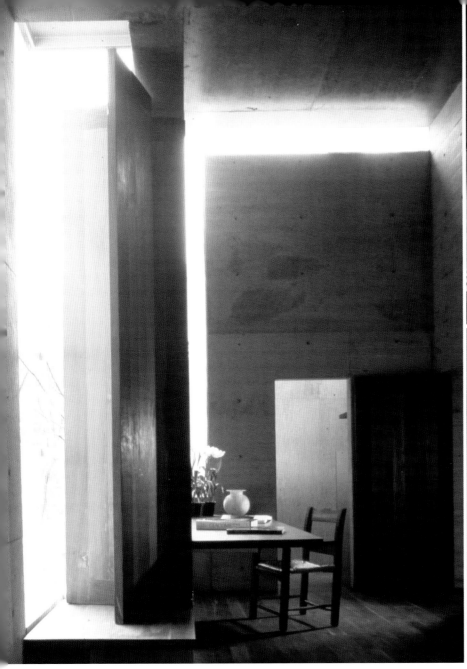

10

11

12

9 View of the house bringing to mind pre-Columbian
 architecture, with bold forms and coarse surfaces
 nestled amid tropical foliage

10 Slivers of bright light, illuminating otherwise dark
 interior spaces

11 External passage, with Yazpik sculpture visible at right

12 Raking light, admitted though partially hidden
 openings in the ceiling, emphasizing the texture of the
 concrete surfaces

Ruffi Sports Complex

This public recreational facility in a gritty neighborhood near the Marseille waterfront had a very tight budget. In designing appropriately sturdy and secure facades for the building, architect Rémy Marciano achieved visual interest inexpensively by varying the finishes of the concrete surface. The otherwise plain walls are animated by a lively, quilt-like pattern in shades of gray—a liberal reinterpretation of the tones and textures prevalent in the surrounding industrial area. The variations in color result from different types of varnish applied to the concrete panels.

Sitting atop the concrete base are three "light boxes," which illuminate the interior by day. Sheathed in polycarbonate panels, the boxes are tilted to facilitate drainage of their aluminum-clad roofs. Because the light boxes overhang the base structure, at night they cast a soft glow over the exterior concrete walls, turning the building into a beacon for its community.

Marseille, France
Completed 2001
Architect: **Rémy Marciano**
Engineers: **SP2I: Société Phocéenne d'Ingénierie**
Consultants: **ART'M Architecture**
Contractor: **Campenon Bernard Construction Méditerranée**

1

2

1 Main facade
2 Interior of gymnasium
3 Exterior at dusk, showing overhanging light boxes illuminated from within
4 Site plan, with gymnasium building shown in gray

3

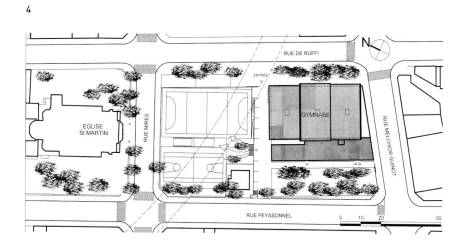

4

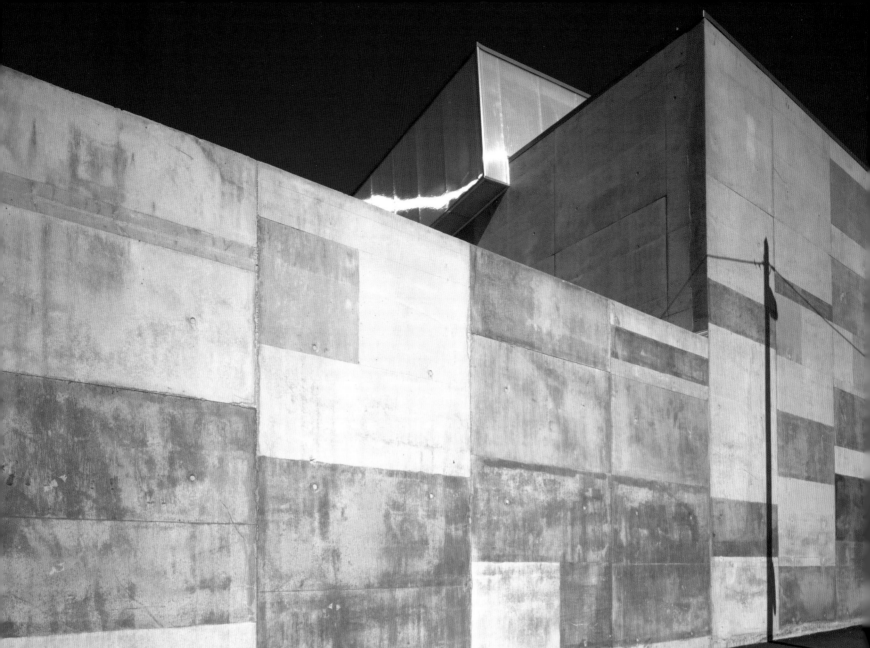

5

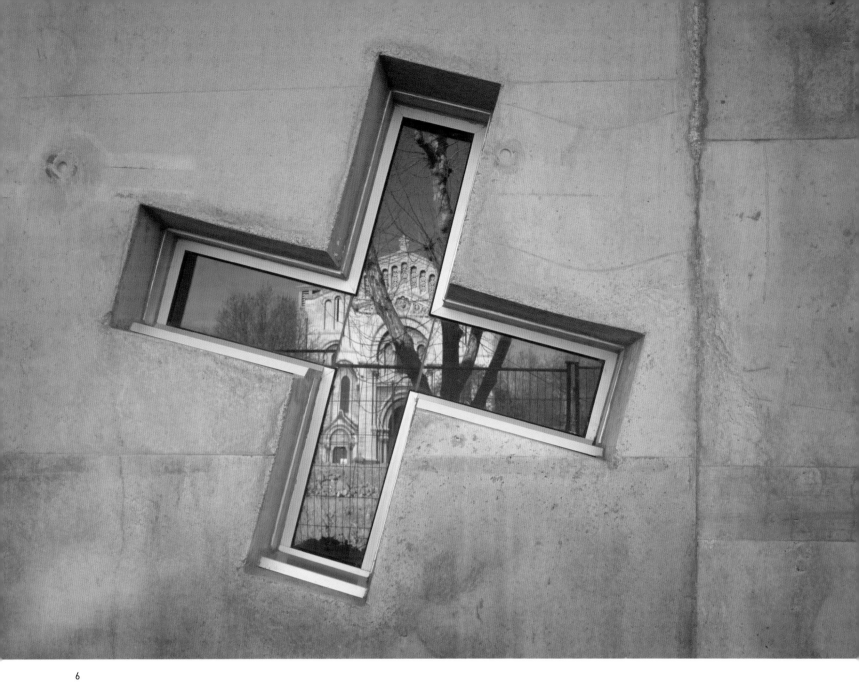

6

5 Mottled concrete facade

6 Detail of cross-shaped window, with reflection of
 adjacent church

M-House

Michael Jantzen is a designer and artist who has developed several innovative shelter concepts, including the "M-vironments" system, comprising lightweight modular units. The M-House prototype consists of Viroc® concrete composite panels—cement-bonded particleboard— attached with hinges to an open framework of 4-inch- (10-centimeter-) square-section steel tubing. Some of the panels are insulated and fully enclose interior spaces; others are uninsulated and serve as movable sunshades or platforms for sitting, sleeping, or working.

The version of the house pictured here was designed to serve as a vacation retreat, studio, and party facility. It can be assembled and disassembled relatively quickly, and requires no foundations—its supports are simply anchored directly to the ground. Jantzen envisions numerous variations on this prototype, including groups of such structures designed as self-sustaining communities, off the electrical power grid and free of other expensive infrastructure.

Although the composite panels do not fit the traditional definition of concrete, they are representative of the increasingly common hybrids that are muddling the distinctions between contemporary construction materials.

Gorman, California, United States
Completed 2001
Architect: **Michael Jantzen**
Structural Engineers: **Advanced Structures Inc.**

1
2

1 View of main facade
2 View of living area
3 Exterior, showing movable concrete composite panels
4 Plan

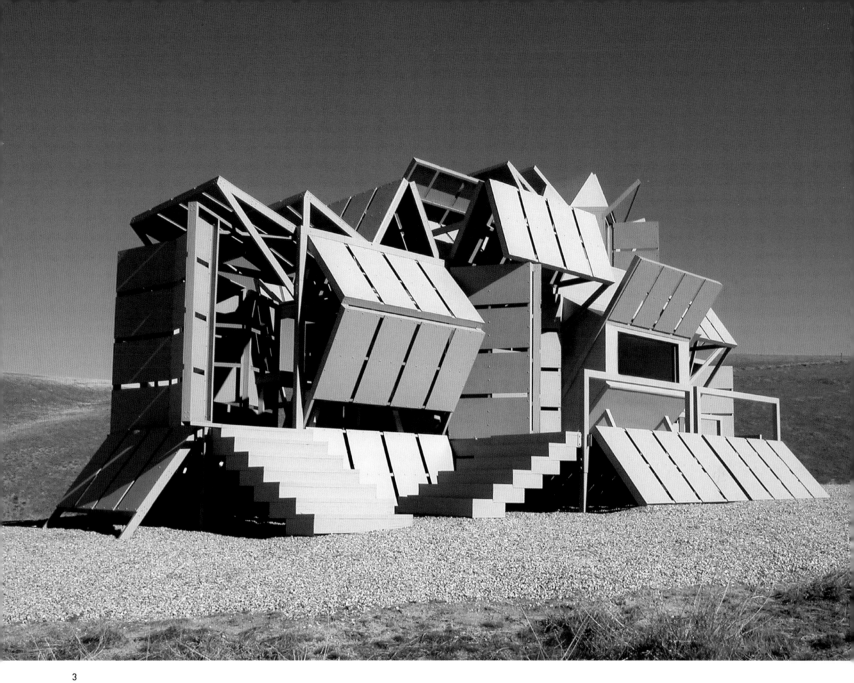

3

4

5

6

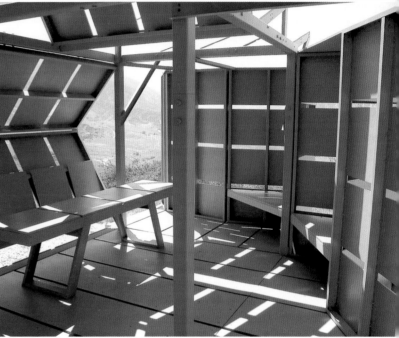

7

8

9

10

11

Visiting Artists House

This guesthouse is the product of close collaboration among architect Jim Jennings, artist David Rabinowitch, and the owner Steven Oliver, who also served as the contractor for the project. Oliver and his wife are avid art collectors who have commissioned various large-scale sculptures expressly for their ranch. This structure accommodates visiting artists while they are working at the ranch and simultaneously serves as a large-scale artwork in its own right.

The house is defined primarily by two concrete walls, one 207 feet (63 meters) long and the other 209 feet (64 meters) long, running slightly out of parallel and marking the axis between a pond and a major sculpture by Robert Stackhouse on the property. The inside surfaces of these 14-inch- (36-centimeter-) thick walls are incised with fluid lines in an abstract, curvilinear pattern, yielding, in effect, two huge works of bas-relief sculpture. The walls incorporate a 4-inch- (10-centimeter-) thick inner layer of concrete that was left free of steel reinforcement and which contains only very fine aggregate, allowing Rabinowitch to carve into the surfaces at will. The finished walls were ground by hand to produce a smoothly honed finish.

Spanning between the two concrete walls are lightweight steel-and-glass structures that enclose the actual living spaces, consisting of two distinct apartments separated by a shared courtyard. At the edges of the ceiling structures are linear skylights, which wash the incised concrete surfaces with light.

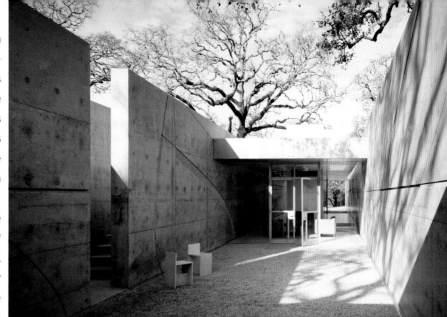

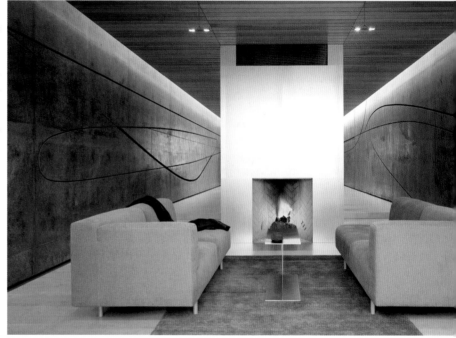

Geyserville, California, United States
Completed 2002
Architect: **Jim Jennings Architecture**
Artist: **David Rabinowitch**
Contractor: **Oliver & Co.**

1
2

1 Courtyard between enclosed areas
2 Living area
3 Exterior view of concrete walls
4 Plan

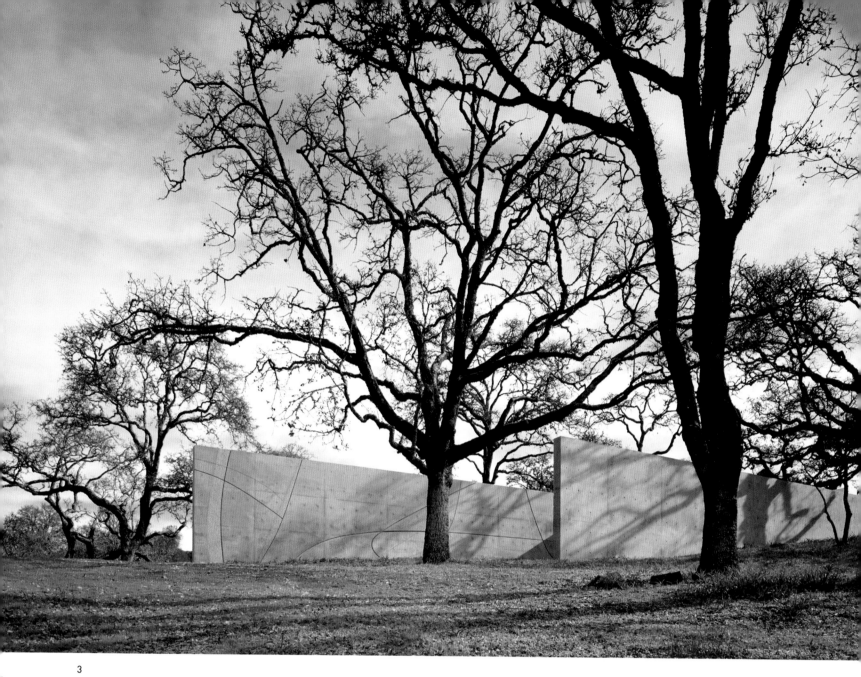

3

4

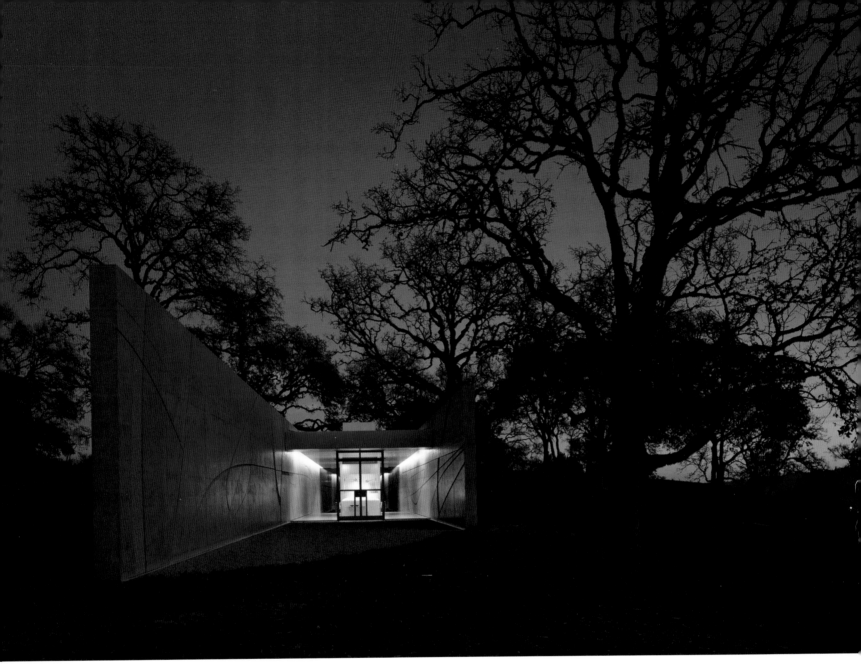

5

6

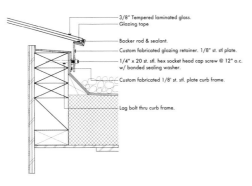

3/8" Tempered laminated glass.
Glazing tape
Backer rod & sealant.
Custom fabricated glazing retainer. 1/8" st. stl plate.
1/4" x 20 st. stl. hex socket head cap screw @ 12" o.c. w/ bonded sealing washer.
Custom fabricated 1/8' st. stl. plate curb frame.
Lag bolt thru curb frame.

SKYLIGHT FRAME & CURB

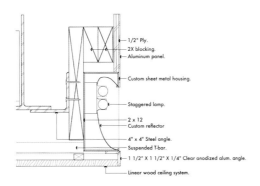

1/2" Ply.
2X blocking.
Aluminum panel.
Custom sheet metal housing.
Staggered lamp.
2 x 12
Custom reflector
4" x 4" Steel angle.
Suspended T-bar.
1 1/2" X 1 1/2" X 1/4" Clear anodized alum. angle.
Linear wood ceiling system.

CEILING SOFFIT

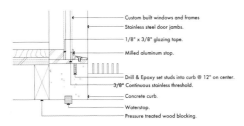

Custom built windows and frames
Stainless steel door jambs.
1/8" x 3/8" glazing tape.
Milled aluminum stop.
Drill & Epoxy set studs into curb @ 12" on center.
3/8" Continuous stainless threshold.
Concrete curb.
Waterstop.
Pressure treated wood blocking.

WINDOW SILL

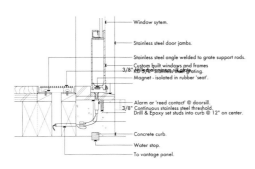

Window sytem.
Stainless steel door jambs.
Stainless steel angle welded to grate support rods.
Custom built windows and frames
3/8" bar stainless steel grating.
Magnet - isolated in rubber 'seat'.
Alarm or 'reed contact' @ doorsill.
3/8" Continuous stainless steel threshold.
Drill & Epoxy set studs into curb @ 12" on center.
Concrete curb.
Water stop.
To vantage panel.

DOOR SILL

DETAILS

7

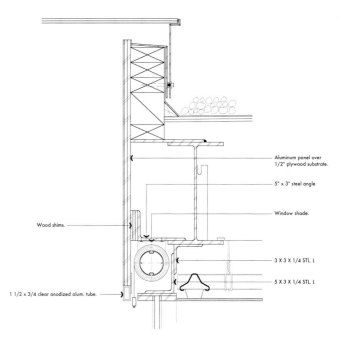

Aluminum panel over 1/2" plywood substrate.
5" x 3" steel angle
Window shade.
Wood shims.
3 X 3 X 1/4 STL. L
5 X 3 X 1/4 STL. L
1 1/2 x 3/4 clear anodized alum. tube.

SECTION AT SKYLIGHT OPENING

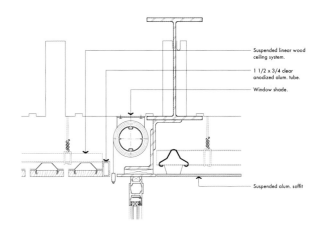

Suspended linear wood ceiling system.
1 1/2 x 3/4 clear anodized alum. tube.
Window shade.
Suspended alum. soffit

SECTION AT WINDOW/DOOR HEAD

*all details are drawn at same scale

Artist David Rabinowitch generated more than one thousand sketches and drawings before deciding on the final design of the house's incised walls. Here, workers review final working drawings in preparation for inscribing the concrete walls.

Workers use a mechanical lift to position themselves against one of the walls.

A circular saw is used to incise the curving lines into the wall.

A worker refines the edges of the cut.

8
9

10

8 Interior view, showing incised curves in the concrete wall

9 View to the exterior

10 Detail of entrance, with incised concrete wall at right

McKinley Residence

A compound of four buildings connected by bridges, the McKinley Residence, named for its street, is the architect's own house. Concrete is the predominant material, selected because it can be used for both interior and exterior surfaces, although it appears in many different forms. Much of the concrete used is actually Syndecrete®, a lightweight version invented by the architect that contains a variety of recycled materials as aggregate, fly ash (replacing up to 15 percent of the cement base), and polypropylene fiber—a recycled scrap product that increases the concrete's tensile strength and gives it structural properties similar to those of wood. Syndecrete® is used throughout the project in various colors, textures, and applications, from fireplaces and shower tiles to soap dishes and tissue holders.

The exterior walls are of rough, poured-in-place concrete, while the interior surfaces are generally of cast, polished concrete. Some of the concrete floors were burnished—literally burned by the friction of a steel trowel—to a dark, smooth finish. Unusual details include a wall with glass fins slicing all the way through the concrete surface, and a 2,000-pound (909-kilogram) concrete gate that pivots easily thanks to precise balancing.

Venice, California, United States
Completed 2003
Architect: **David Hertz AIA Architects/Syndesis, Inc. with Stacy Fong**
Structural Engineers: **C. W. Howe & Associates Structural Engineering Consultants, Inc.**
Contractor: **David Hertz/Syndesis, Inc.**

1

2

1 Courtyard, with pool house at left
2 Detail of stair and concrete block wall behind
3 Street facade, with concrete gate open
4 Perspective drawing of courtyard and pool house

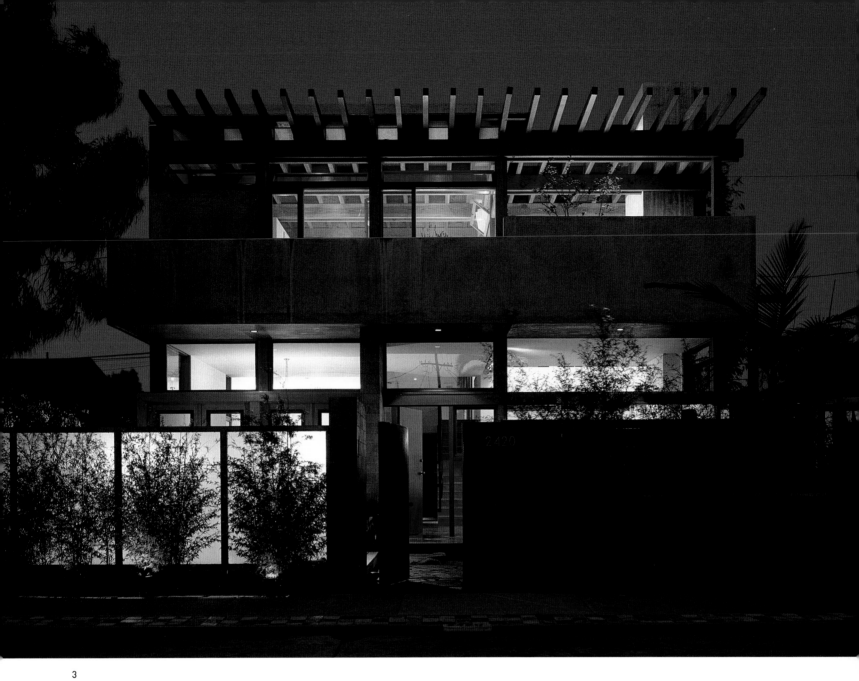

3

4

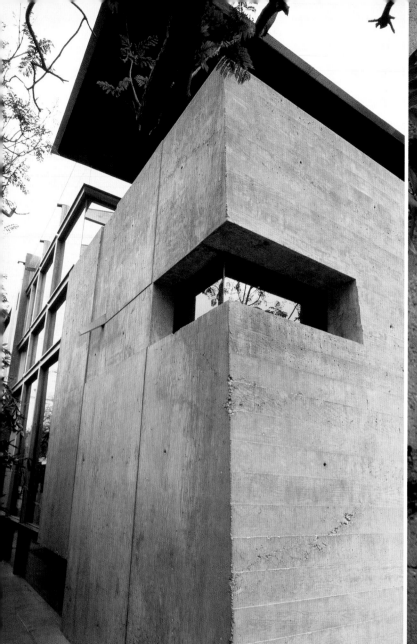

5

6

5 Corner, showing board-formed concrete walls

6 Detail of concrete surface

7 Concrete wall with glass fins

7

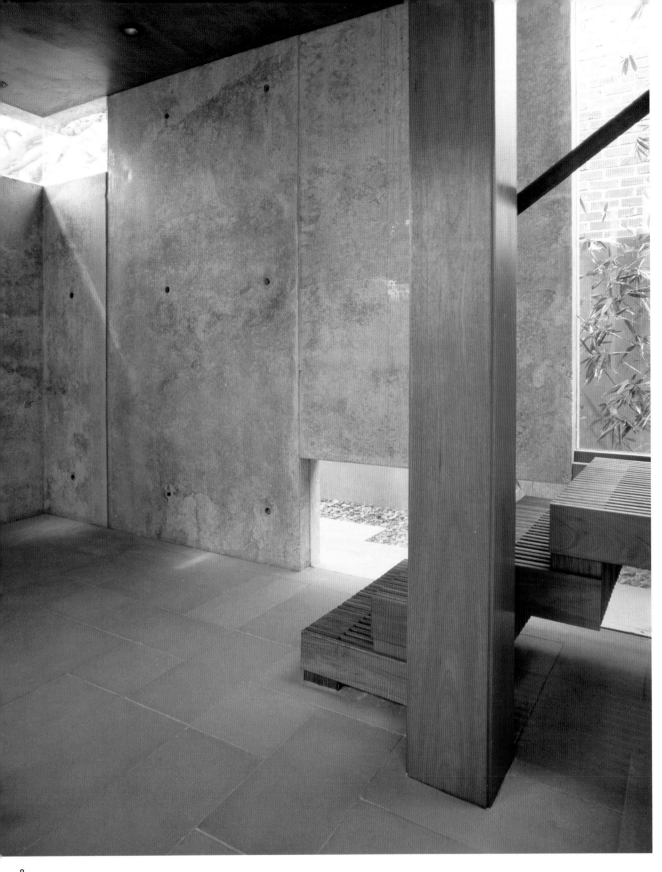

8 Smooth concrete flooring, juxtaposed against the
rough concrete walls

9 Concrete dining table and bench

10 Concrete wall with embedded glass fins, visible
beyond the living area

11 Dining area, with the living area in the background

12 Second- and first-floor plans

9

10

11

12

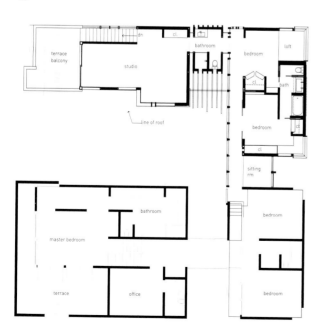

Floor plan labels (left):
terrace balcony, dn, cl, bathroom, bedroom, loft, studio, line of roof, cl, bath, bedroom, cl, sitting rm, cl, bathroom, bedroom, master bedroom, terrace, office, bedroom

Floor plan labels (right):
up, bath, kitchen, pool house, bench, rec. room, patio, lap pool, pool bath, dining room, kitchen, existing patio, existing garage, living room, den

San Jose State University
Museum of Art & Design

The skin of this proposed museum deliberately blurs the usual distinction between opacity and transparency in building surfaces. Translucent walls of corrugated, molded glass will be integrated with polished, precast concrete panels containing bits of recycled glass. The "windows" will thus afford only very filtered views, while the concrete surface will have unusual visual depth and reflect light in unpredictable ways. Although glass does not easily bond with concrete, the architects, in conjunction with a firm called Counter Production, have produced a successful prototype of the concrete panels.

After the competition results were announced, San Jose State University decided to pursue a much larger project for a new school of art and design and has since invited the winning architects to design the new facility, expanding on their proposed design for the museum.

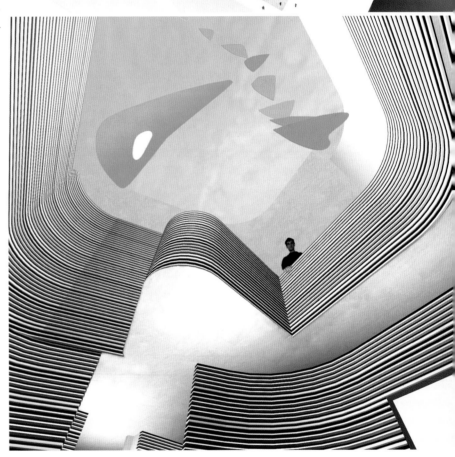

San Jose, California, United States
Proposed 2003
Architect: **WW**
Collaborative Architects: **SMWM**
Engineers: **Buro Happold**
Facades Consultant: **James Carpenter Design Associates**
Precast Panel Manufacturer: **Counter Production**

1

2

1 Aerial view of model
2 Rendering of atrium
3 Rendering of the facade, showing concrete panels (mottled green surfaces) and corrugated cast glass (horizontally striated surfaces)

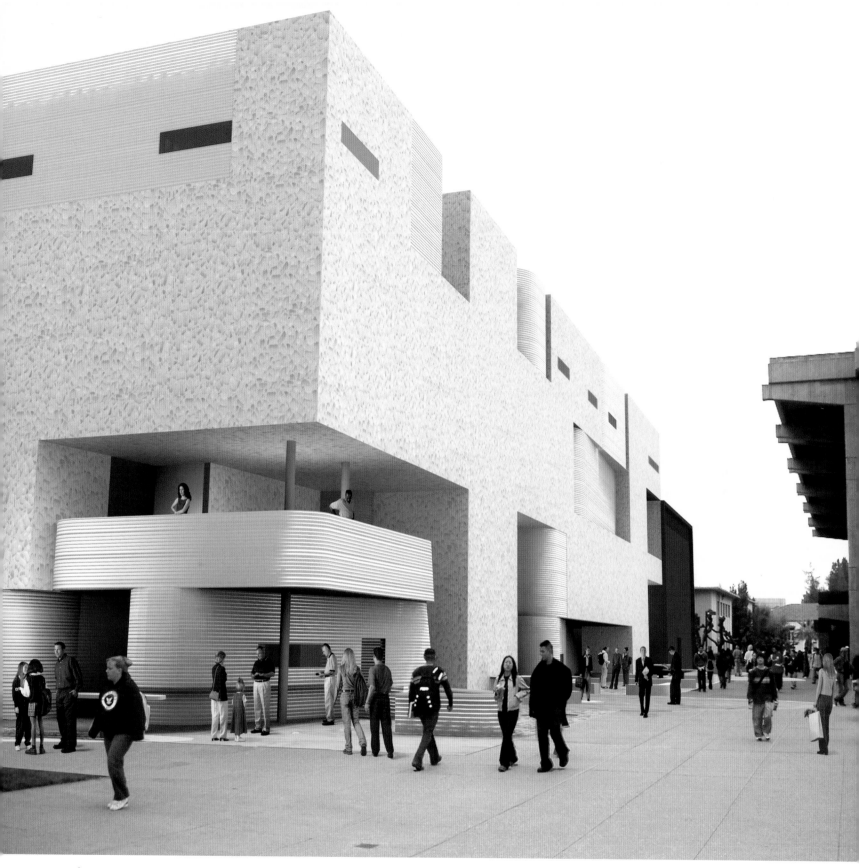

3

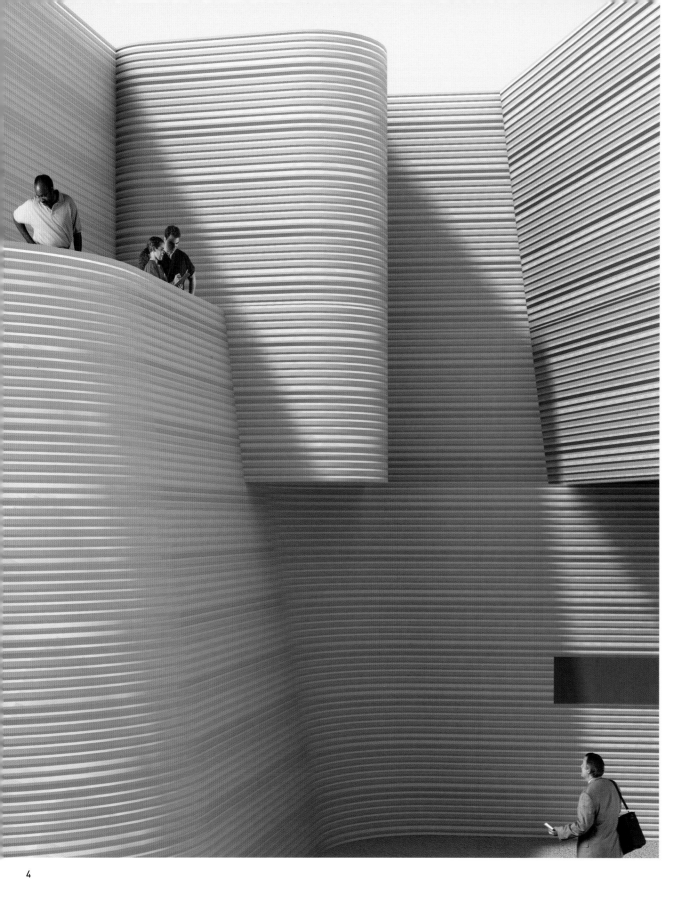

4

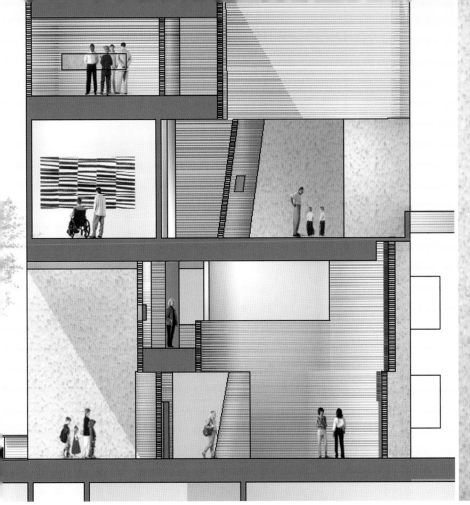

5

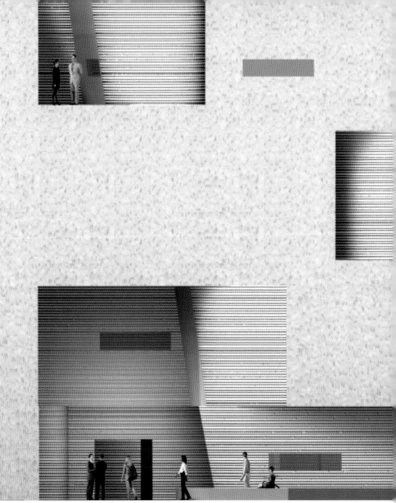

6

7

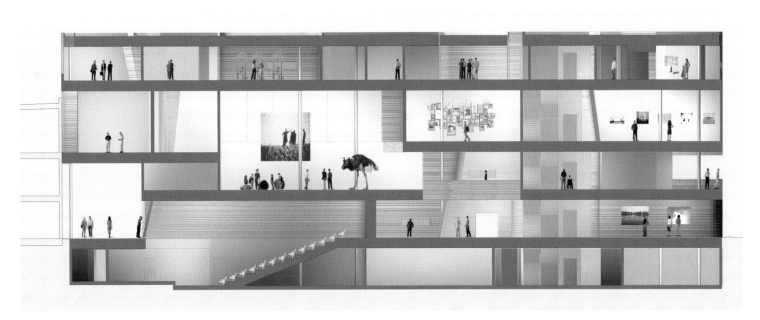

Eberswalde Technical School Library

One of the most intriguing concrete finishing technologies to emerge in recent years is photoengraving. Photoengraved concrete is produced through a process that is somewhat reminiscent of silk screening. A photographic image is applied as a layer of tiny dots onto a polystyrene sheet, but instead of paint or ink, the image is "printed" with a cure retarder—a chemical that slows the cure rate of concrete. The plastic sheet is placed into a concrete mold and the concrete is poured on top of the sheet. After the concrete sets, it is removed from the mold and pressure-washed, revealing a half-tone-like image reflecting the differential cure rates of the concrete surface.

Using this material combined with etched glass, Herzog & de Meuron turned a basic box of a building into a kind of surreal, three-dimensional photographic album. The facades are divided into a series of seventeen horizontal bands, each bearing an image that is repeated sixty-six times around the full circumference of that band. The result is a building that is also a large work of pop art, simultaneously suggesting depth on a flat plane and movement on a stationary surface.

Eberswalde, Germany
Completed 1999
Architect: **Herzog & de Meuron**
Artist: **Thomas Ruff**

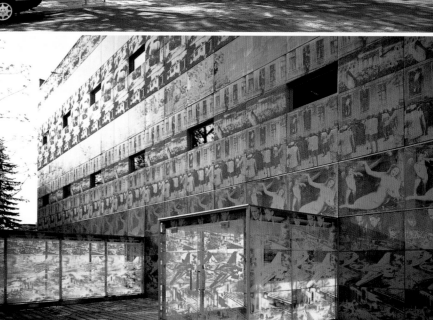

1

2

1 Main facade
2 Entry pavilion (center) and corridor (left) connecting the library to an existing structure
3 Facade at dusk, when fenestration is more visible
4 Site plan, with the library shown in gray at lower right

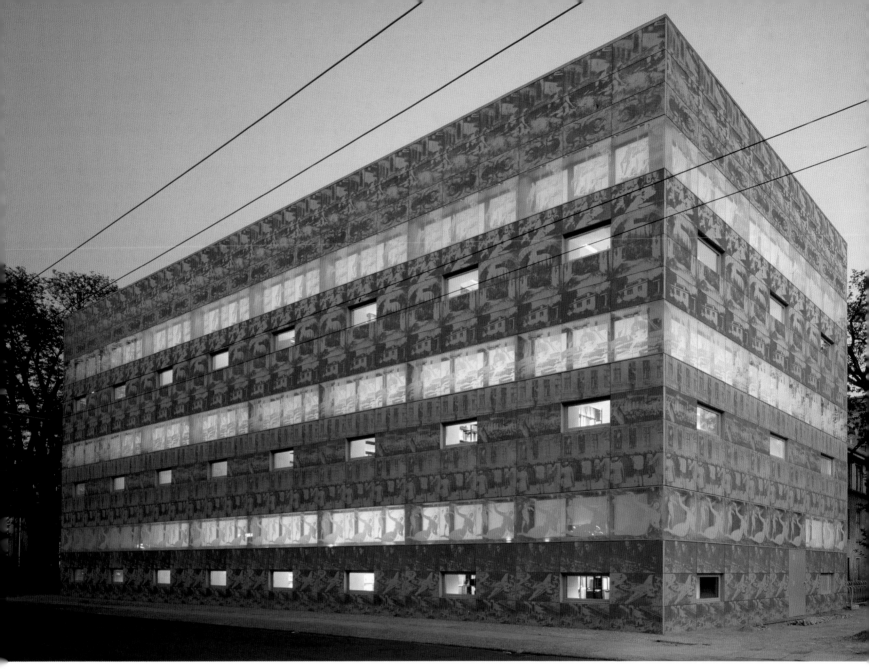

3

4

The concrete mixture is placed into formwork lined with a plastic sheet to which a chemical cure retarder has been applied in a dot pattern mimicking a specific photographic image.

After the concrete has set, the formwork is removed and the panel is power-washed to reveal the differentiations in the surface and, thus, the photoengraved image.

Workers hold one of the completed panels on which photographic images are now evident. The photoengraving technique used on these panels was developed by Herzog & de Meuron with artist Thomas Ruff.

Now completed, the photoengraved concrete panels await shipment to the construction site. The specific images were taken from Ruff's archives of newspaper clippings.

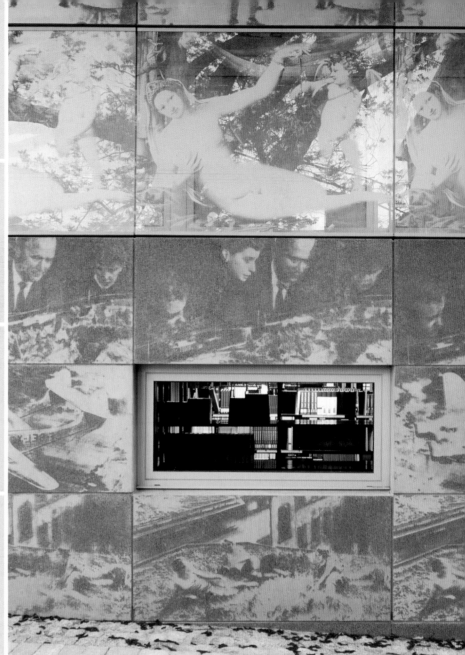

5

6

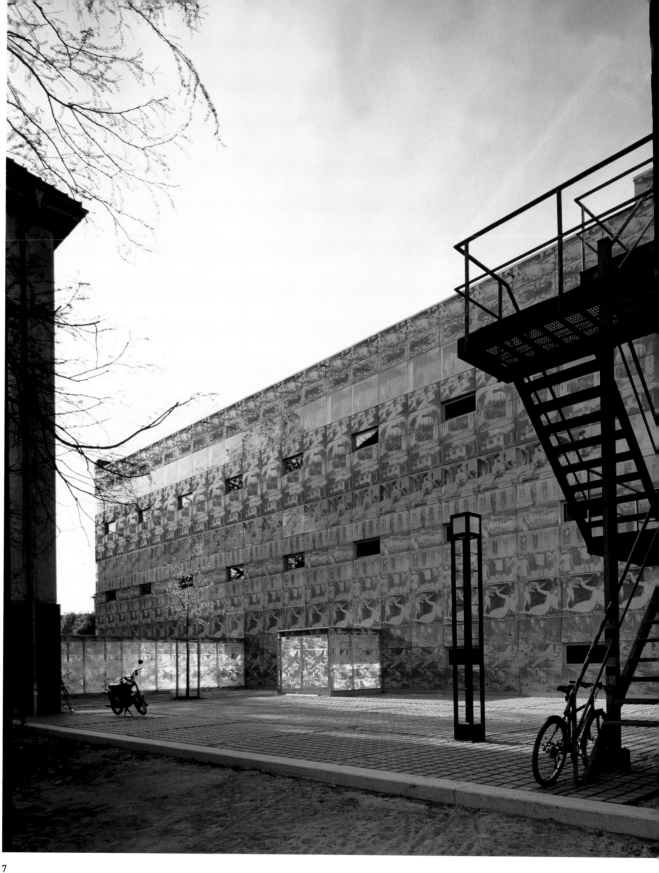

7

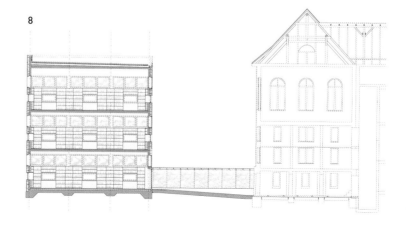

8

5 Detail of facade, showing etched glass, photoengraved
 concrete, and traditional transparent-glass panels
6 Second- and first-floor plans
7 Entrance courtyard
8 Transverse section of the library and connecting
 corridor

Sculptural Form

Reinforced Concrete and the Morality of Form

G. Martin Moeller, Jr.

Reinforced Concrete and the Morality of Form

G. Martin Moeller, Jr.

The image seems, at first glance, to be nothing more than a few quick squiggles—a 1915 sketch by architect Erich Mendelsohn (1887–1953) of a grain elevator, presumably inspired by a series of photographs of American grain elevators that had been published in the *Jahrbuch des Deutschen Werkbundes* two years earlier. [Figure **1**] Yet this simple drawing by someone who, like Picasso, could capture the essence of a subject with a minimum of lines on paper was actually a harbinger of a revolution in architectural form. The sketch, with its sensuous, free-flowing curves, succinctly expressed—perhaps even more compellingly than the structures that inspired it—the full promise of reinforced concrete to liberate architects and engineers from the constraints of the traditional structural frame. For the first time in history, a truly *spatial* architecture, its forms limited only by the designer's imagination, was conceivable.

While the almost infinite moldability, or plasticity, of concrete obviously excited many engineers and architects at the dawn of the modernist era, enthusiasm for the material was far from universal. Because concrete had no intrinsic form, some architects and critics in the late nineteenth and early twentieth centuries considered it "unnatural" and therefore, morally questionable. This was a time, after all, when the theories of figures such as John Ruskin (1819–1900) and William Morris (1834–1896) held great sway. Ruskin argued for "truth" in materials, meaning not only that builders should use them in ways that were logical given their physical properties but also that the character of the materials should be plainly revealed in the finished structure. But if a material had no inherent shape, and its physical characteristics varied wildly based on the skills—and whims—of the worker, then what constituted "truth" with respect to that material? The lack of a convincing answer to that question led many practitioners of the Victorian and Edwardian periods to avoid using concrete, lest they be accused of a lack of aesthetic discipline.

Such strongly moralistic attitudes toward reinforced concrete—especially as regards its sculptural potential—continued well into the twentieth century, though the nature of the skepticism mutated over time. In *The Ferro-Concrete Style*, originally published in 1928, author Francis S. Onderdonk, Jr., not only accepted but celebrated concrete's lack of specific form, stating, "The more a material can be affected by mechanical and chemical influences while being formed, the more possibilities it contains and hence the more perfect it is." Having embraced concrete's plasticity, however, he then issued a warning: "The many possibilities created by reinforced concrete can also be dangerous because they permit architects to indulge in stunts." Indeed, Onderdonk's purpose in writing the book was twofold: to call attention to the exciting potential of the material but also to codify certain aesthetic and technical principles governing its use in modern construction. The message seemed to be that all sorts of fun could be had with reinforced concrete, provided that everyone agreed to play by his rules. His tone in some passages was downright priggish: "The freaks of a future degenerate period will far surpass those of the Baroque, as ferro-concrete gives the designer more liberty. Even now the shapes given to the new material by some architects remind one of the manners of a parvenu." The reader can practically picture the author, lips pursed, waving an admonishing finger at some architect whose "dangerous" work had taken too many liberties with this gloriously liberating material. [Figures **2, 3**]

Early modern architects were equally doctrinaire in their views of reinforced concrete morphology. Le Corbusier (1887–1965), entranced by the aesthetic "honesty" of

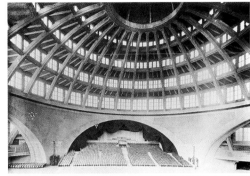

Figure **1** Erich Mendelsohn, sketch of imaginary grain "silo," 1915

Figure **2** Max Berg, Jahrhunderthalle, Breslau, Germany (now Wrocław, Poland), 1913, interior, noted by author Francis S. Onderdonk, Jr., for its circular skeleton of parabolic arches, which he called "the characteristic curve of the Ferro-Concrete Style"

Figure **3** Rudolf Steiner, the Goetheanum, Dornach, Switzerland, 1928, which Onderdonk, Jr., criticized for its "misuse of the possibilities of liquid stone" and "illogical crudeness"

utilitarian structures like the grain elevators that had captivated Mendelsohn, warned in *Towards a New Architecture*, "Let us listen to the counsels of American engineers. But let us beware of American architects." To illustrate his point, Le Corbusier helpfully included a photograph of the neo-baroque crown of the Spreckles Building in San Francisco, which was made of reinforced concrete. [Figure **4**] The example was perhaps too facile—an overtly *retardataire* excess—but it also clearly illustrated the common, continuing practice of using concrete to mimic traditional masonry construction and ornamentation. This practice, of course, was a symptom of the ongoing mistrust and even fear of the new material's indeterminacy, but at the same time, Le Corbusier's evangelical advocacy of a functionalist approach to the derivation of concrete forms simply represented a new, more dominant thread in the moralizing about concrete design.

Obviously, in the modern era, dogmatism regarding the appropriate use of building materials was by no means limited to concrete, but it does seem that the material was especially problematic for practitioners and theoreticians alike. For the most part, a true comfort with the plasticity of concrete did not emerge until after World War II. A new expressionism, as exemplified by Le Corbusier's Chapel of Notre Dame du Haut at Ronchamp, France (1955), explored the evocative forms achievable in massive, monolithic concrete construction. Several prominent architects of the period, including Oscar Niemeyer (b. 1907) in Brazil, Félix Candela (1910–1997) in Mexico, and Eero Saarinen (1910–1961) in the United States, pursued similar design threads, yielding forms that exploited the unique tectonics of reinforced concrete. Nonetheless, many other architects remained leery of the latitude that the material allowed in the creation of form.

In this context, P. A. Michelis, an architect and professor in Athens, Greece, wrote a major treatise on the aesthetics of reinforced concrete architecture, published in 1955 in French as *Esthétique de l'architecture du béton armé*. Though more scholarly and objective than Onderdonk's book of several decades earlier, Michelis's work still reflects a deep-seated compulsion to determine concrete's *propre* form. It is interesting that this French word—*propre*—can be read as either *own* or *appropriate*. The meanings in English are different, but the overlap is telling. For Michelis, as for so many others, the dilemma remained: What is the appropriate form when there is no inherent form?

Michelis began his treatise with an analysis of the morphology of concrete construction, following a very methodical progression from the linear to the planar to the volumetric: column, beam, cantilever, portal frame, arch, simple slab, "mushroom" slab, folded plate, vault, shells, and suspended roofs. The implication of this sequence was that thin shells and related forms were the logical end result—the ultimate expression— of an intelligent exploitation of concrete's properties. In a shell structure, reinforced concrete revealed its true plastic self—monolithic and continuous, unfettered by Cartesian grids—and thus achieved its destiny as an architectural material.

In the decade or so following the publication of Michelis's book, the debate about the propriety of specific architectural forms in reinforced concrete continued and even intensified. Italian engineer Pier Luigi Nervi (1891–1979), for instance, complained that Saarinen's TWA Terminal Building at Idlewild (now John F. Kennedy International) Airport in Queens (1962) was "too heavy and elaborate for the problem it seeks to solve." This comment, however, seems to have missed the point of the evocative structure—Saarinen used concrete not simply as a medium for solving a technical challenge but also as a vehicle for conveying a certain architectural spirit. Presumably, in Saarinen's view, the

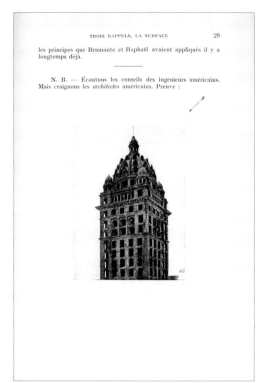

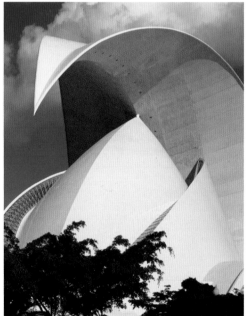

Figure **4** A page from Le Corbusier's *Vers une architecture* (1923) featuring an image of the Reid Bros.'s Spreckles Building, San Francisco, California, which the author derided for its frilly decoration made of concrete

Figure **5** Santiago Calatrava, Auditorio de Tenerife, Santa Cruz de Tenerife, Canary Islands, Spain, 2003

weight and intricacy of the concrete shell were necessary to evoke the desired emotional response from the harried travelers passing through the terminal. Nervi's prescriptive attitude, shared by many engineers and even other architects, may have contributed to the short shrift that scholars have tended to give Saarinen, Niemeyer, and others whose sculptural concrete work they criticized as capricious and undisciplined.

Despite such criticism, in the 1950s and early 1960s, a period of unusual economic expansion and cultural optimism, the expressionistic movement in reinforced concrete architecture developed a strong following among those seeking a foil to the predominant, straight-edged Miesian aesthetic. Inevitably, perhaps, the backlash came with the advent of the postmodern era, and particularly with the resurgence of overt historicism in the 1980s. Aesthetic puritanism returned to the architectural profession, and with it, another round of moralizing about unbridled abstract form, with reinforced concrete blamed for much of the "failure" of modernism. Inventive sculptural architecture became the proverbial baby that was thrown out with the bathwater of cheaply built public housing projects, badly detailed brutalist skyscrapers, and other obvious embarrassments of mundane concrete construction.

Concrete and the New Plastic Imagination
Beginning in the 1990s, both the restrictive orthodoxies and the aberrant excesses of the postmodern era began to wane, and architects once again began to explore the vast formal potential of the increasingly sophisticated materials available to them. As the twentieth century came to a close, reinforced concrete was rapidly evolving from a specific material with numerous variations into a broad spectrum of interrelated materials with wildly divergent characters and properties. Innovative architects leapt at the possibilities of such a versatile medium.

The projects featured on the following pages reflect not only the diverse results of this renewed spirit of experimentation but also the finesse that is now evident in many concrete buildings, combining beauty, expressiveness, and technological sophistication. From a private chapel, the form of which was derived through the Japanese art of origami, to a proposed skyscraper conceived as a cantilevered tower composed of an organic web of concrete surfaces, these projects reveal the almost limitless sculptural potential of reinforced concrete.

Still, the moralistic assessments of sculptural concrete forms have not yet evaporated. Witness the reactions of some critics to Santiago Calatrava's new opera house at Tenerife in the Canary Islands (2003), the signature feature of which is an audacious, cantilevered "wing" or "wave" that soars over the main volume of the building. [Figure **5**] Because it has no structural or programmatic purpose, the wing has been decried as a wasteful folly, and even—yes—a "stunt." Yet this admittedly useless form, complementing the highly sculptural body of the main building, has yielded an extraordinarily exhilarating work of architecture that has become an icon not just of Tenerife, or even of the Canary Islands, but of all of Spain. Like Nervi's complaint about the TWA Terminal, the criticisms of the Auditorio de Tenerife seem to miss the point. The quantification of material efficiency and the explicit legibility of structural forces are only marginally relevant in such a hybrid work of art, in which pure, abstract sculpture and architecture are united in a modern marriage of equal partners.

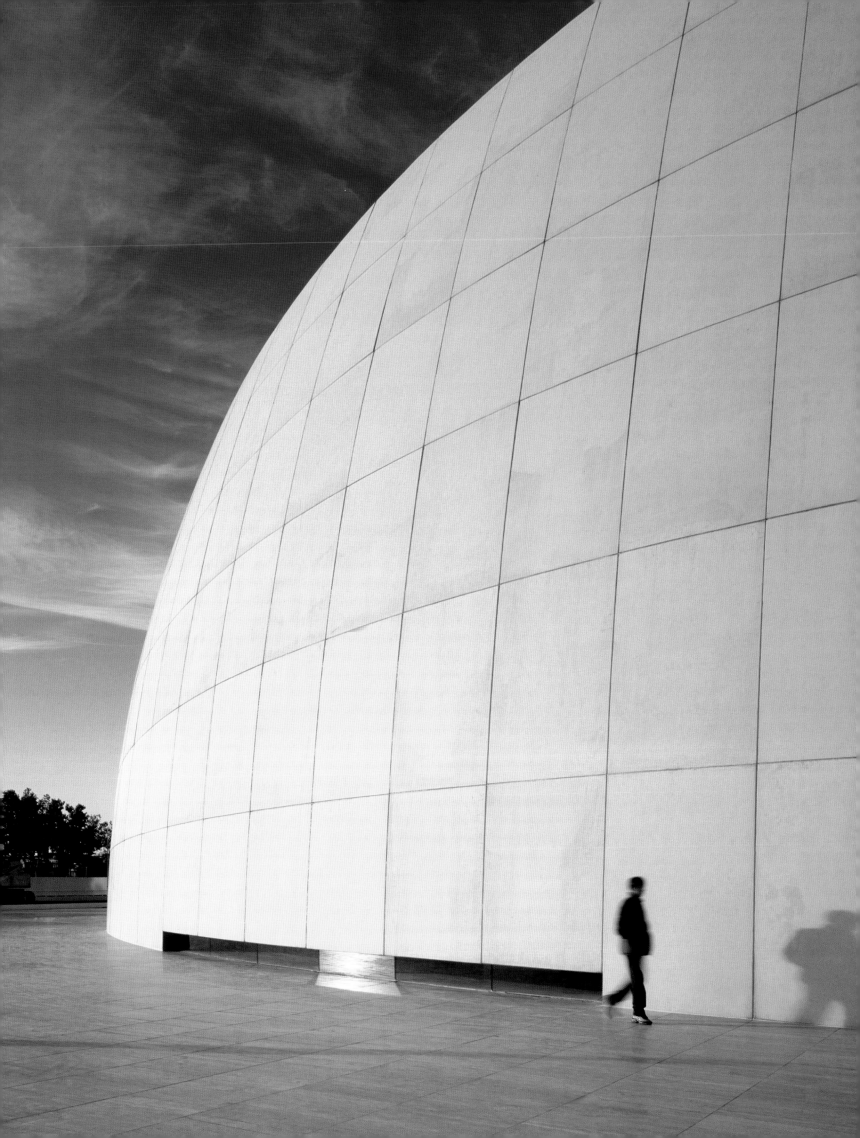

Private Chapel in Valleacerón

Inspired by the Japanese art of origami, the architects of this private chapel on the estate of a professional soccer player began the design process with a plain, rectangular paper box, which they repeatedly folded and cut, always maintaining the original total surface area of material. Eventually they ended up with the faceted form—complex when viewed from some angles, simple from others—that defines the finished building. The final structure was built directly from models, using no formal construction drawings.

Designed without artificial lighting or ventilation, the chapel is meant to be experienced only by day, when the space captures slivers of the intensely blue Mediterranean sky. The geometry of the folds focuses both views and natural light on an area of the rear wall where an image of the Virgin Mary will eventually hang. Currently, only a small, square window and a minimalist Greek cross adorn this focal wall.

Almadén, Ciudad Real, Spain
Completed 2000
Architect: **Sancho-Madridejos Architecture Office**
Structural Engineer: **Ignacio Aspe**
Contractor: **Ignacio Diezma S.L.**

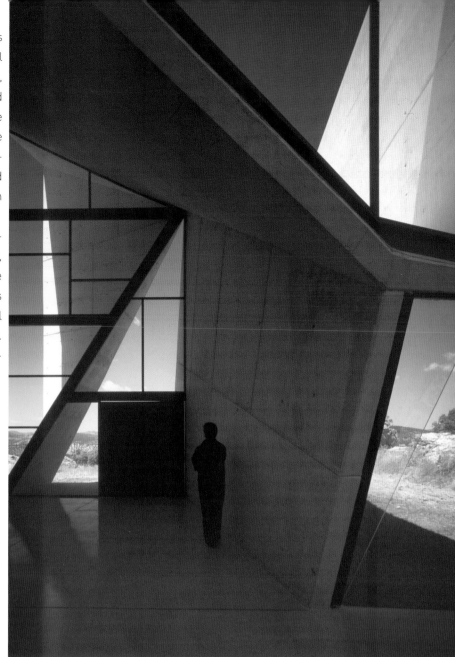

1

1 Interior, looking toward the entrance
2 Chapel, poised against the stark landscape

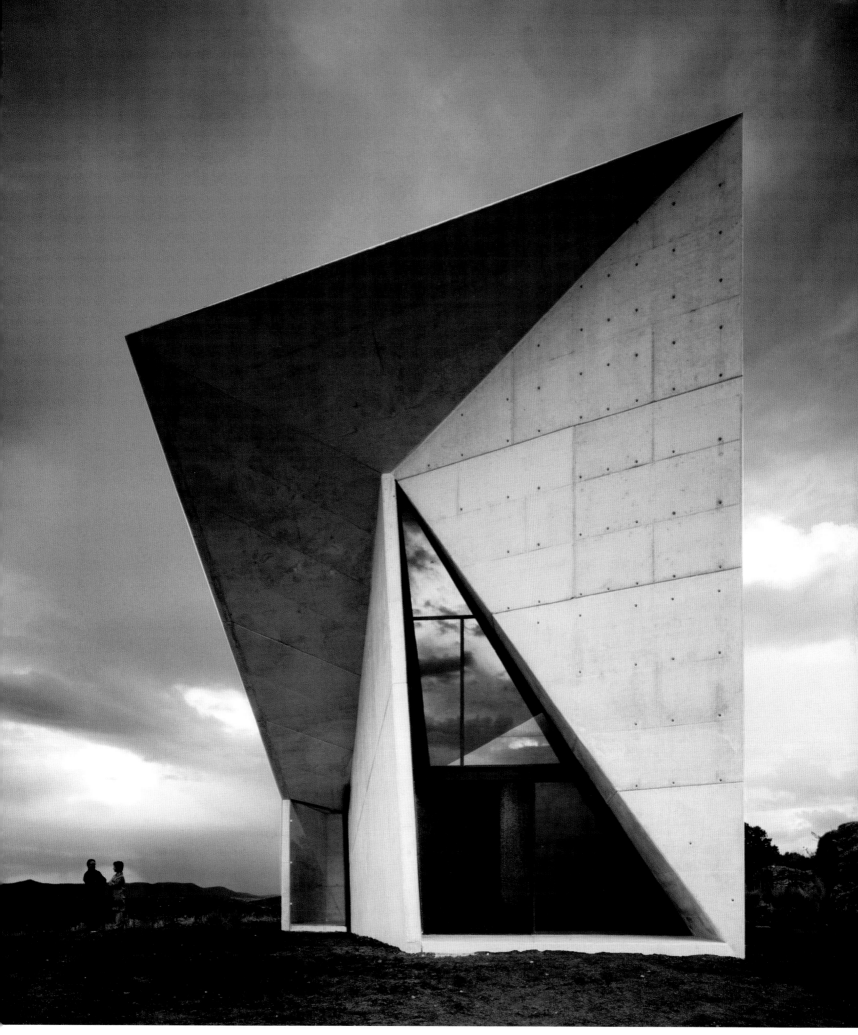

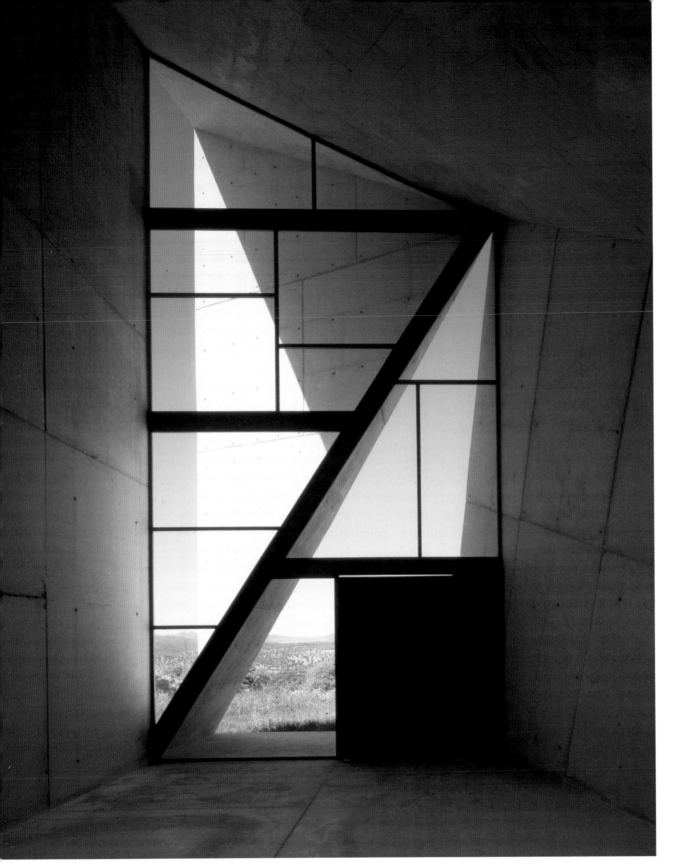

3

4

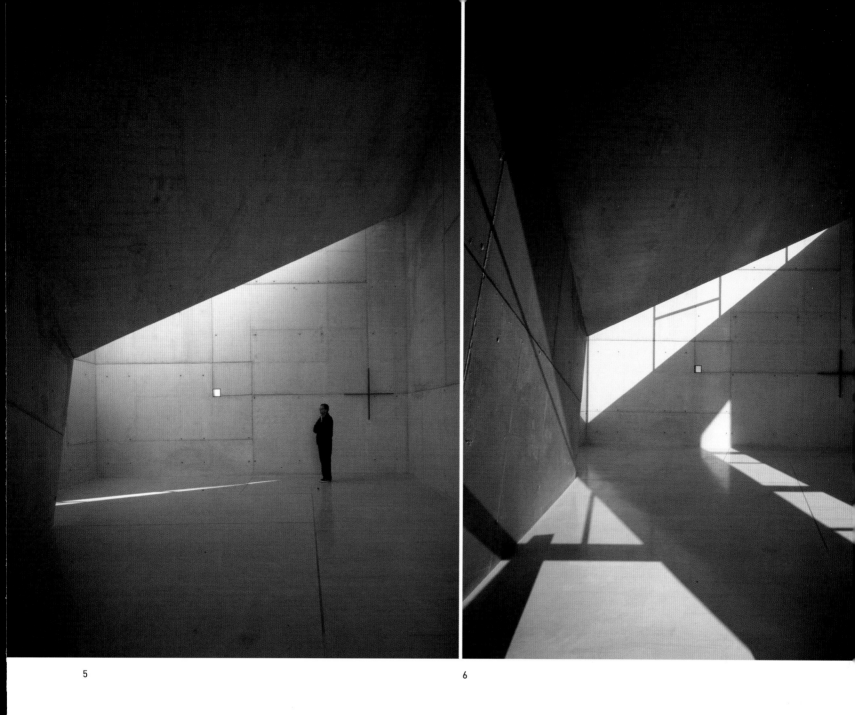

5

6

7

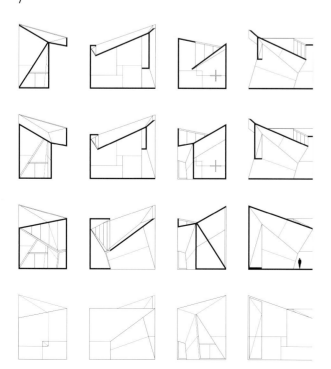

3 Interior, looking toward the entrance

4 Sequence of images conveying the origami-inspired design process

5 Small square window and minimalist cross adorning the rear wall

6 Interior, marked by dramatic contrasts between light and shadow

7 Series of sections and elevations, revealing the geometric complexity of the building

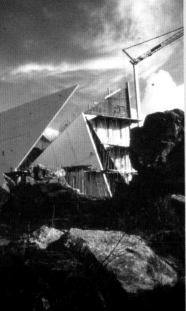

Before the roof of the chapel is installed, the cast-in-place concrete planes appear rather chaotic. The geometric integrity of the structure will not become intelligible until the final plane is set in place.

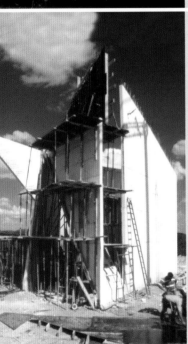

Triangular formwork is visible in the foreground of this photograph, which also shows scaffolding against the freshly poured concrete walls.

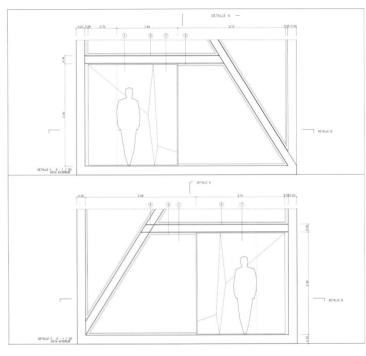

8

9

8 Partial sections
9 Sections
10 Exterior view
11 Rear facade
12 Interior, with cross visible on the left

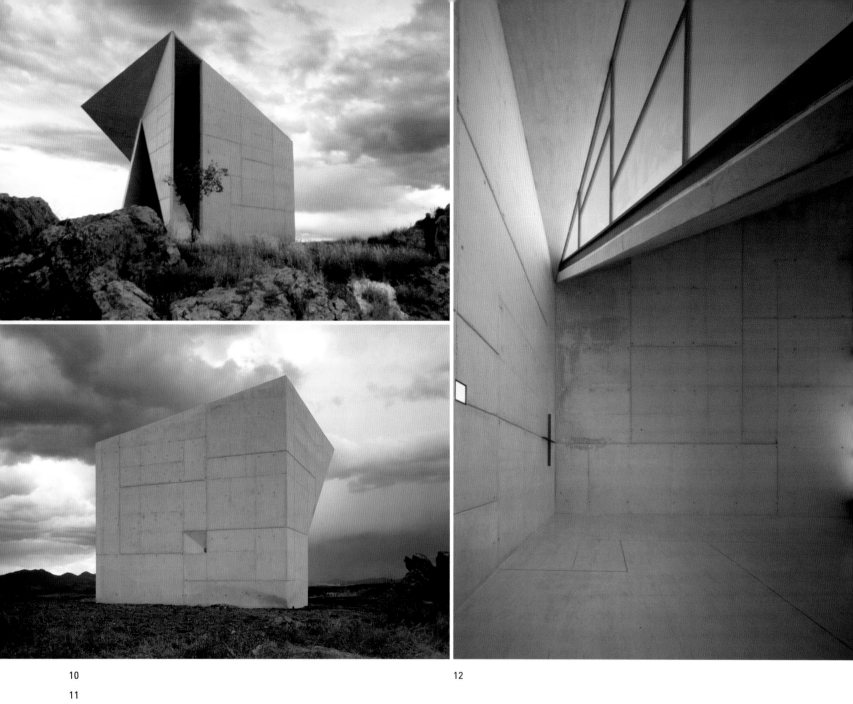

10
11

12

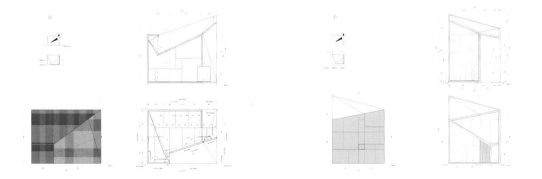

Sited at the end of a vast plaza lined with historic buildings including a sixteenth-century monastery that has been converted into a luxury hotel, León's new concert hall achieves an appropriate monumentality by virtue of its assertive and animated concrete facade. Though clearly modern in character, the facade harks back to traditional Spanish architecture in its deeply set windows—which also recall Le Corbusier's Ronchamp chapel—and strong interplay of light and shadow.

The pattern of the facade at first appears entirely random, and while the positions and shapes of the windows are irregular, the layout of the tray-like niches is actually governed by a precise geometric order. The niches grow in size from bottom to top, with each successive layer having one fewer niche than the level below. Concrete was used for this facade because the material could easily be molded to create the varied forms of the individual niches. The rear and side elevations of the building are clad primarily in travertine.

The primary facade of the building acts as a kind of giant billboard, and accordingly, the name of the concert hall is emblazoned across the base in huge letters. Just inside this sculptural wall is a triple-height exhibition space, which is marked by dramatic and constantly changing light entering through the irregular grid of windows.

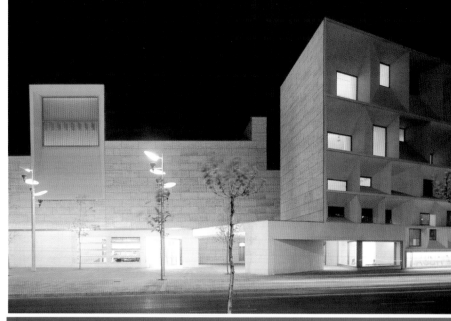

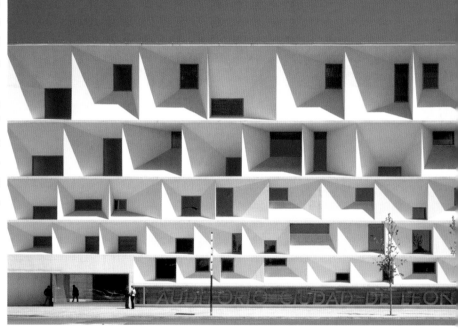

León, Spain
Completed 2001
Architect: **Mansilla + Tuñón Arquitectos**
Structural Engineers: **Ove Arup**

1

2

3

1 The two primary wings of the concert hall, with the main entrance at the center
2 Primary facade, with its billboard-like sign at the bottom
3 Sketch of the primary facade
4 Window wells, viewed from the interior

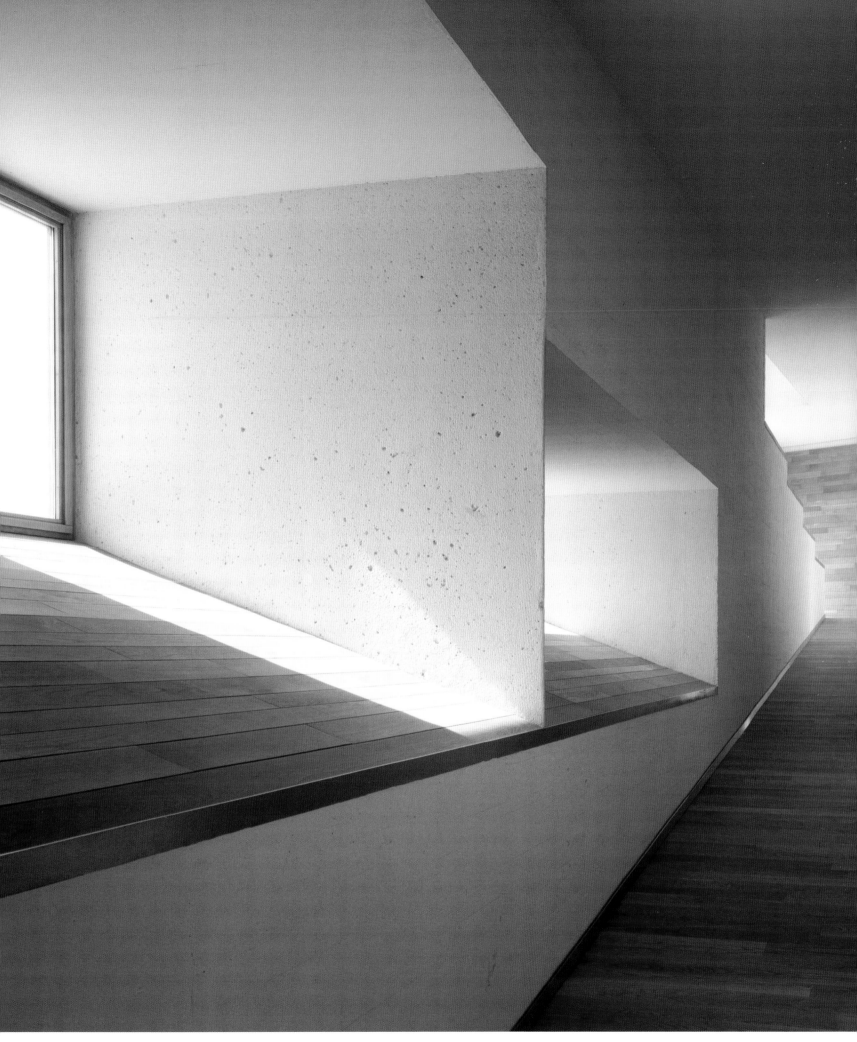

4

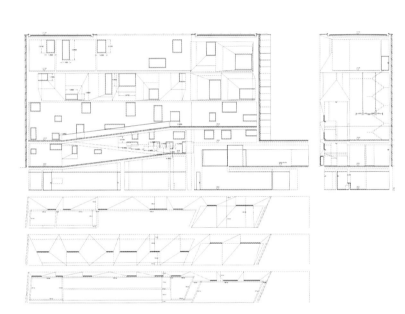

5

6

7

8

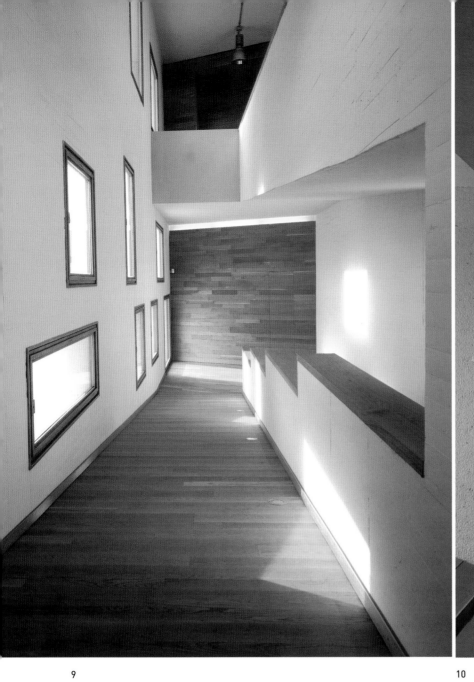

9

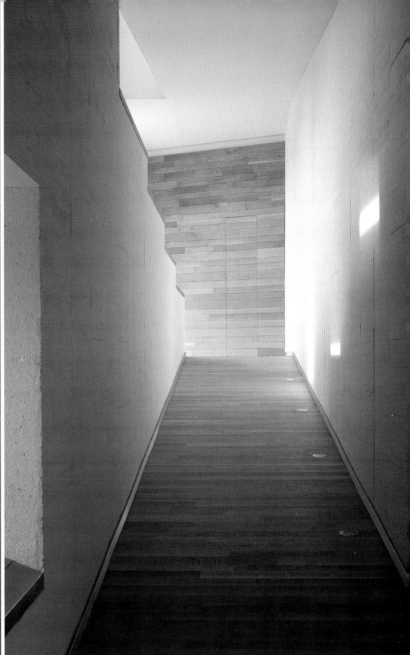

10

Auditorio Ciudad de León

Vail-Grant Residence

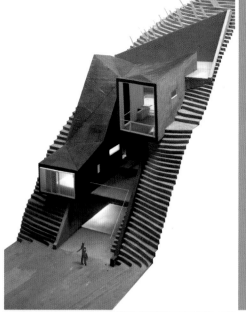
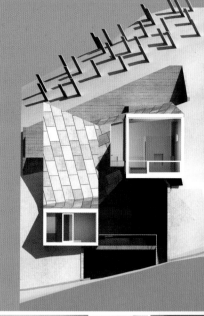
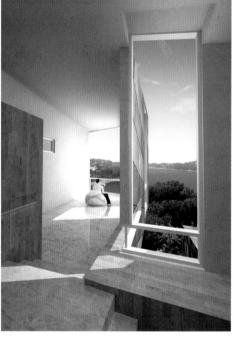

Clinging to the side of a steep hill in the Silverlake area of Los Angeles, the proposed Vail-Grant Residence was conceived as a single, twisted rectangular tube that alternately dives into and leaps away from the hillside. This spiraling form was largely a response to setback requirements intended to protect views from a landmark modernist house by Richard Neutra next door. The disposition of the house would also reduce the need for large retaining walls, enhance natural ventilation patterns, and take advantage of the thermal mass of the earth and of the structure itself to reduce mechanical heating and cooling requirements.

The proposed house was to be built of Structural Concrete Insulating Panels (SCIPs), which consist of sheets of rigid foam insulation (typically expanded polystyrene) surrounded by wire mesh. Once the panels are in place, both sides are covered with a continuous coating of dry-mix "Shotcrete," or sprayed concrete. Wire trusses connect the two concrete faces to create a strong, rigid wall that, in structural terms, behaves monolithically. The system offers various environmental advantages: the panels are made with a high percentage of recycled material, the sprayed concrete finishes minimize construction waste because they require virtually no temporary formwork, and the finished assembly has an excellent insulation value of R-40. The SCIPs panels would be used not only for the house's structural tube but also for its foundations.

The exterior of the SCIPs tube was to be clad in a thin metal skin, while the interior walls would be primarily of plaster, which would gradually absorb heat during the day and then help gently warm the house at night. The clients who commissioned the house sold the property before construction began, and the project therefore is not going forward.

Los Angeles, California, United States
Proposed 2003
Architects: **Pugh + Scarpa Architects**
Structural Engineer: **Luis Vasquez, PE**
Construction Consultant: **Green Sandwich Technologies**

1
2

3
4

1 View of model
2 Rendering of interior, looking out toward the lake
3 Head-on view of model
4 Rendering of the interior staircase
5 Rendering of view from the street
6 Preliminary sketch of the project

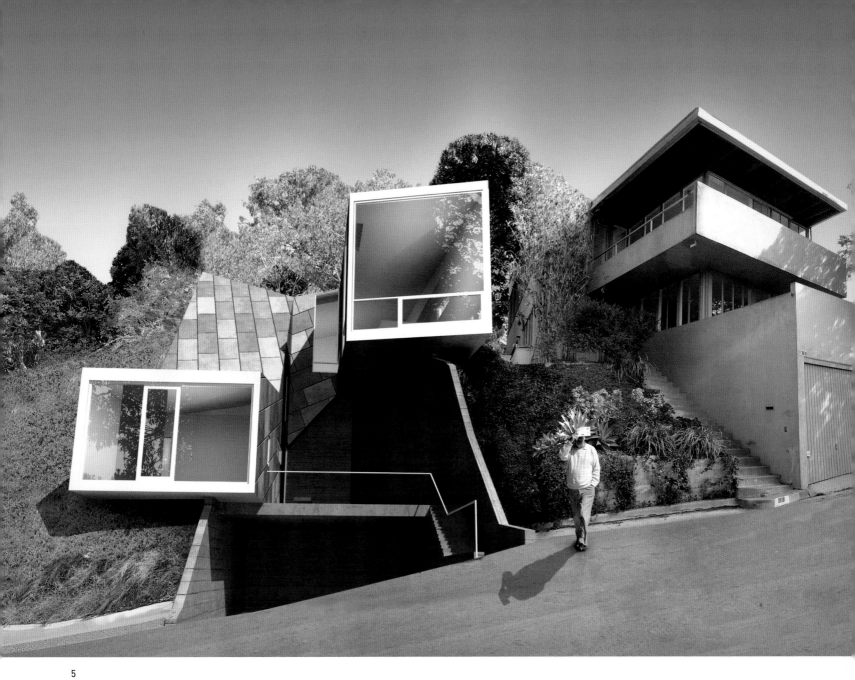

5

6

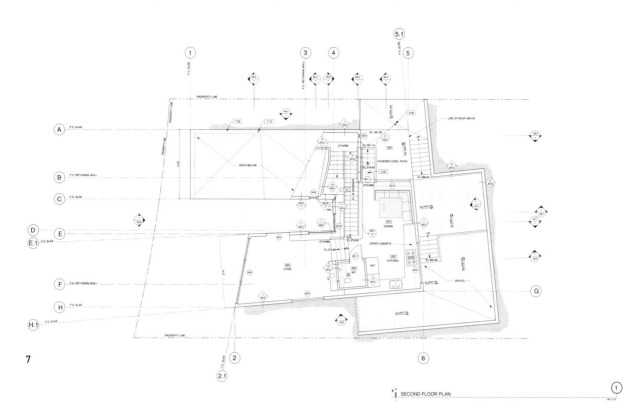

7 SECOND FLOOR PLAN

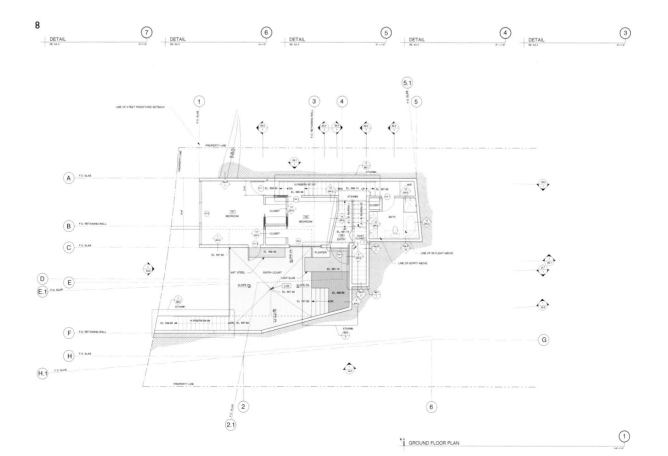

8 GROUND FLOOR PLAN

9

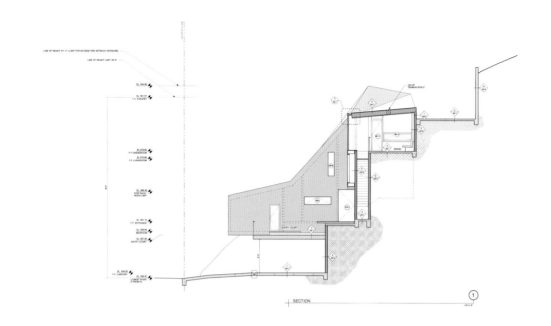

DETAIL ⑥	DETAIL ⑤	DETAIL ④	DETAIL ③	DETAIL @ CONCEALED GUTTER ②

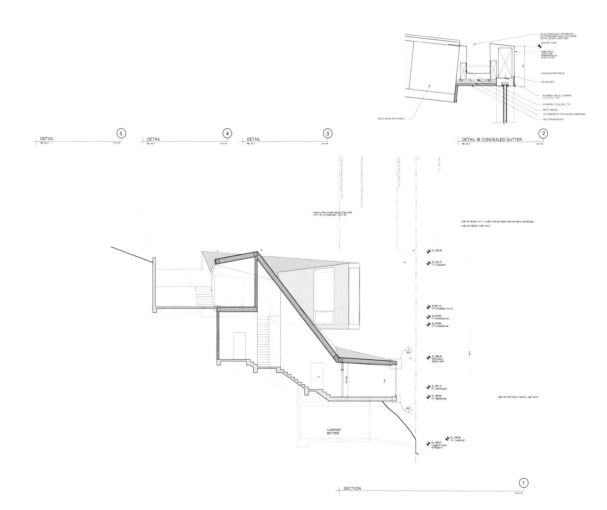

DETAIL ⑤	DETAIL ④	DETAIL ③	DETAIL @ CONCEALED GUTTER ②

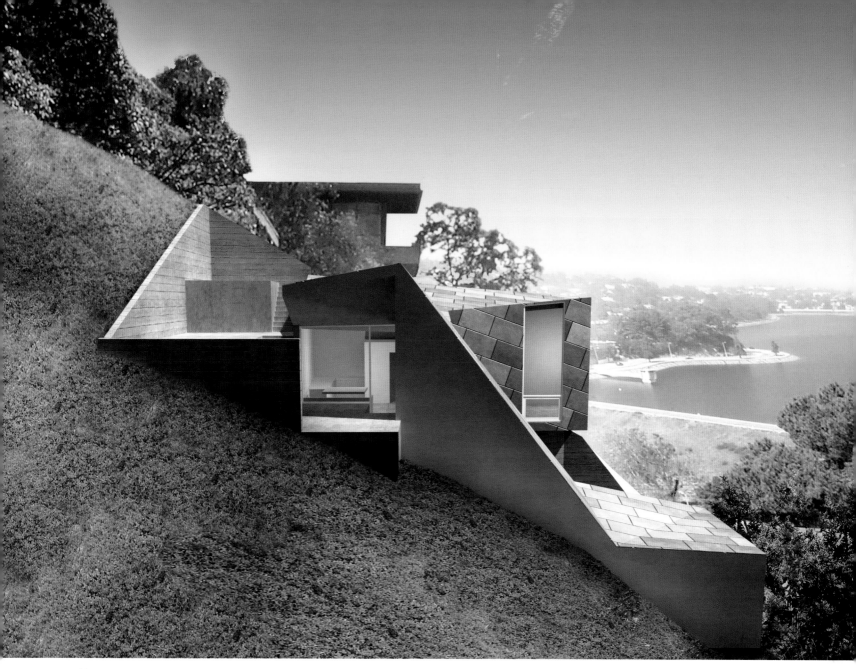

11

12 13

Rigid
Foam
Sections

Concrete-
Plaster
skins
(1"min.
with any
designed
finish)

Continuous high
strength "W" truss
(normal spacing
6" oc)

"C" ring
fastners
(secures
face wire
to trusses
& panel
to panel)

Front & back
welded face wire

GREEN SANDWICH SPREAD™
(PORTLAND CEMENT/FLY
ASH MIX) AT INTERIOR
SIDE OF GST PANEL
1" MINIMUM THICKNESS

MICRO"T"S

EPS FOAM CORE

CONTINUOUS WIRE WARREN
TRUSS GAGE, DEPTH, &
SPACING PER ENGINEERING

GREEN SANDWICH SPREAD
(PORTLAND CEMENT/FLY ASH
MIX) AT EXTERIOR SIDE OF GST
PANEL 1" MIN THICKNESS

WELDED WIRE MESH GAGE AND
SPACING PER ENGINEERING

"C-RING" FASTENERS
SECURING MESH TO TRUSS

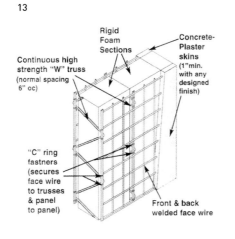

Mission Hill Family Estate Winery

The architecture of this Canadian winery alludes to traditional, vernacular structures of Mediterranean winemaking regions while remaining resolutely modern itself. The below-ground spaces are of board-formed concrete, a relatively crude casting technique intended to hint at the ancient history of winemaking, while the above-ground elements use precast concrete components, a more sophisticated technique suggesting the contemporary side of the wine industry.

The two large wine cellars, for instance, were excavated out of the land and are structured as a series of board-formed concrete arches, between which the natural, rough granite of the site remains visible. A baronial dining and tasting hall, also supported by board-formed concrete arches, occupies the remaining portion of the cellar level. Connecting the cellar to the ground floor is a stair tower, which is also the focal element of the entire complex. Composed of a series of interlocking precast panels, the tower, which houses four working bells at the top, is open to the elements. Rain entering through the openings in the tower may fall all the way to the cellar, where it collects in a spiraling tray of concrete.

Westbank, British Columbia, Canada
Completed 2001
Architect: **Olson Sundberg Kundig Allen Architects**
Associate Architect: **R. Martin Cruise, Architect**
Structural Engineers: **John Bryson & Partners**
Contractor: **Selco Construction**

1

2

1 Open pavilion with a barrel-vaulted roof, echoing the forms of the structural ribs in the below-ground spaces
2 Barrel room, supported by concrete ribs, with natural stone exposed between them
3 General view of the complex
4 Site plan

3

4

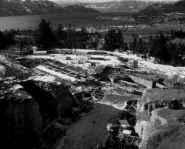

The winery sits atop a glacial geological formation. After the native rock was blasted away, the concrete foundations were poured.

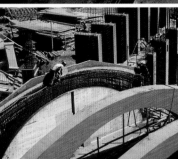

The board-formed, reinforced concrete piers and cycloid arches of the cellars and dining hall are poured.

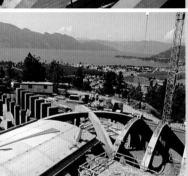

Precast shells are set in place above the cycloid arches and cross vault.

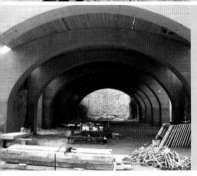

This view from below the cross vault looking into the east cellar shows the series of arches that support the roof and also buttress the exposed rock walls.

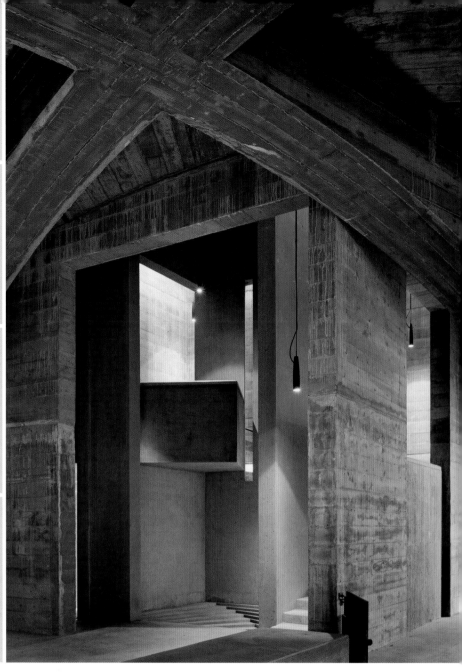

5

6

5 Concrete groin vault in the cellar, with base of the tower visible at center left
6 Lower-level plan
7 View of exterior, with dining and tasting hall on the lower level to the right
8 Open-air pavilion with the dining and tasting hall below
9 Entrance to the cellar
10 Section

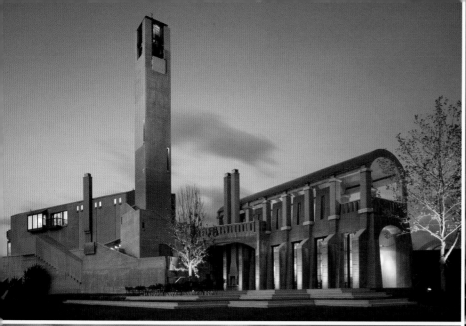

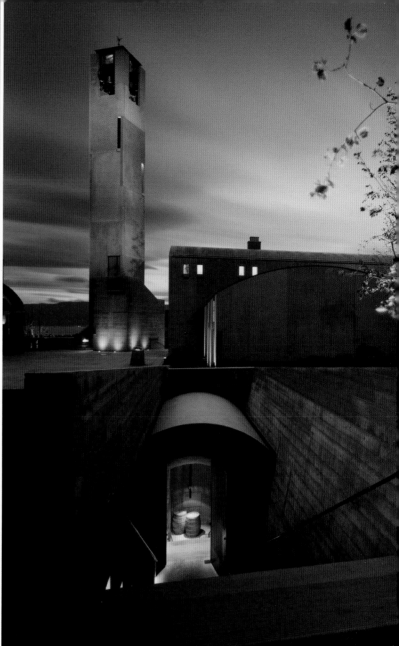

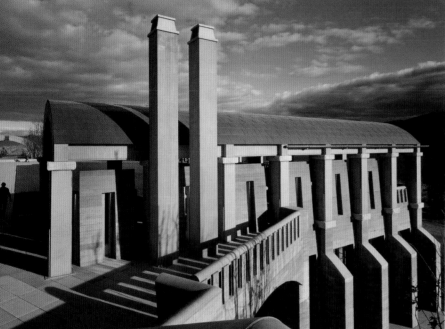

7

8

9

10

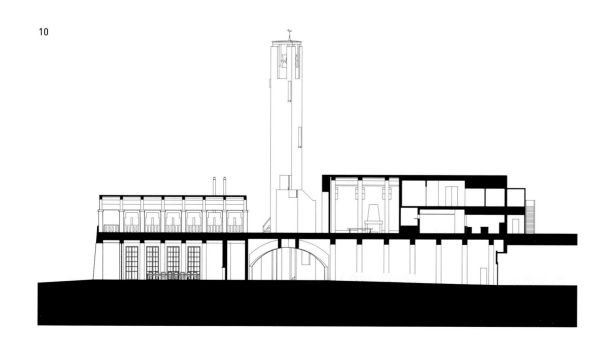

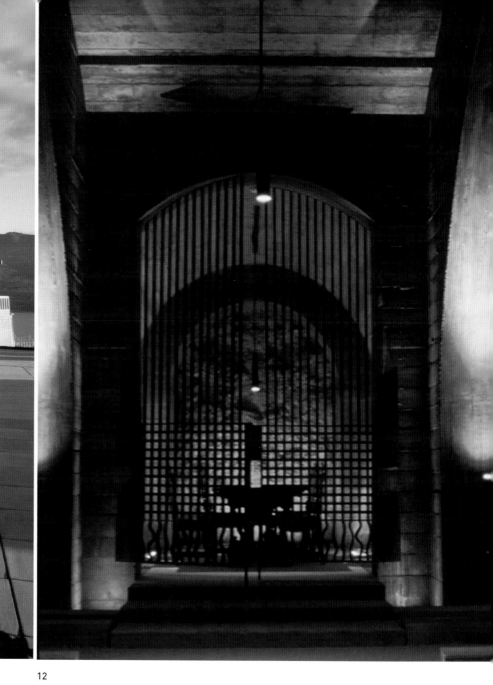

11

12

8
9

10

Big Belt House

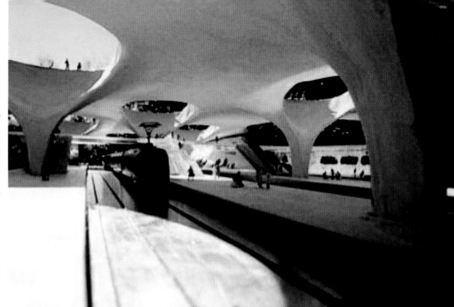

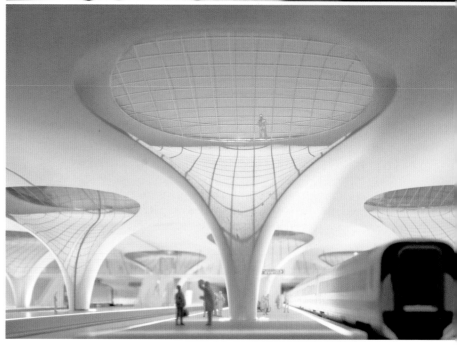

Main Station Stuttgart

The current central train station in Stuttgart, Germany, is a terminal, with tracks entering from only one direction, and therefore cannot efficiently handle high-speed, intercity trains that typically run on through-station tracks. To address this problem, the German national railway is embarking on an ambitious plan to build new, underground tracks that enter the city center at a right angle to the existing lines. These tracks will bypass the historic terminal, which is expected to be converted to some other civic use.

Replacing the old terminal will be a new, subterranean railway station, nearly 1,400 feet (420 meters) long, inserted into the heart of the dense city. The vast, underground train shed will be covered by a reinforced concrete roof supported by just twenty-nine columns. Reminiscent of giant calla lilies, the gracefully flaring columns will be capped by vented "light eyes," which will bring daylight into the space by day and provide natural ventilation at all times. The glazing will be supported by a web of cables connected to a ring beam around the edges of the openings, which will transfer the loads as simple compression to the columns. Preliminary calculations indicate that chimney-effect air circulation through the vents will keep the temperature in the station below 68 degrees Fahrenheit (20 degrees Celsius) in the summer, while the thermal mass of the surrounding earth will prevent the temperature from dropping below freezing in the winter.

The structural design was inspired in part by Frei Otto's experiments involving the physical properties of soap bubbles. The subtly vaulted roof will be extremely efficient from an engineering standpoint—the thickness of the concrete shell is less than one hundredth of the length of the span between columns. In effect, the columns and roof will work together as a monolithic concrete structure. The top surface of the roof will be landscaped to serve as an extension of an existing park.

1
2

Stuttgart, Germany
Projected completion 2013
Architect: **Ingenhoven und Partner, in collaboration with Frei Otto**
Structural Engineers: **Ingenieurgemeinschaft Leonhardt, Andrä und Partner, with Buro Happold Consulting Engineers Ltd.**
Structural Consultants: **Frei Otto, with SL Sonderkonstruktion und Leichtbau**
Building Physics Consultants: **DS-Plan GmbH**

1 View of a model of the proposed station
2 Rendering of station interior
3 Cross-sectional view of the proposed station, with existing station at right
4 Longitudinal and transverse sections

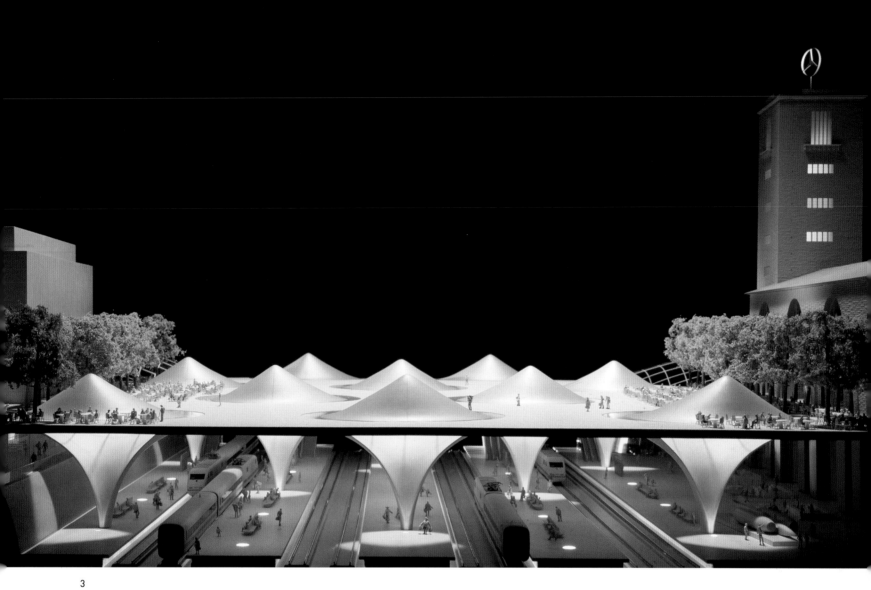

3

4

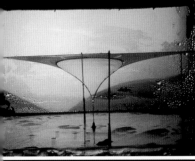

The fundamental form of the station's giant columns is inspired by engineer Frei Otto's studies of the structural properties of soap bubbles. The soapy film shown here has a shape that is remarkably similar to that of the final column design.

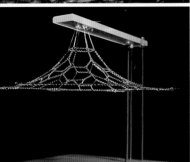

The architects develop dozens of working models in collaboration with Frei Otto to explore the structural properties of various designs. These experiments demonstrate that a vaulted compression shell would be more efficient structurally than a suspended tension shell.

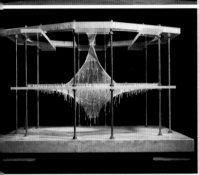

Even more precise working models are used to fine-tune the computational analysis of the columns' structure.

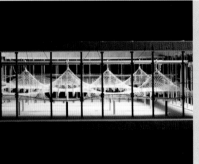

Following the structural analysis of the individual column design, the architects and engineer develop larger models to examine the properties of the fully integrated system of columns and roof. They discover how to engineer the structure so that all of its components would be in compression, thereby maximizing the efficiency of the building.

5

6

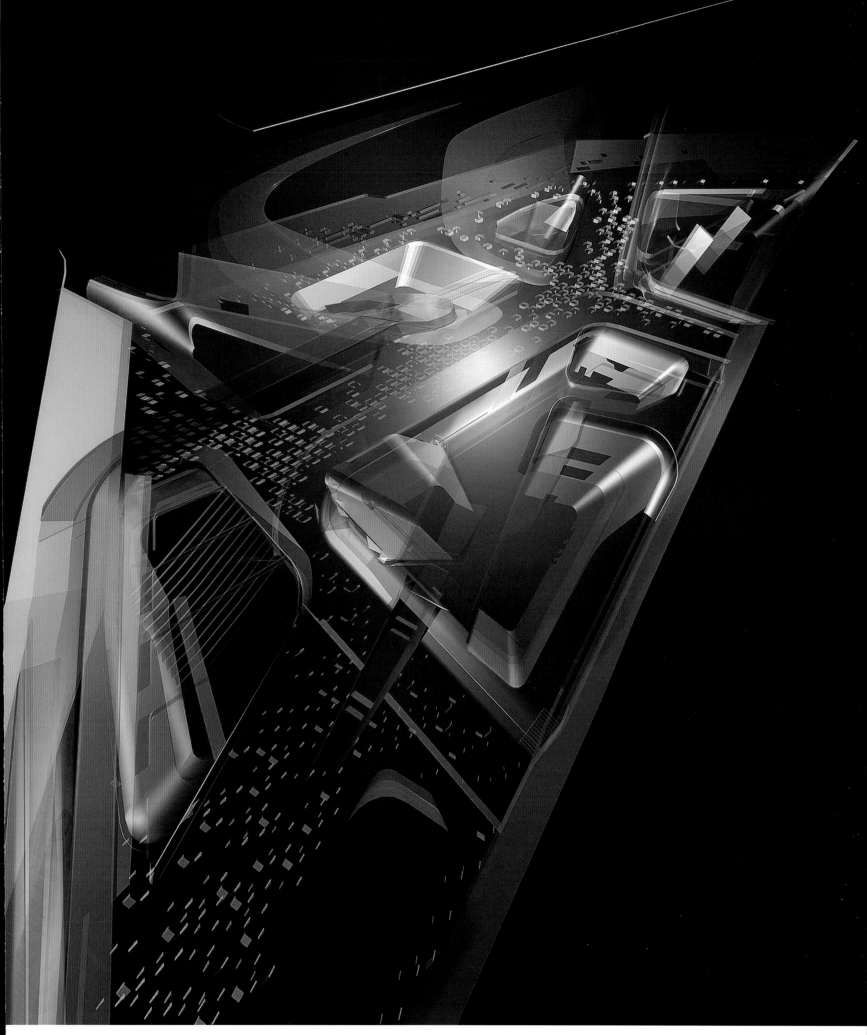

3

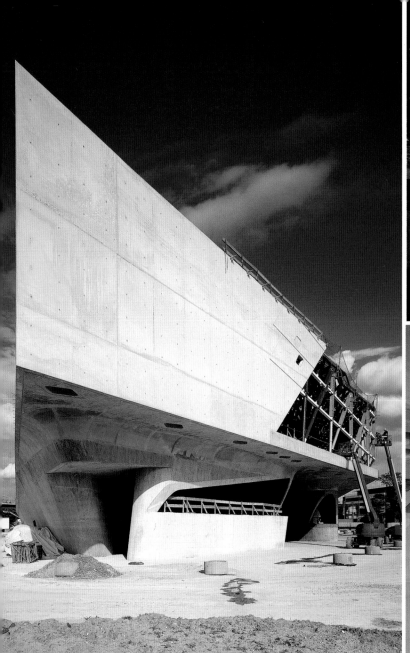

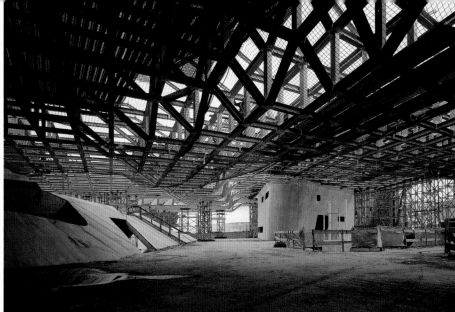

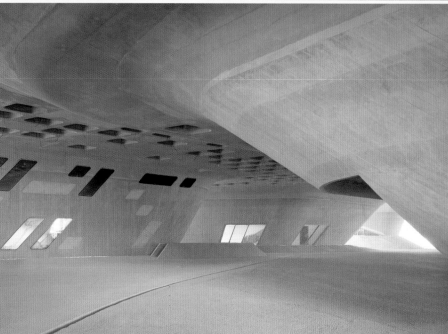

4

5

6

7

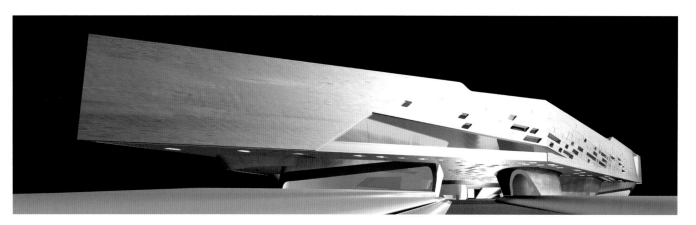

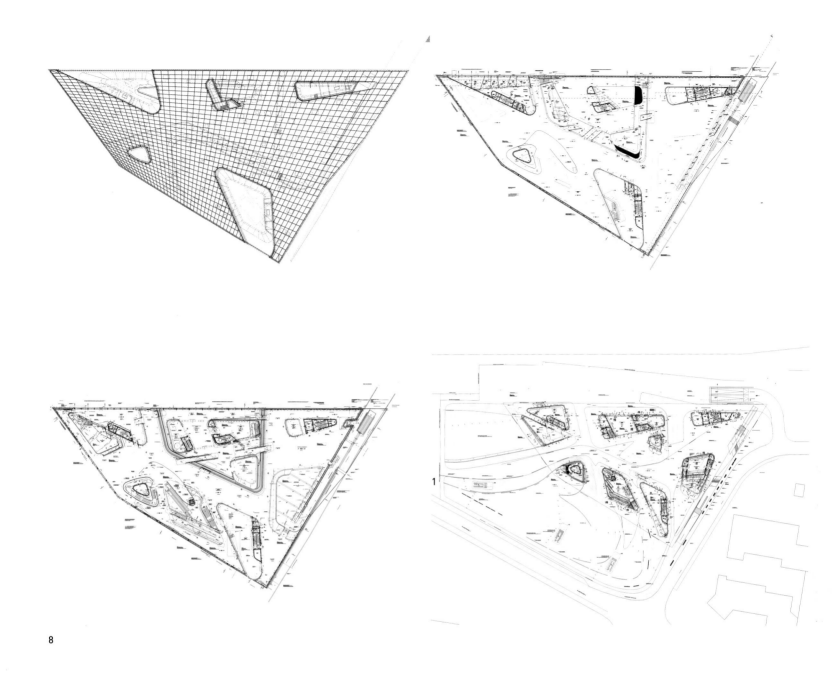

8

9

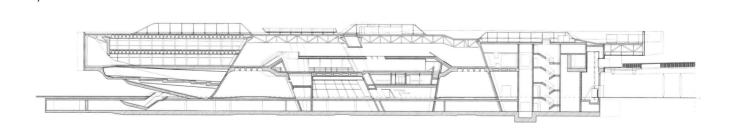

4, 5, 6 Views of building at various stages of construction

7 Rendering of the building

8 Roof, mezzanine, ground-floor, and basement plans

9 Section

This aerial view of Phaeno Science Center during construction shows the concrete structure for the principal floor level cantilevered over funnel-shaped legs.

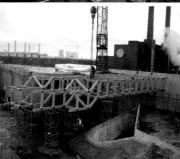

The building's roof structure consists of steel trusses.

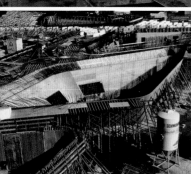

Large, funnel-like concrete columns support the cantilevered structure. This construction photograph shows steel reinforcing bars that will be tied into the structure of the floor that this leg supports.

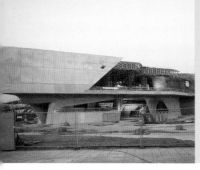

The basic structure of the building nears completion.

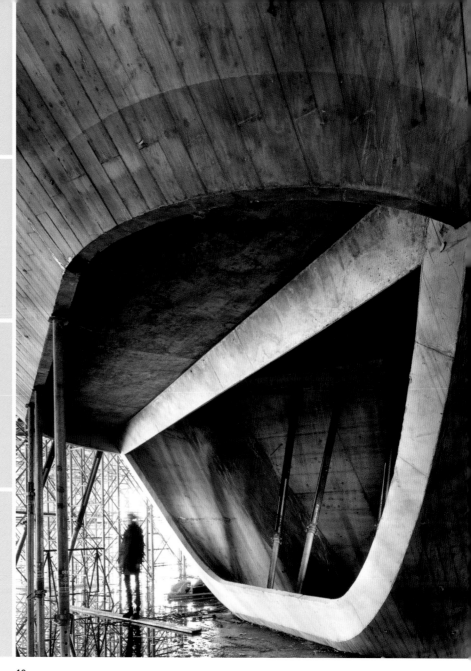

13

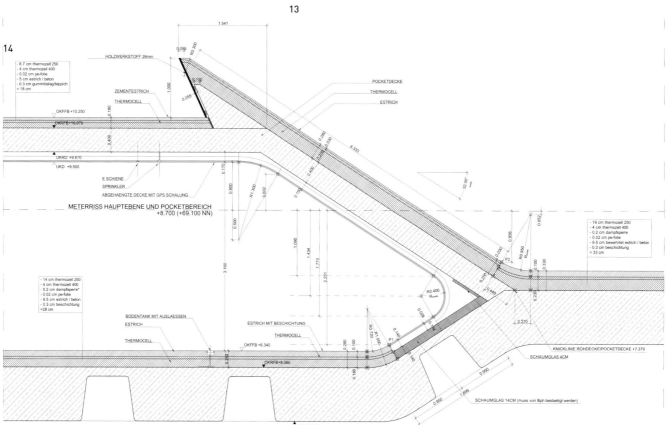

14

- 8.7 cm thermozell 250
- 4 cm thermozell 400
- 0.02 cm pe-folie
- 5 cm estrich / beton
- 0.3 cm gummibelag/teppich
= 18 cm

HOLZWERKSTOFF 26mm

POCKETDECKE
THERMOCELL
ESTRICH

ZEMENTESTRICH
THERMOCELL

OKFFB +10.250
OKFFB +10.070

UKRD +9.670
UKD +9.500

E SCHIENE
SPRINKLER
ABGEHAENGTE DECKE MIT GPS SCHALUNG

METERRISS HAUPTEBENE UND POCKETBEREICH
+8.700 (+69.100 NN)

- 19 cm thermozell 250
- 4 cm thermozell 400
- 0.2 cm dampfsperre
- 0.02 cm pe-folie
- 9.5 cm bewehrter estrich / beton
- 0.3 cm beschichtung
= 33 cm

- 14 cm thermozell 250
- 4 cm thermozell 400
- 0.2 cm dampfsperre*
- 0.02 cm pe-folie
- 9.5 cm estrich / beton
- 0.3 cm beschichtung
=28 cm

BODENTANK MIT AUSLAESSEN
ESTRICH
THERMOCELL

ESTRICH MIT BESCHICHTUNG

THERMOCELL
OKFFB +6.340

OKRFFB +6.060

KNICKLINIE ROHDECKE/POCKETDECKE +7.370

SCHAUMGLAS 4CM

SCHAUMGLAS 14CM (muss von Bph bestaetigt werden)

UKRD +5.160

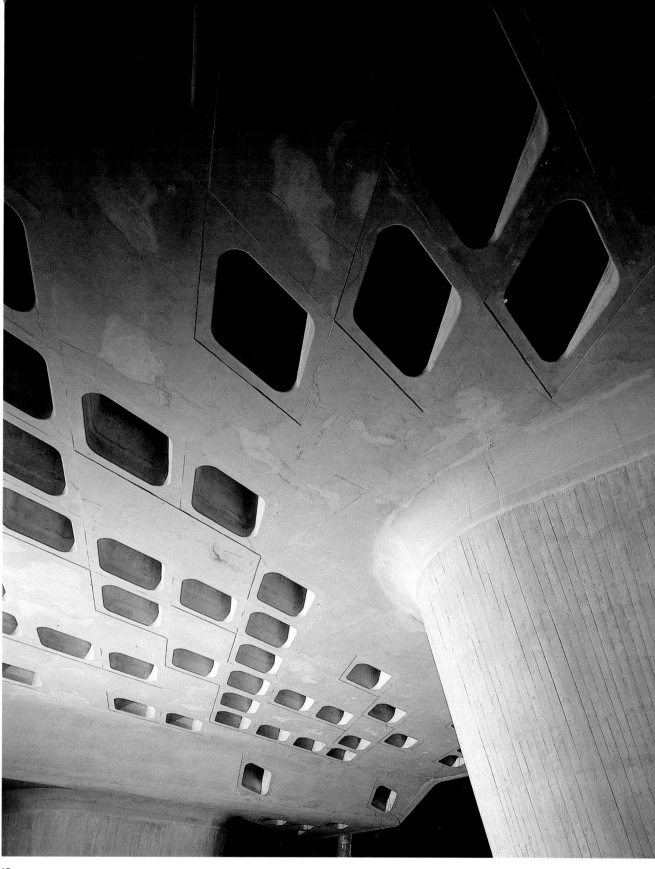

15

13 Detail of supporting structure under construction
14 Section detail at upper level
15 Underside of second level, showing coffers in concrete
 structure

Jubilee Church

Commissioned by the Vatican to celebrate the two thousandth anniversary of Christianity, the Chiesa del Dio Padre Misericordioso, or Jubilee Church, stands out amid the bland housing developments of suburban Rome. The signature feature of the building is a series of three sail-like forms, ranging in height from 56 to 88 feet (17 to 27 meters) and loosely representing the Holy Trinity. These arcs were built of 12-ton (nearly 11,000-kilogram) precast concrete blocks, 32 inches (80 centimeters) thick, each of which is a segment of a perfect sphere: only a single steel form, adjustable at the ends, was needed to produce all of the more than three hundred precast units. The blocks were then lifted into place by a huge gantry, which moved along curved rails to create the arcs. Because the arcs are self-supporting (except for minimal ties to resist seismic and wind loads), the metal-and-glass elements between them are very light, as they must carry only their own weight.

Richard Meier is most famous for his gleamingly white buildings, which he usually covers in enameled metal panels. In order to produce concrete of unadulterated whiteness, he worked with local contractors to resurrect a brilliantly white cement that had been developed for Rome's Stadio Flaminio in 1960 by engineer Pier Luigi Nervi. Stark white Carrara marble was used as the aggregate. To ensure that the finished concrete would not become discolored over time, the contractor added photocatalytic particles to the concrete mix. In theory, when these particles are activated by the light of the sun, they will neutralize atmospheric pollutants.

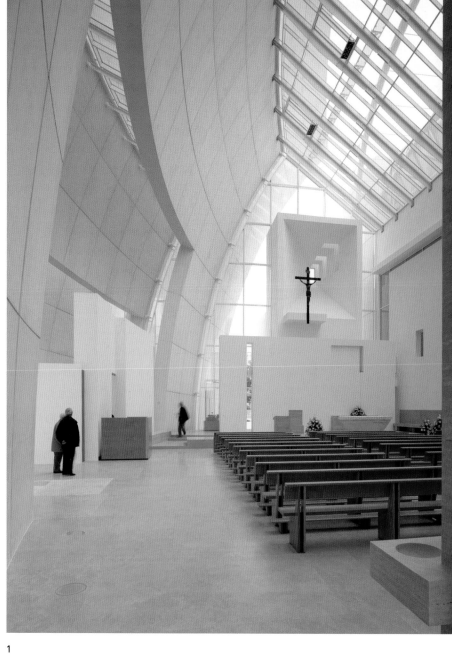

1

Rome, Italy
Completed 2003
Architect: **Richard Meier & Partners Architects**
Engineers: **Arup, Guy Nordenson and Associates, Studi Tecnic Michetti, Luigi Dell'Aquila, Dott. Ing.**
Precast Concrete: **Italcementi Gruppo**

2

1 Interior view, looking toward the altar
2 Diagram showing spherical curvature of concrete shells
3 Entrance facade

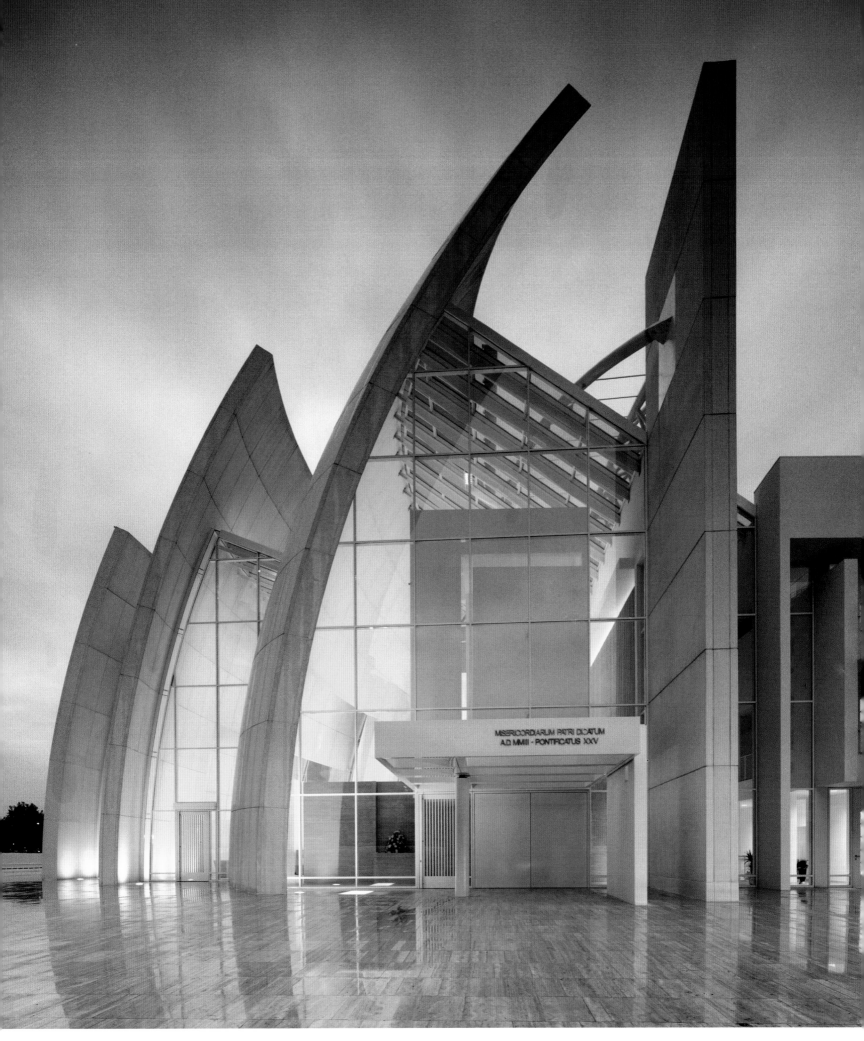

The moveable gantry, reminiscent of temporary structures employed to build ancient cathedrals, is used to place the concrete panels in the three great arcs of the Jubilee Church. In this view of the very early stages of construction, the curving tracks along which the gantry moves are visible.

A precast panel is lifted into place by the gantry. The machine is designed to rotate freely in all dimensions and is carefully balanced to enable it to support the precast panels in any position during the installation process.

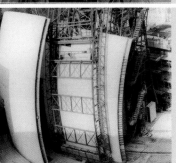

The panels are actually sandwich-like units, with steel reinforcement in the middle and precisely designed brackets on the sides that facilitate connections between units. Shown here is the edge of one of the arcs before it is sealed.

The gantry is still in place as the arcs near completion.

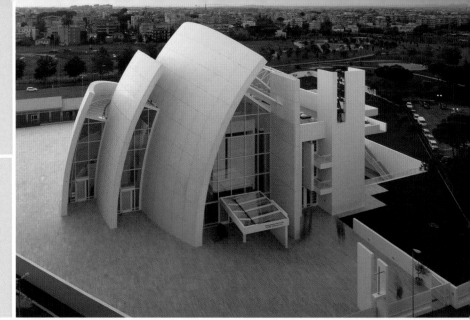

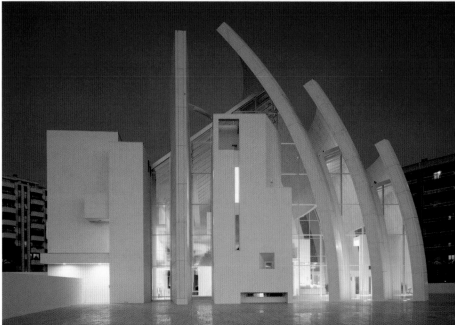

4
5

6

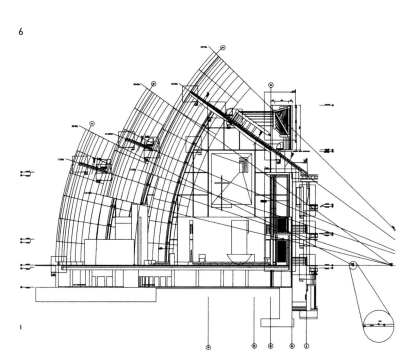

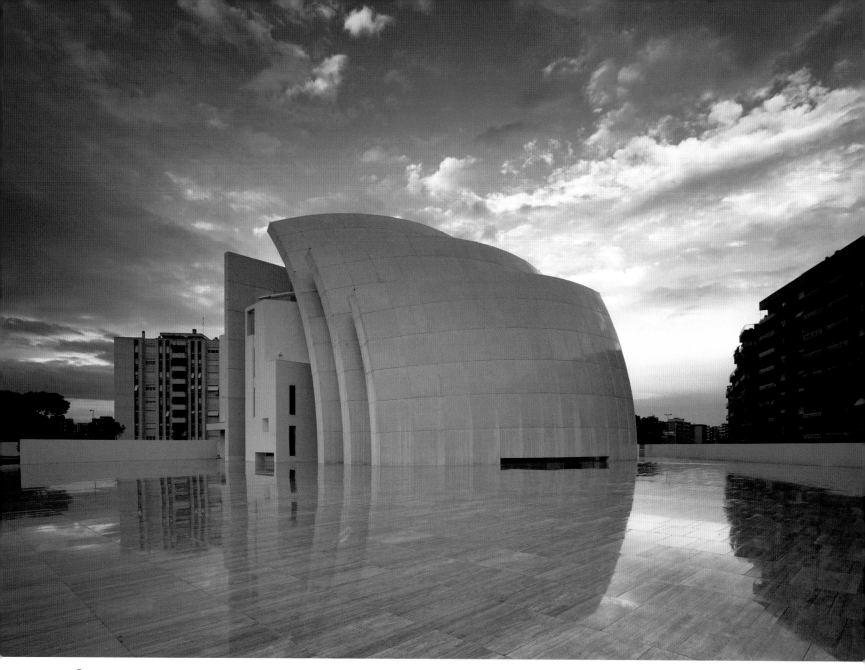

7

8

4 Aerial view of the church
5 Rear facade
6 Diagram showing the curving geometry of the shells
7 Side view
8 Diagrams of the curving rails and gantry

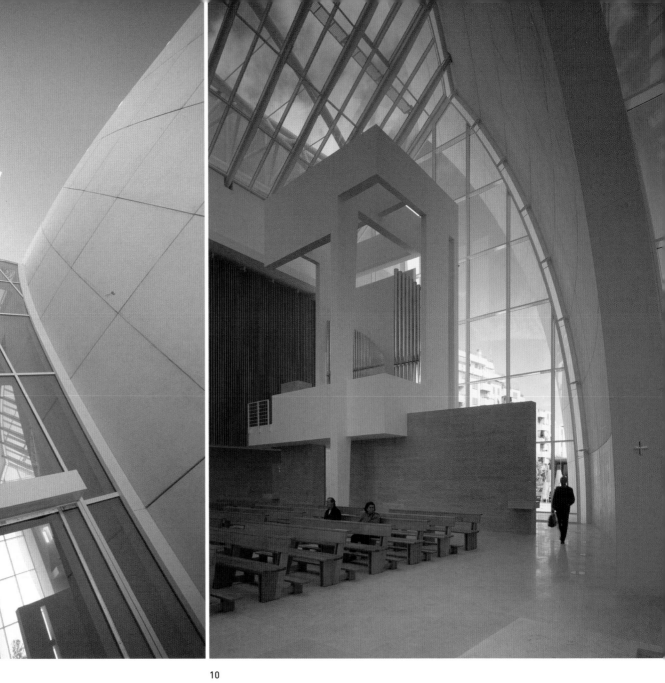

9

10

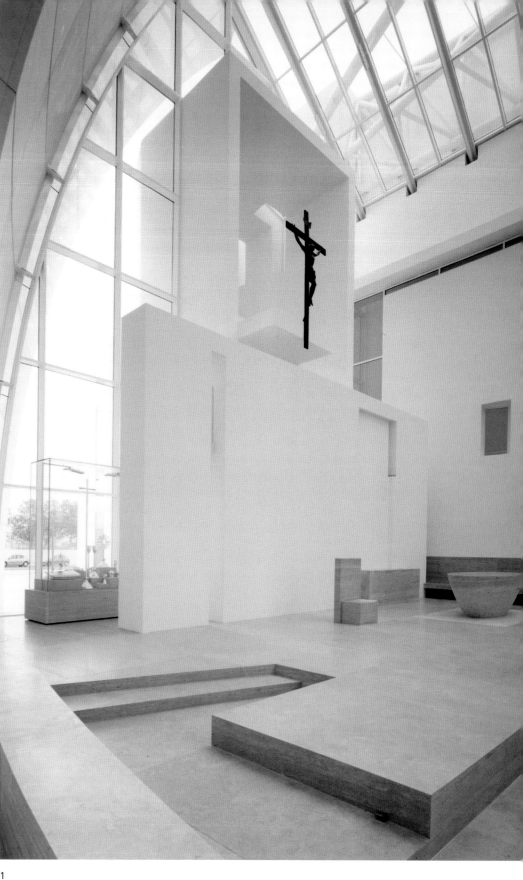

11

9　View of the lazed juncture of two curving facades

10　Interior view, looking toward the rear of the sanctuary

11　Interior of the sanctuary

Auditorio de Tenerife

Destined to become the very symbol of the Canary Islands, just as the Sydney Opera House is for Australia, the astonishing new concert hall in Tenerife is as much a work of sculpture as of architecture. The soaring concrete "wing" that crowns the building serves no functional purpose, but it provides the monumental scale and dramatic gesture that the architect felt were vital for such an important public structure to hold its own visually against the open sea on one side and the city and mountains on the other.

The wave, which reaches a height of almost 200 feet (60 meters), was prefabricated on the mainland in seventeen pieces, the largest of them weighing over 60 tons (54,000 kilograms). Once on site, these pieces were lifted into place by crane, and the voids in the prefabricated components were then filled with concrete. Spanning 320 feet (98 meters) from the base of the arc to the tip, the wave is supported only at the base and at one central point at the top of the main body of the building—the side wings do not quite touch the soaring form.

Much of the building's exterior concrete surface is covered with broken white ceramic tiles, a technique that recalls the work of the early twentieth-century Catalán architect Antoni Gaudí and other, more traditional Spanish buildings. This finishing method is repeated in the interior circulation and lobby spaces.

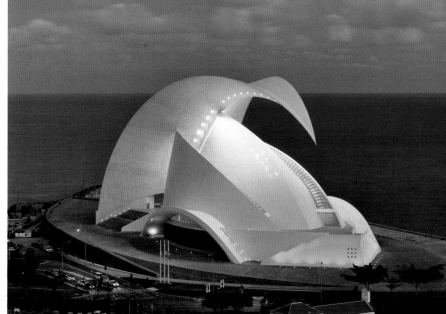

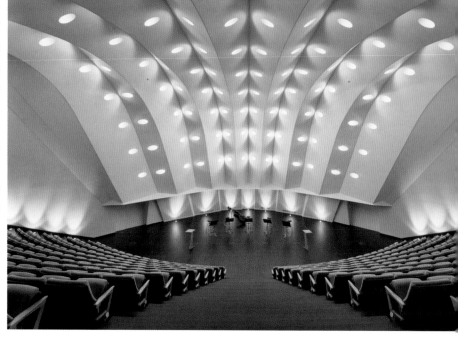

1

2

Tenerife, Canary Islands, Spain
2003
Architect: **Santiago Calatrava**
General Conctractor: **Ute Auditorio de Tenerife**

3

1 Aerial view, with the ocean in the background
2 Interior of the chamber orchestra hall
3 Diagrams of the main concert hall's interior shell
4 Head-on view of the building

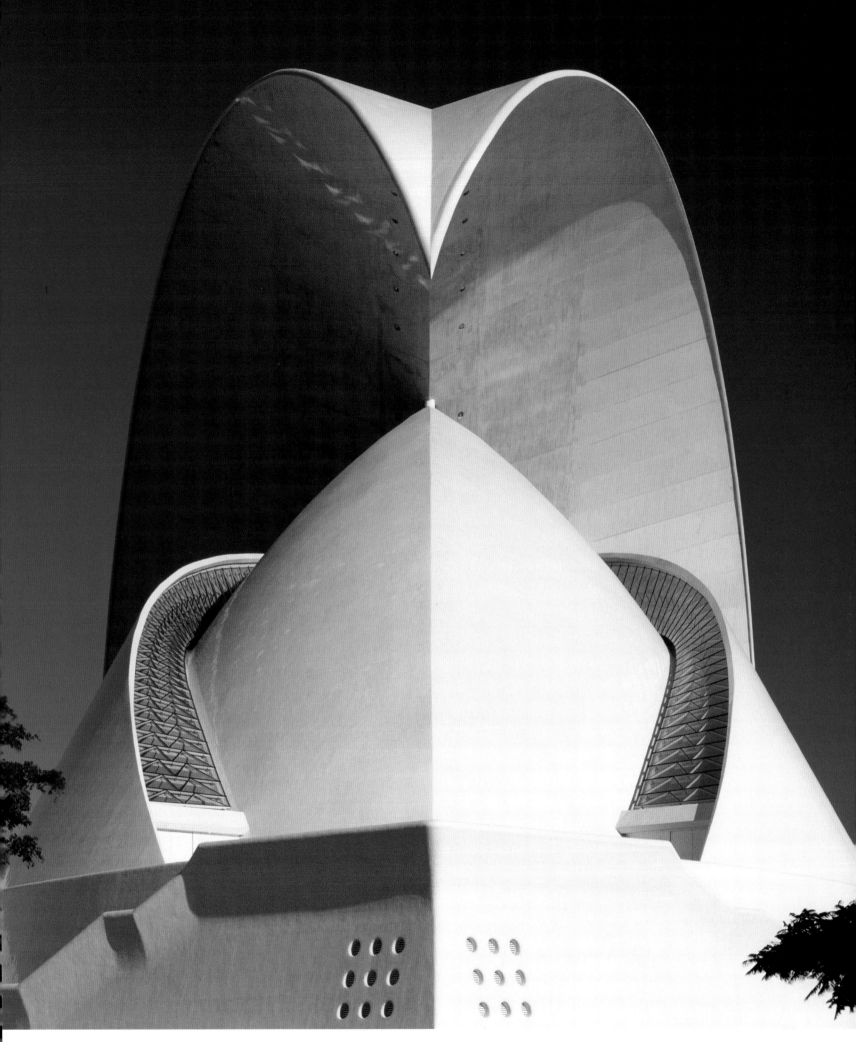

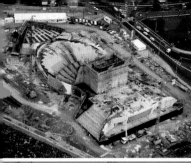

In this aerial view of the site during construction, the rounded form of the main auditorium is visible at the center. The spring point for the huge, cantilevered "wing" is in the right foreground.

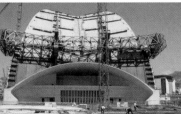

This construction photograph of the rear of the building shows a scaffold in place to allow finishing of the concrete surface.

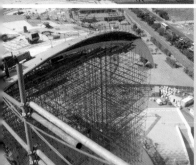

Scaffolding supports the cantilevered "wing" during construction.

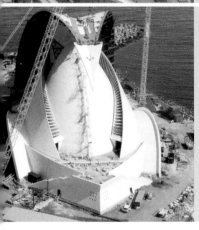

The prefabricated tip of the "wing" is installed before the finished concrete for the rest of the structure is set in place.

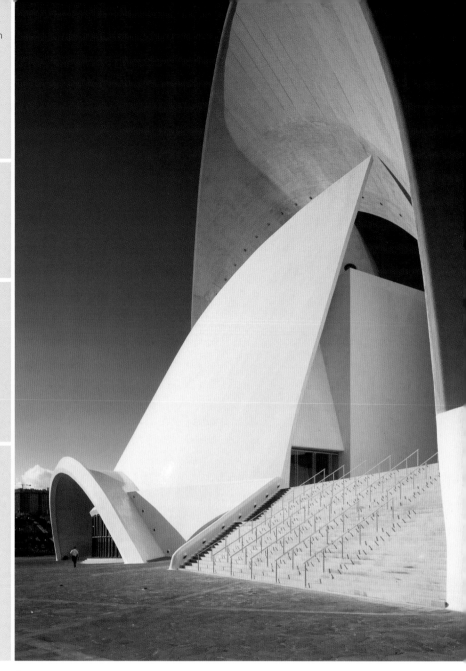

5

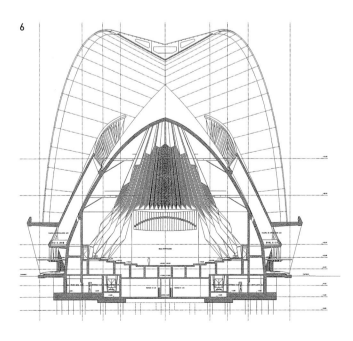

6

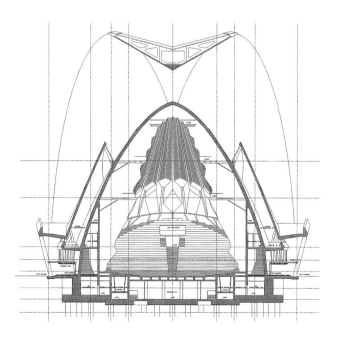

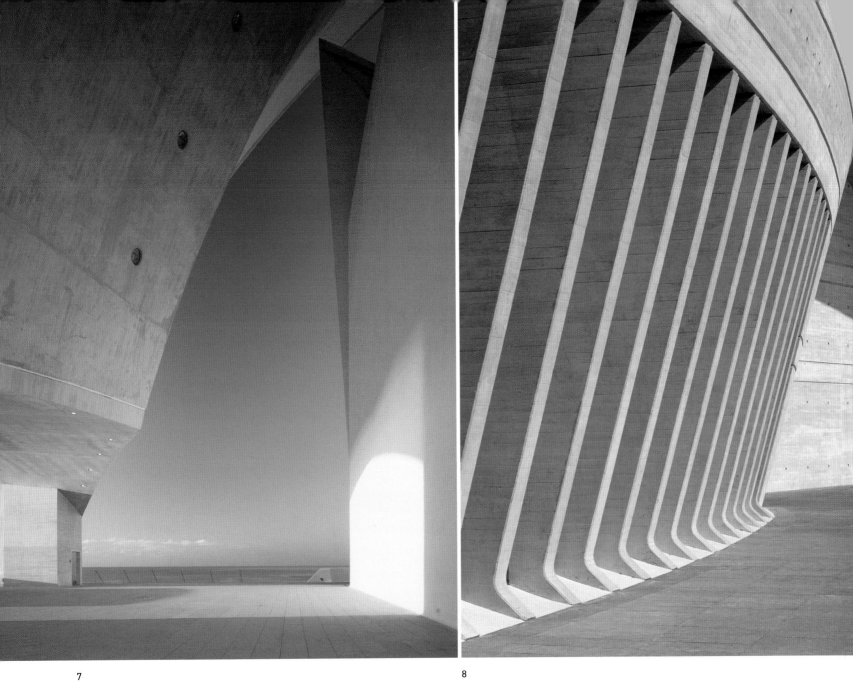

7 8

9

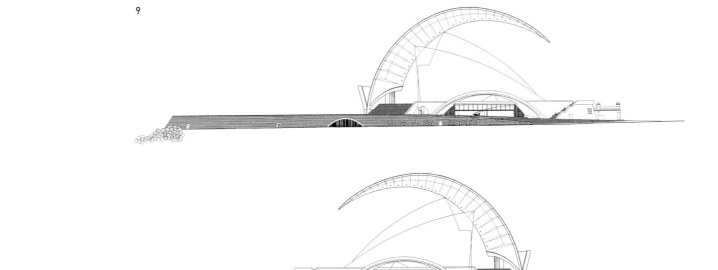

5 Main exterior staircase

6 Transverse sections

7 Opening between two elements of the structure

8 Exterior view, showing concrete ribs

9 Longitudinal sections

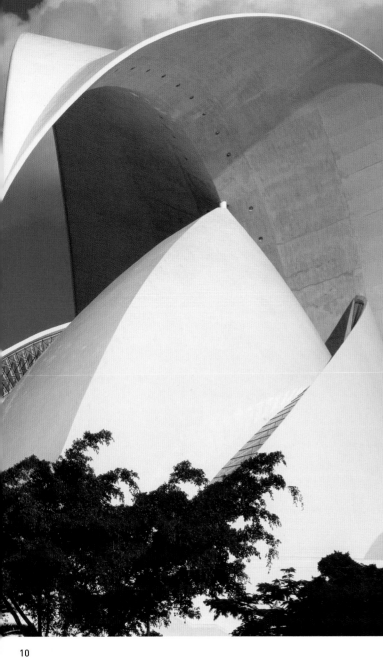

10

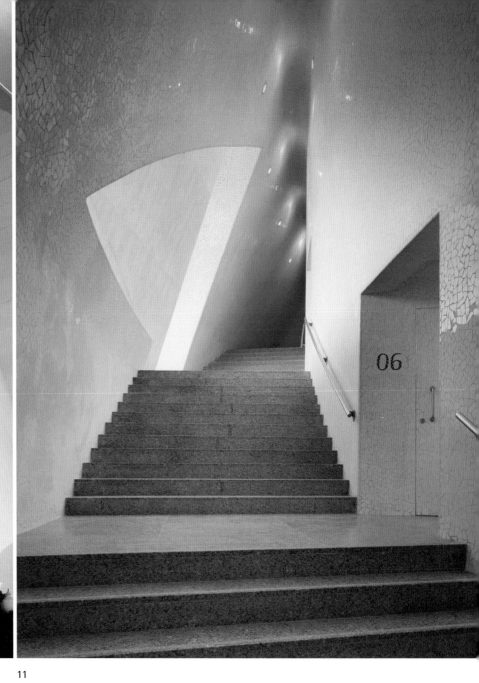

11

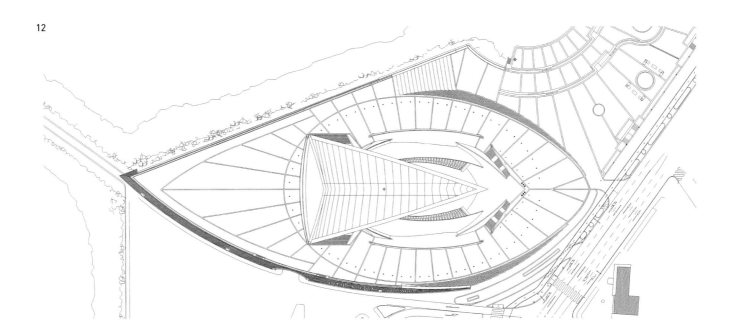

12

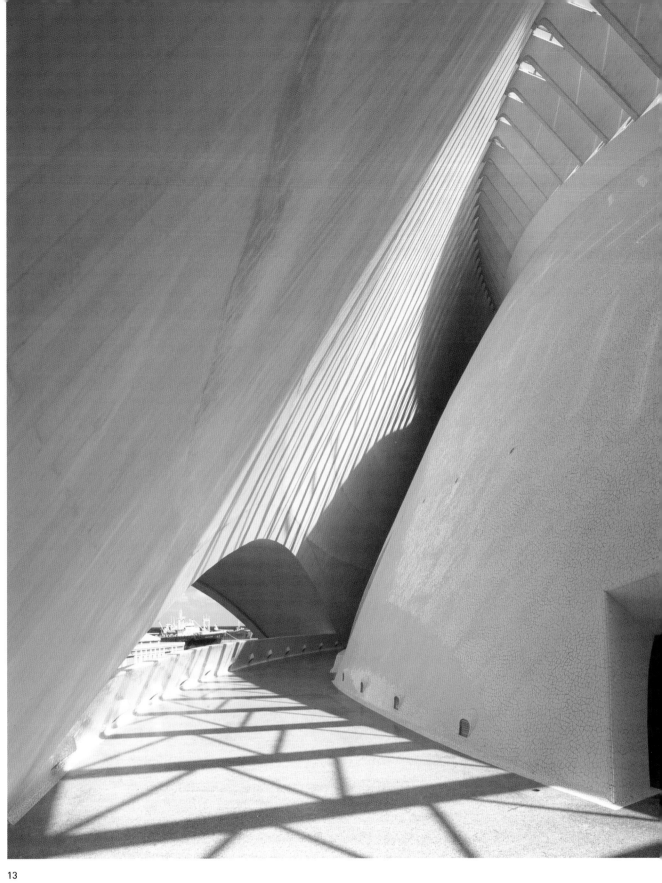

13

211

Museum of the 21st Century

When a developer approached Hariri & Hariri with a rather undefined commission to design a building for a site along the Hudson River in Lower Manhattan, the architects proposed a mixed-use complex incorporating a residential structure and a Museum of the 21st Century, which they conceived as a venue for cutting-edge—and presumably electronic—art. The architects quickly devised a striking scheme in which the residential component would occupy a tall, slender tower cantilevered from a narrow base and emerging from a sunken plaza. The tower itself would be cloven in two, with its north and south facades composed of structural concrete ribbons and the others, entirely glazed. The floor slabs would tie the concrete facades together to create something like a vertical truss. Counterbalancing the tower would be the low-rise museum.

As the design developed, the architects and their engineers have moved toward an even more sophisticated solution in which the concrete facades and slabs are effectively woven together to create a holistic structural web. Perhaps even more astonishing is the proposal to use the concrete surfaces themselves as a kind of interface between visitors to the museum and the artworks on display. Because the artworks would be electronic, various sensors, phosphors, and other devices embedded in the concrete could be used to control, modify, and project artistic images, creating a highly interactive experience. The proposed project thus represents a revolutionary concept in which structure, surface, and electronic media are fused into one.

New York, New York, United States
Proposed 2003
Architect: **Hariri & Hariri—Architecture**
Structural Engineers: **Robert Silman Associates, P.C.**

1

2

3

1 Rendering of the entrance to the proposed complex
2 Rendering of the museum interior
3 Conceptual sketch
4 Rendering of the project as seen from the southwest

5 Aerial perspective rendering

6 Rendering from inside the tower

7 Sections

8 Rendering of view from the Hudson River

9 Plans of tower level, upper level of museum,
 mid-level of museum, and basement

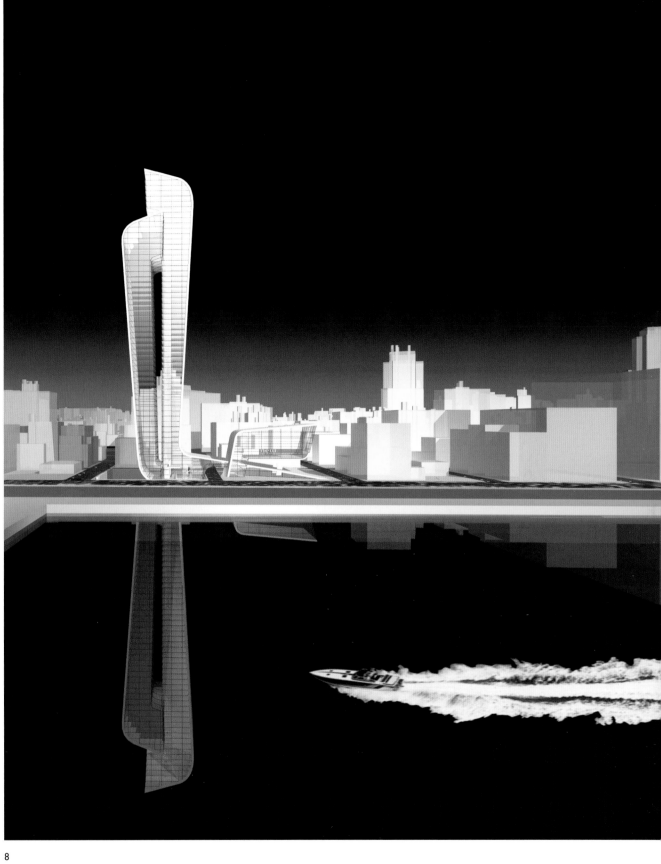

8

9

Future of Concrete

2

Mound Builders Museum

Inspired by the unique properties of Agilia®, a self-consolidating concrete produced by Lafarge, the Memphis firm Building Studio designed a hypothetical museum dedicated to the earthen mounds built by ancient Native Americans in the Mississippi River Valley. The museum is organized around a remarkably thin, spiraling ribbon of concrete, punctuated by hundreds of rectangular openings that would allow slivers of sunlight to dot the landscape below. This ribbon would alternately engage the land and the sky, conceptually pulling together the fundamental elements of nature that figure so prominently in Native American mythology and culture.

The use of Agilia would facilitate precise construction of the project's crisp geometric forms and allow thorough distribution of wet concrete amid the dense reinforcement the structure would require.

This project was commissioned especially for the Liquid Stone exhibition and book.

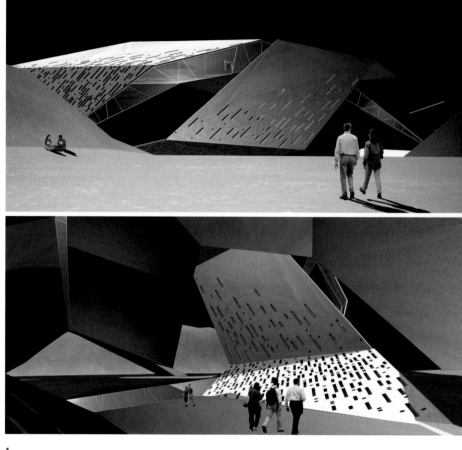

Memphis, Tennessee, United States
Proposed 2004
Architects: **Building Studio**
Project leaders: **Coleman Coker, Jonathan Tate, and David Dieckhoff**

1
2
3

1 Rendering of proposed museum
2 Rendering, showing perforated concrete planes and glazed spaces of the museum
3 Rendering of perforated Agilia® spiral emerging from the earth
4 Aerial rendering
5 Rendering of the spiral engaging the landscape

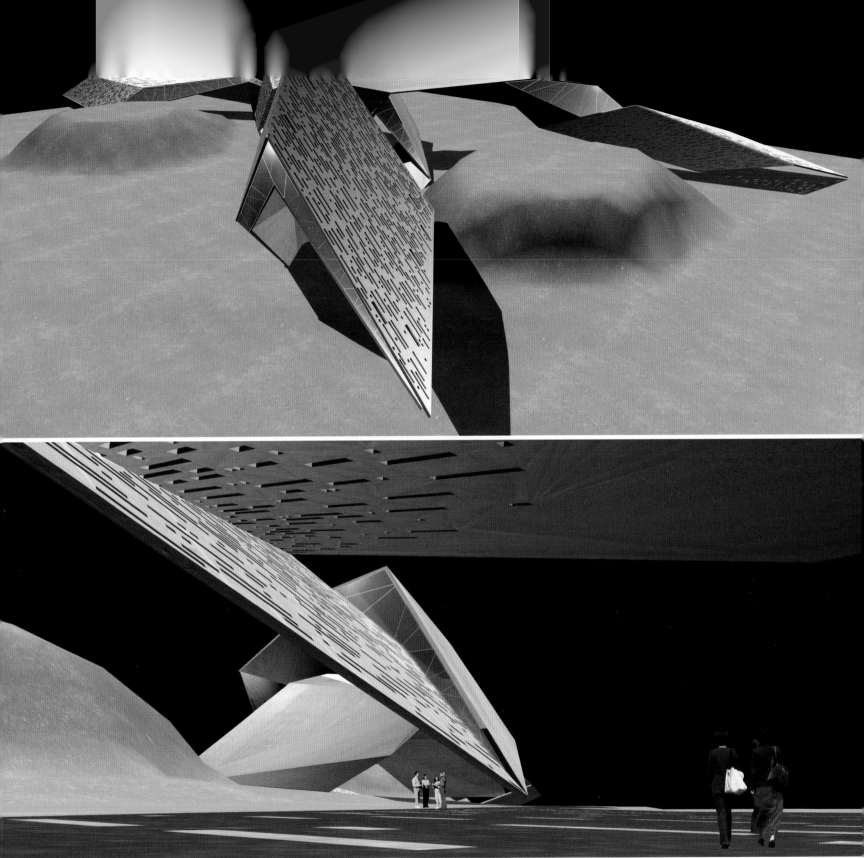

4
5

Ultra-High-Performance Concrete

Virtually all concrete structures built over the past century have been reinforced with steel, which absorbs the tensile forces that concrete alone cannot. The assumption that all concrete must be reinforced is being challenged, however, by a new material called Ductal®, an ultra-high-performance concrete developed by Lafarge. Ductal® contains extremely strong metal fibers that, in effect, render the material self-reinforcing. The material's name is a play on the word "ductile," meaning flexible, and alludes to the fact that, in contrast to typical, brittle concrete, Ductal® actually retains a degree of "give" even after it has completely set, making it resistant to cracking and chipping. The material can be used to create very thin structural members—even spanning long distances—without the use of conventional steel reinforcement. Ductal® has a remarkably smooth finish, resembling solid-surface plastics or ceramics more than traditional concrete. It can be used to create astonishingly strong and intricate architectural forms.

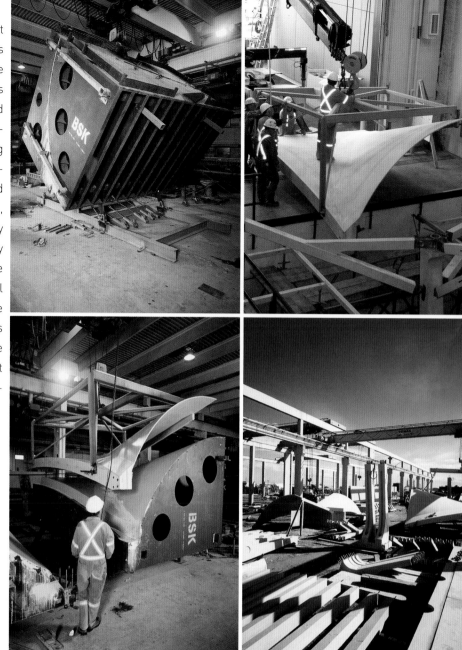

Calgary, Alberta, Canada
2004
Project: **Shawnessy LRT Station**
Architect: **CPV Group Architects and Engineers Ltd.**

1
2
3
4

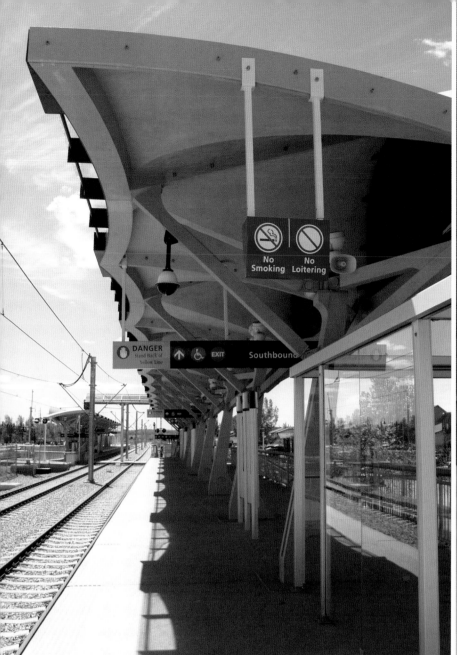

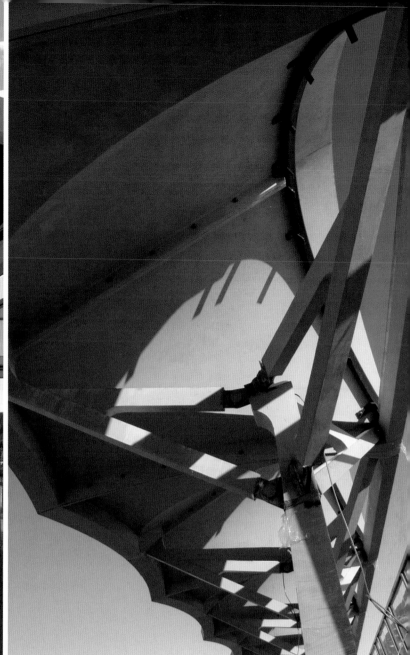

5

6

1 Precast section of Ductal® shell roof, setting up in
formwork

2 Shell-roof section, being removed from formwork

3 The 4-inch- (2-centemeter-) thick, 20-foot- (7-meter-)
wide shell being moved by a crane

4 Shell-roof sections, delivered to the site

5 Completed station, showing a row of Ductal® roof
canopies

6 Detail of Ductal® columns and struts supporting the
roof canopies

Musée des Civilisations de l'Europe et de la Méditerranée

Winner of an invited competition that included several of the world's most famous architects, Rudy Ricciotti covered the design of the Musée des Civilisations de l'Europe et de la Méditerranée (Museum of European and Mediterranean Culture) in a delicate, free-form lattice made of Ductal®. This proposed concrete web has a somewhat biomorphic character but also evokes the complex geometric patterns of Islamic decorative motifs. The architect describes the building as a "vertical casbah"—a modern, multistory reinterpretation of the traditional North African citadel. The project site is immediately adjacent to the historic Fort Saint-Jean and would be connected to the main waterfront by a long, slender bridge.

The Ductal® lattice would not serve as the actual building enclosure but as a kind of *brise-soleil*, modulating the strong Mediterranean sun and casting constantly changing shadows through the glass walls below and behind it. The lattice would be constructed out of identical modular units that would be joined together on site and attached to the main structure.

Marseille, France
Projected completion 2009
Architect: **Rudy Ricciotti, with RCT Architects**

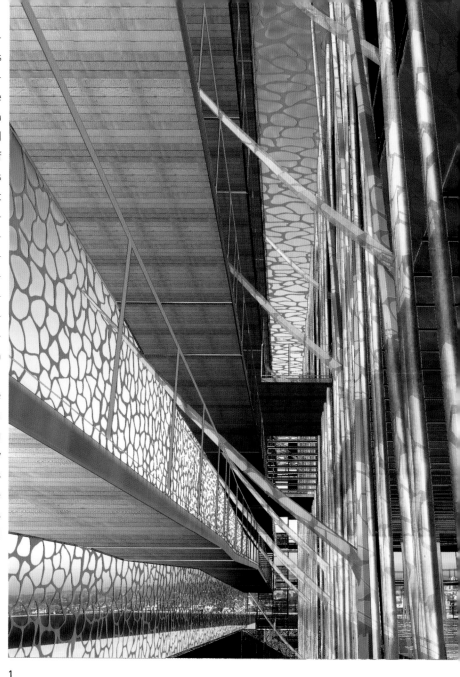

1

1 Rendering of the proposed museum
2 Rendering, showing the Ductal® screen suspended around the perimeter of the building, with the historic fort in the background.

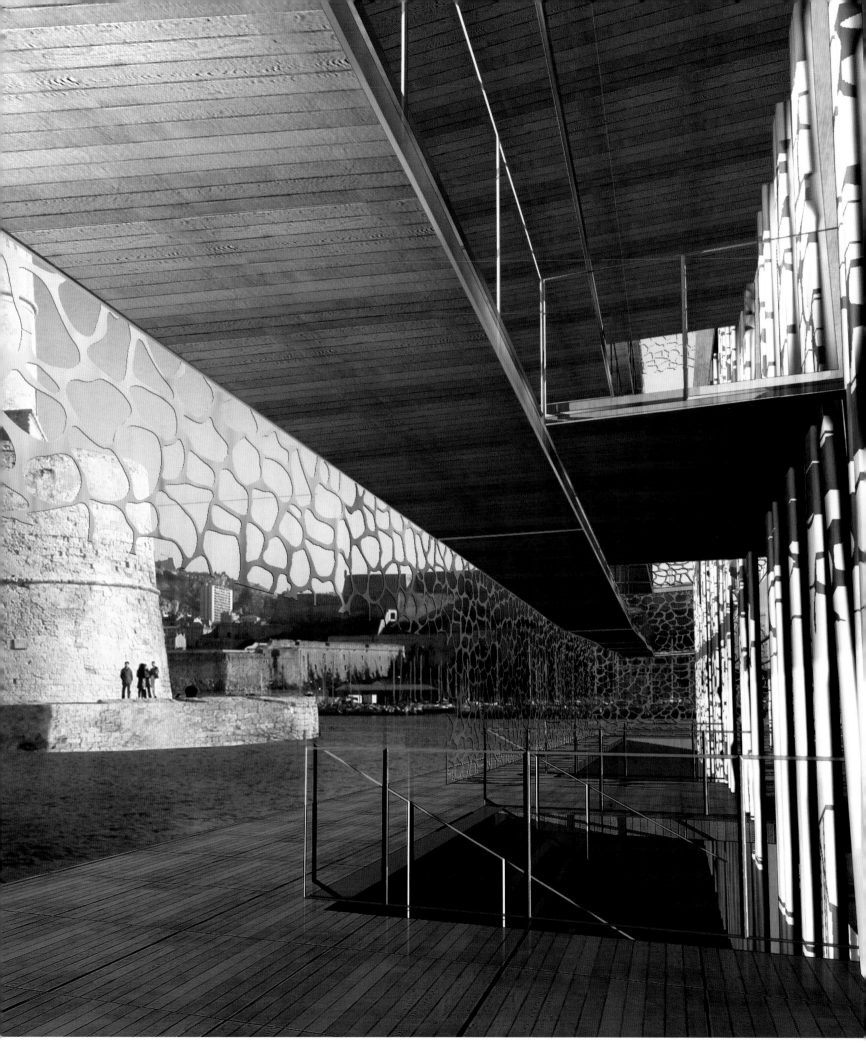

2

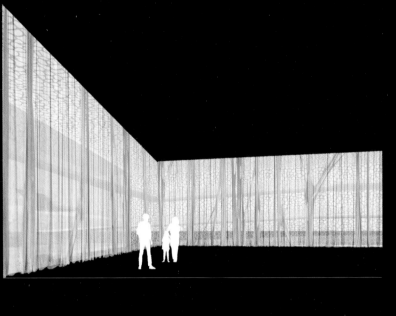

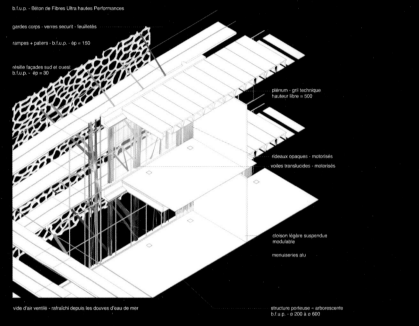

b.f.u.p. - Béton de Fibres Ultra hautes Performances

gardes corps - verres securit - feuilletés

rampes + paliers - b.f.u.p. - ép = 150

résille façades sud et ouest
b.f.u.p. - ép = 30

plénum - gril technique
hauteur libre = 500

rideaux opaques - motorisés

voiles translucides - motorisés

cloison légère suspendue
modulable

menuiseries alu

vide d'air ventilé - rafraîchi depuis les douves d'eau de mer

structure porteuse « arborescente »
b.f.u.p. - ø 200 à ø 600

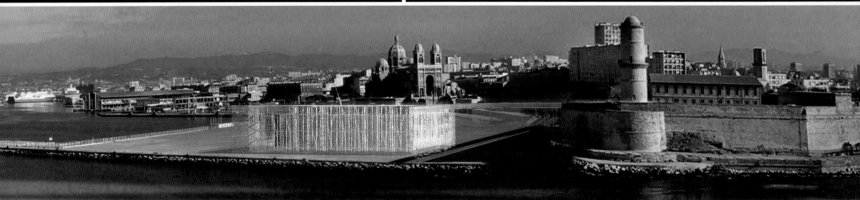

3

4

5

6

7

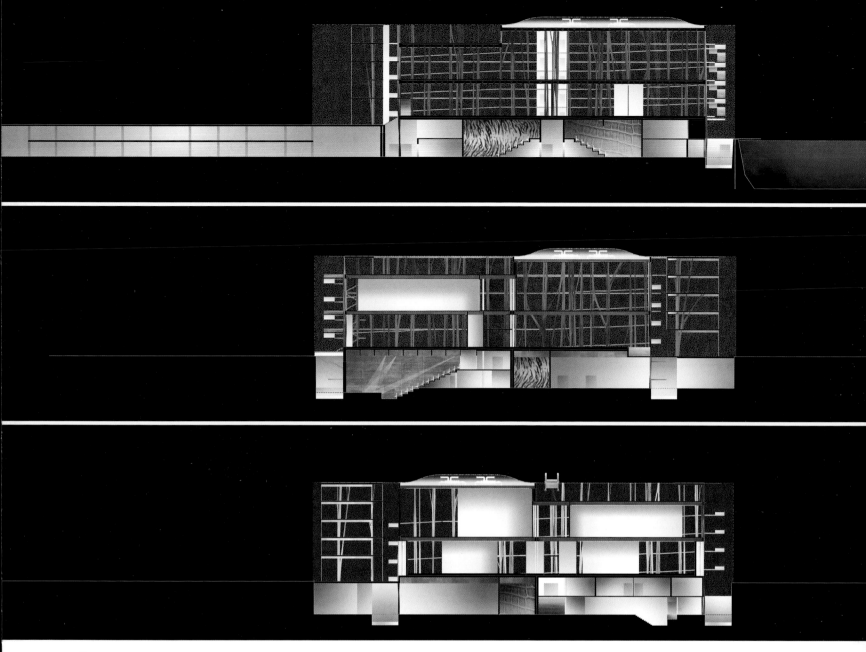

8
9
10

3 Diagram of single module of Ductal© lattice
4 Rendering of an interior space
5 Photomontage of the project in context
6 Diagram exploring layers of a typical façade
7 Cut-away axonometric drawing
8, 9, 10 Cross-sections of museum project

Translucent Concrete

Concrete is synonymous with solidity and, by extension, opacity. Academic and commercial researchers, however, are currently developing remarkable types of concrete that actually transmit light. For example, Will Wittig, now a professor of architecture at the University of Detroit-Mercy, developed a process for producing concrete panels that are just one-tenth of an inch (2.5 millimeters) thick at their centers—thin enough to be translucent under direct light. The panels are made of Portland cement and sand, reinforced with a small amount of chopped fiberglass.

As the technology of translucent concrete progresses, basic conceptions of structure and building skins may change dramatically, leading to new forms of architectural expression that challenge the imagination.

Project: **Prototypical Translucent Concrete Panels**
1999
Engineer: **Will Wittig**

1

1 Translucent concrete panels, thin enough to allow light to pass through

LiTraCon

LiTraCon® is an acronym for "Light Transmitting Concrete." Invented in 2001 by Hungarian architect Áron Losonczi, the product, which is currently made only in the form of precast blocks or panels, transmits light via embedded fiber-optics. Because the fibers do not significantly reduce the compressive strength of the material, LiTraCon® can be used not only for decorative purposes but also in many structural applications.

Theoretically, since fiber-optics carry light over great distances with almost no diminishment, a LiTraCon® wall or block could be quite thick—even as much as, say, 6 feet (2 meters)—and still transmit light as effectively as the roughly 6-inch (15-centimeter) wall illustrated here. For the pattern of light and dark to remain coherent from one side to the other, however, the tiny fibers in the concrete must all be parallel. In a finished block of LiTraCon®, the fiber-optics comprise only about 4 percent of the total volume.

To date, this material has been incorporated into a very small number of built projects, including the ceremonial Europe Gate, built in 2004 to celebrate Hungary's entry into the European Union.

Project: LiTraCon®
2001
Engineer: **Áron Losonczi**

1

2

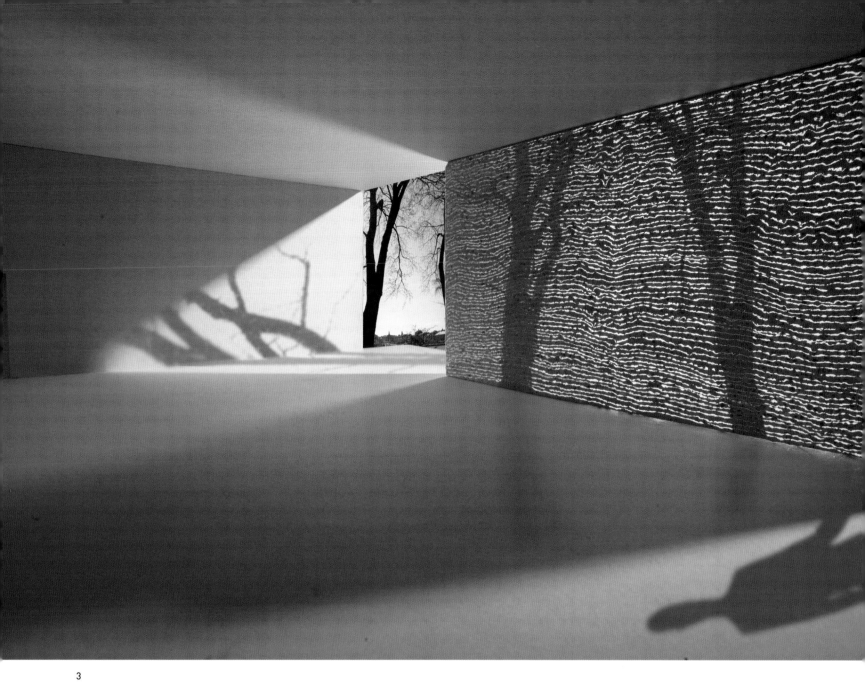

3

1 Wall of LiTraCon® in the Europe Gate
2 LiTraCon® used as a ground surface in a plaza
 in Stockholm, Sweden, by Áron Losonczi with
 E. Giovannione, G. Hildén, and A. Lucca.
3 Model of LiTraCon® structure emphasizing the
 material's transparency

Pixel Chapel

The Pixel Panel®, invented by Bill Price, a professor at the University of Houston, is a thin concrete panel containing a regular grid of fine plastic fibers set perpendicular to the surface that carry light from one side to the other. To explore the possible applications of this innovation, Price, along with Scott McGhee, designed a small, hypothetical chapel with walls made of these panels. Like the White Temple, featured in the "Structure" section of this book, the proposed Pixel Chapel is a simple, rectangular building in which light plays a central role. While the White Temple is lit mysteriously through hidden skylights, the source of outside light in the Pixel Chapel is obvious, though counterintuitive in a concrete-surfaced building. By day, the space would appear as if lit by thousands of tiny stars. Viewed from the outside at night, with the interior artificially lit, the structure's physicality would almost disappear amid the constellation of tiny shafts of light.

This project was commissioned especially for the Liquid Stone exhibition.

Houston, Texas, United States
Proposed 2004
Architect: **Bill Price, Inc.**
Structural Engineer: **RDP Engineers Inc.**

1

2

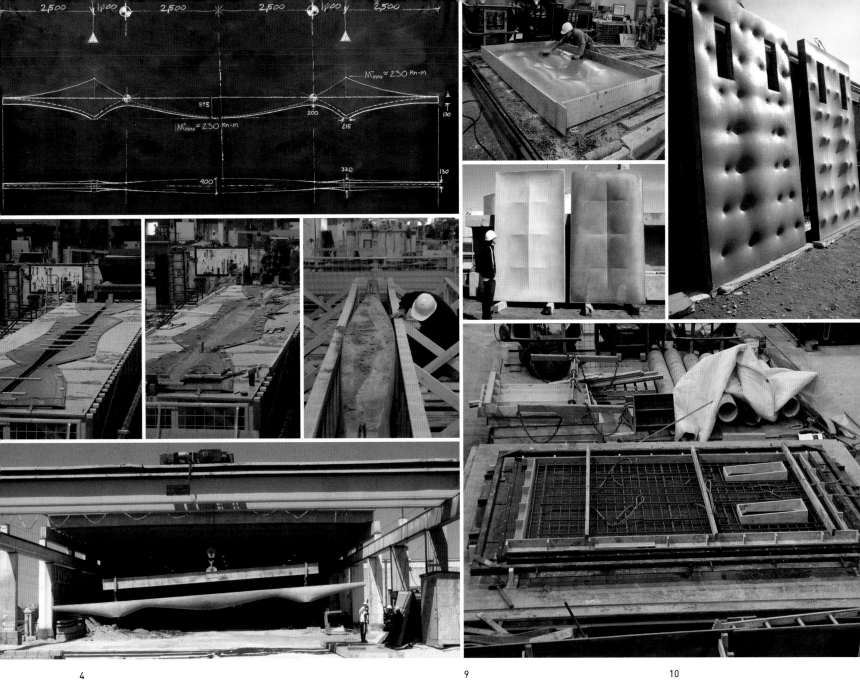

4 Diagram of a beam cast in fabric, indicating forces
 acting on the beam

5, 6, 7 Fabric form, positioned and filled with concrete;
 resulting beam in temporary wooden suppports

8 Prototypical beam, suspended from a crane

9 Large fabric-formed panel being cast

10, 11 Molds and resulting cast panels

12 Large fabric-formed panel form

Fabric-Reinforced Concrete

Lancelot Coar, a Washington architect and artist who also holds a degree in engineering, is developing a concept for using fabric not merely as the formwork for concrete but as a replacement for steel reinforcement in concrete structures, taking advantage of the enormous tensile strength of certain synthetic textiles. In contrast to steel bars, fabric can be easily shaped into patterns that more accurately reflect the curvilinear forces within structural elements. Moreover, fabric weighs much less than steel, meaning that it can be more readily transported to building sites and help to reduce the deadweight of the finished concrete.

The use of fabric as reinforcement in structural concrete members raises the prospect of quite unusual construction methods. Buildings of fabric-reinforced concrete might actually be constructed from the top down, with the fabric for a given floor's columns stretched from the floor slab above, filled with concrete, and then used to support the next slab and columns below.

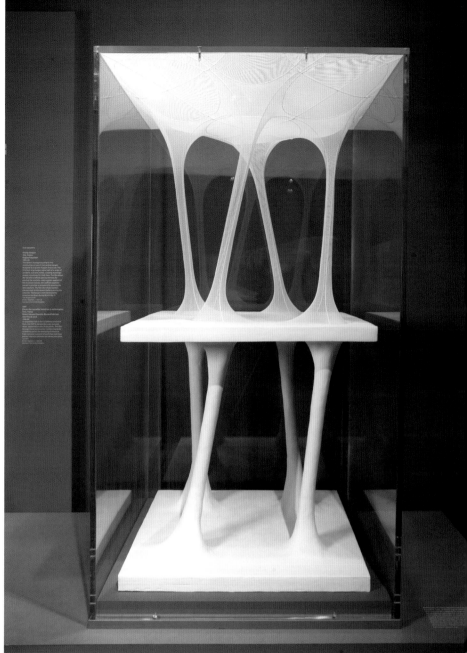

1

1 Mock-up of a fabric-reinforced concrete structure, showing unfinished, taut fabric "columns" on upper tier

1

2

3

"Rapid prototyping" is a general term for what is, in effect, three-dimensional printing—the construction of physical models directly from computer-aided design files, using any of a number of different substances to create the actual objects. Based on this fundamental technology, Professor Behrokh Khoshnevis of the University of Southern California has developed a robot that builds walls and other building forms out of numerous layers of concrete. The key component of the robot is a large nozzle, rather like a giant ink-jet, that sprays a mix of liquid concrete in a pre-determined pattern. Known as "contour crafting," this technique, still in its infancy, may eventually allow substantial automation in the construction of foundations, walls, floors, and other structural and even decorative concrete elements.

Professor Khoshnevis has established as a near-term goal the construction of a 2,000-square-foot house in less than one day with no direct human labor. He predicts that such automated techniques will eventually become routine, helping to reduce construction waste, minimize danger to workers, and decrease building costs.

1, 2, 3 Series of views showing concrete wall being constructed by a robot in a laboratory at the University of Southern California

Acknowledgments

This volume brings together in a compact form reflections and ideas developed since 2004, and the editors wish to thank all the institutions and persons involved in the various stages of what has been an extremely creative adventure.

First of all, this book is based on the exhibition curated by Martin Moeller at the National Building Museum in Washington, D.C., held between June 2004 and January 2006. The unprecedented duration of the show is a testament to the popular acclaim it generated. Many institutions, architects, and researchers contributed content to the enterprise, including the designers of the featured projects, some of the essayists in this publication, and the manufacturers who produced samples of innovative concrete products for display.

Lafarge, represented by Philippe Hardouin at Group level and by Philippe Rollier and Sherry Peske for Lafarge North America, was the exclusive sponsor of the exhibition and provided not only vital financial support but also technical information, useful contacts, and in-kind contributions of specific materials that helped to explain various aspects of concrete technology.

Various advisors lent guidance throughout the development of the exhibition and book. The formal Advisory Committee, whose early input was essential, was composed of Peter McCleary of the University of Pennsylvania, Amy Slaton of Drexel University, and Rick Yelton of Hanley Wood Magazines. Kenneth Frampton of Columbia University, Sarah Gaventa of Scarlet Projects, and Daniel Margulies also made useful suggestions at the project's inception. Once planning was under way, Amy Gardner of the University of Maryland, Michael Grutzeck of Pennsylvania State University, and various staff members of the Portland Cement Association were quite helpful.

The exhibition installation was designed by Tod Williams Billie Tsien Architects. Working with project manager Jennifer Turner, they created an elegant, serene environment that complemented the exhibition's content.

If the second half of this book puts the projects presented in Washington in perspective, the first half is a direct extension of presentations made at a symposium hosted by Princeton University in October 2004, which was produced in cooperation with Lafarge and the National Building Museum. Thanks go to Stan Allen, dean of Princeton's School of Architecture, for graciously hosting the symposium; to Cynthia Nelson, who handled logistics on behalf of the school; and to Charlotte Cova, who took care of the mobilization and travel arrangements of dozens of European participants.

Our gratitude goes to those who contributed essays to this publication: Adrian Forty, Réjean Legault, Guy Nordenson, Antoine Picon, Franz-Josef Ulm, Tod Williams, and Billie Tsien. Finally, our thanks go to Nancy Eklund Later, the competent and incisive editor who made the project possible at Princeton Architectural Press, and to the press' staff.

G. Martin Moeller, Jr.
Jean-Louis Cohen

Banham, Reyner. *A Concrete Atlantis: U.S. Industrial Building and European Modern Architecture*. Cambridge, Mass.: MIT Press, 1986.

Banham, Reyner. *The New Brutalism: Ethic or Aesthetic?* New York: Reinhold, 1966.

Bennett, David. *The Art of Precast Concrete: Colour Texture Expression*. Basel: Birkhäuser, 2005.

Bennett, David. *Exploring Concrete Architecture: Tone Texture Form*. Basel: Birkhäuser, 2001.

Béton beau masque. Special issue, *Monuments historiques* 140 (August–September 1985).

Bill, Max. *Robert Maillart: Bridges and Constructions*. London: Pall Mall Press, 1969.

Billington, David P. *Robert Maillart's Bridges: the Art of Engineering*. Princeton, N.J.: Princeton University Press, 1979.

Cent ans de béton armé, 1849–1949. Paris: Science et industrie, 1950.

Le Ciment-roi: Réalisations architecturales récentes. Ossatures, formes, ornements. Paris: Librairie de La Construction moderne, 1927.

Cohen, Jean-Louis, Joseph Abram, and Guy Lambert. *Encyclopédie Perret*. Paris: Éditions du Patrimoine, Institut français d'architecture, and Éditions Le Moniteur, 2002.

Collins, Peter. *Concrete: The Vision of a New Architecture. A Study of Auguste Perret and His Precursors*. London: Faber & Faber, 1959. Reprinted with foreword, introduction, and additional essays. Montreal and Kingston: McGill-Queen's University Press, 2004.

Croft, Catherine. *Concrete Architecture*. Layton, Utah: Gibbs Smith, 2004.

Delhumeau, Gwénaël. *Le Béton en représentation, la mémoire photographique de l'entreprise Hennebique*. Paris: Norma, 1999.

Delhumeau, Gwénaël. *L'invention du béton armé: Hennebique, 1890–1914*. Paris: Norma, 1999.

Fernandez Ordoñez, Jose. *Eugène Freyssinet*. Barcelona: 2c Ediciones, 1978.

Frampton, Kenneth. *Studies in Tectonic Culture*. Cambridge, Mass.: MIT Press, 1995.

Gaventa, Sarah. *Concrete Design*. London: Mitchell Beazley, 2001.

Giedion, Sigfried. *Building in France, Building in Iron, Building in Ferroconcrete*. 1928. Translated by J. Duncan Berry. Introduction by Sokratis Georgiadis. Santa Monica: The Getty Center for the History of Art and the Humanities, 1995.

Hitchcock, Henry-Russell. *Latin American Architecture Since 1945*. New York: Museum of Modern Art, 1955.

Hitchcock, Henry-Russell and Philip Johnson. *The International Style, Architecture Since 1922*. New-York: W. W. Norton & Co, 1932.

Legault, Réjean. "L'appareil de l'architecture moderne: New Materials and Architectural Modernity in France (1889–1934)." Ph.D. thesis, Massachusetts Institute of Technology, 1996.

Marrey, Bernard. *Nicolas Esquillan, un ingénieur d'entreprise*. Paris: Picard, 1992.

Michelis, Panayotis Andreou. *Esthétique de l'architecture du béton armé*. Paris: Dunod, 1963.

Mörsch, Emil. *Der Eisenbetonbau: seine Theorie u. Anwendung*. Stuttgart: Wittwer, 1902.

Nervi, Pier Luigi. *Costruire correttamente, caratteristiche e possibilità delle strutture cementizie armate*. Milan: Hoepli, 1955.

Neufert, Ernst. *Bauordnungslehre*. Berlin: Volk und Reich Verlag, 1943.

Onderdonk, Jr., Francis S. *The Ferro-Concrete Style: Reinforced Concrete in Modern Architecture*. New York: Architectural Book Publishing Co., 1928. Reprint, Santa Monica: Hennessey + Ingalls, 1998.

Reinforced Concrete: Ideologies and Forms from Hennebique to Hilberseimer. Special issue. *Rassegna* 13, no. 49 (March 1992).

Rüegg, Arthur, Reto Gadola, Daniel Spillmann, and Michael Widrig. *Die Unschuld des Betons, Wege zu einer materialspezifischen Architektur*. Zürich: Eidgenössische technische Hochschule, 2004.

Siegel, Curt. *Structure and Form in Modern Architecture*. London: Crosby Lockwood, 1962.

Simonnet, Cyrille. *Le Béton: Histoire d'un matériau*. Marseille: Parenthèses, 2005.

Slaton, Amy. *Reinforced Concrete and the Modernization of American Building, 1900–1930*. Baltimore and London: Johns Hopkins University Press, 2001.

Slessor, Catherine. *Concrete Regionalism*. London and New York: Thames & Hudson, 2000.

Virilio, Paul. *Bunker Archeology*. New York: Princeton Architectural Press, 1994.

Vischer, Julius and Ludwig Hilberseimer. *Beton als Gestalter*. Stuttgart: Julius Hoffmann, 1928.

Index

Image Credits

Abbreviations: t=top; m=middle; b=bottom; r=right; l=left. All images featured in the Designs and Buildings section courtesy of the architect of record unless otherwise noted.

Courtesy *Architectural Review* 54t; *Architecture de C. N. Ledoux* (NY: PAP, 1997) 14t; *Architektur und Bauplastik der Gegenwart* (Berlin: Rembrandt-Verlag, 1938) 30t; © archphoto—eduard hueber 68t, 68b, 69, 70t, 71tl, 71tr, 71mr; © 2005 ARS, NY/ADAGP, Paris/FLC 15, 16, 25b, 47t; Luis Asín 154, 166t, 166m, 167, 169l , 169r; Jean Badovici, *Grandes constructions* (Paris: Albert Morancé, 1931) 25t; Horst Berger, *Light Structures, Structures of Light* (Basel: Birkhäuser Verlag, AG, 1996) 11m and b; *Le Béton armé, étude théorique et pratique* (Paris: C. Béranger, 1909) 22b; Ted Bieler 55t; © Hélène Binet 194b, 196tl, 196tr, 198tl, 198t 2nd from l, 198t 3rd from l, 198t 4th from l, 198tr, 199; © Tom Bonner 141t; Courtesy Marcel Breuer papers, 1920–86, Archives of American Art, Smithsonian Institution 49bl; © Tamás Bujnovszky & Áron Losonczi 235; *Cent ans de béton armé, 1849–1949* (Paris: Science et industrie, 1950) 22t; *Le Ciment-roi Réalisations architecturales récents. Ossatures, formes, ornements* (Paris: Librairie de la Construction moderne, 1927) 21b; Bernice Clark © JunebugClark.com 49br; © Jean-Louis Cohen 21t, 24, 26l, 26tr, 26br, 28t, 28b, 31t, 31m, 31b; *Concrete Products* 49tl, 50br; F. X. Deloye et al., Laboratoire Central des Ponts et Chaussées 17; © DRHA 145b; École Nationale des Ponts et Chaussées 10t, 10b; Jose A. Fernandez-Ordoñez, *Eugène Freyssinet* (Barcelona: Romagraf, 1979) 11t; Adrian Forty 35t, 35m, 35b, 36, 37, 38t, 38b, 39t, 39b, 40l, 40r, 41t, 41m, 41b, 42t, 42m, 42b, 43l, 43r; Courtesy Goetheanum, Dornach, Switzerland 157b; © Jeff Goldberg/Esto 109, 120t, 120b, 121, 123tr, 123mr, 125tl, 125tr, 125mr; © Reinhard Görner 94m, 97tl, 97tr, 97mr; © Tim Griffith back cover, 57, 76t, 77, 78tl, 78ml, 78tr, 79, 81tl, 134t, 134b, 135t, 136t, 138tr, 138br, 139; © Jan Haux front cover; Geo. M. Howe, courtesy Steven Oliver 138tl, 138t 2nd from l, 138b 2nd from l, 138bl; Courtesy Dr. Jerzy Ilkosz, director, Museum of Architecture, Wrocław 157m; Holger Knauf, for Ingenhoven und Partner 186t, 186b, 187t, 187b, 188tl, 188t 2nd from l, 188b 2nd from l, 188bl, 188tr, 188br, 189; Institut français d'architecture 13r, 14b, 23; Courtesy Italcementi 202tl, 202t 2nd from l, 202t 3rd from l, 202t 4th from l, 203b; Ben Johnson 99, 103; © 1977 Louis I. Kahn Collection, UPenn and Pennsylvania Historical and Museum Commission 49tr, 55b; © Alan Karchmer 158b, 159, 200t, 201, 202tr, 202mr, 203t, 204l, 204r, 205, 206t, 206m, 207, 208tr, 209tl, 209tr, 210tl, 210tr, 211; Courtesy Berokh Khoshnevis 243l, 243tr, 243br; Bernhard Kroll 60, 94t, 95, 96; Courtesy Lafarge 226tl, 226bl, 226tr, 226br, 227l, 227r; Le Corbusier, *Almanach d'architecture moderne* (Paris: G. Crès & Cie, 1926) 29; Le Corbusier, *Towards a New Architecture* (NY: Dover Publications, 1960) 158t; Le Corbusier, *Vers une architecture* (Paris: G. Crès & Cie, 1923) 12; Réjean Legault 47b, 48b, 53b, 54b; Courtesy Victor Li 239t, 239b; T. Y. Lin International 63b; Courtesy the artist and Luhring Augustine 107b; J. B. Lyttle, *ACI Journal Proceedings*, permission of American Concrete Institute 52b; Mitsuo Matsuoka 110t, 110b, 111, 112, 113tr, 113br, 114, 115; Liz McBee 76m, 81tr; Michael Moran, courtesy TWBTA 108t, 108m, 108b; *Das neue Frankfurt, 1930* 28m; Ernst Neufert, *Bauordnungslehre* (Berlin: Volk und Reich Verlag, 1943) 30b; Guy Nordenson and Associates 63t; Jack Norman 107 2nd from t; Tomio Ohashi 90t, 90b, 91, 92tr, 92br, 93; Klemens Ortmeyer 194t, 196mr; I. M. Pei & Partners 48t, 53t; Courtesy Paco Perez/Allure.com 124; Robert Perron 50tr, 51; Courtesy Antoine Picon 9, 13l, 14m; © Robert Reck 116t, 116b, 117, 119t; Philippe Ruault 126t, 126b, 127t, 128, 129l, 129tr, 129br; Philip Ryan, courtesy TWBTA 107t; © Mark Seelen 140t, 142l, 142r, 144, 145tl; Shinkenchiku-sha 65t, 67t; © Margherita Spiluttini 58-59, 150t, 150b, 151t, 152tr, 153; Allan Sprecher, for National Building Museum 232, 233, 238, 240t, 242; Ezra Stoller © Esto. All rights reserved 50l, 52t; Lloyd Sutton, courtesy Lafarge 222, 223; © Hisao Suzuki 160, 161, 162t, 163tl, 163tr, 165tl, 165ml, 165tr; Marc Treib, *Space Calculated in Seconds* (Princeton: Princeton U. Press, 1996) 63m; Courtesy Franz-Josef Ulm 219t, 219 2nd from t, 219 2nd from b, 219bl, 219br, 220t, 220 2nd from t, 220m, 220 2nd from b, 220b, 221t, 221ml, 221bl, 221br; © Paul Warchol 82t, 82m, 83, 84 t 4th from l, 84tr, 85, 176t, 176b, 177t, 178tr, 179tl, 179ml, 179tr, 180l, 180r, 181; Eleanor Weinel 107 2nd from b; Courtesy Mark West, Centre for Architectural Structures and Technology 240bl, 240br, 241tl, 241lm, 241 l 2nd from m, 241 l 3rd from m, 241bl, 241tm, 241 t 2nd from m, 241tr, 241br; Nigel Young/Foster and Partners 98tr, 100, 101t, 102tl, 102 t 2nd from l, 102 t 3rd from l, 102 t 4th from l, 102tr; Bruno Zevi, *Erich Mendelsohn The Complete Works* (Basel: Birkhäuser Verlag, AG, 1999) 157t

Published in North and South America and Australia by
Princeton Architectural Press
37 East Seventh Street
New York, New York 10003

For a free catalog of books, call 1.800.722.6657.
Visit our Web site at www.papress.com.

Princeton Architectural Press
ISBN-13: 978-1-56898-570-1
ISBN-10: 1-56898-570-3

For Library of Congress Cataloging-in-Publication data, please contact the publisher.

Published in Europe, the United Kingdom, Asia and Africa by Birkhäuser – Publishers for Architecture,
P.O. Box 133, CH-4010 Basel, Switzerland
www.birkhauser.ch
Part of SpringerScience+Business Media

Birkhäuser – Publishers for Architecture
ISBN-13: 978-3-7643-7483-9
ISBN-10: 3-7643-7483-7

Bibliographic information published by Die Deutsche Bibliothek
Die Deutsche Bibliothek lists this publication in the Deutsche National-bibliografie; detailed bibliographic data is available in the Internet at http://dnb.ddb.de.

© 2006 Lafarge Group, Paris, France
All rights reserved
Printed and bound in Austria
09 08 07 06 5 4 3 2 1 First edition

No part of this book may be used or reproduced in any manner without written permission from the publisher, except in the context of reviews.

Every reasonable attempt has been made to identify owners of copyright. Errors or omissions will be corrected in subsequent editions.

Editing: Nancy Eklund Later
Editorial Assistance: Dorothy Ball, Moira Duggan
Design: Jan Haux

Special thanks to: Nettie Aljian, Nicola Bednarek, Janet Behning, Becca Casbon, Penny (Yuen Pik) Chu, Russell Fernandez, Peter Fitzpatrick, Clare Jacobson, John King, Mark Lamster, Linda Lee, Katharine Myers, Lauren Nelson, Scott Tennent, Jennifer Thompson, Paul Wagner, Joseph Weston, and Deb Wood of Princeton Architectural Press —Kevin C. Lippert, publisher

This book is published with the generous support and assistance of the Lafarge Group as an integral part of its Creative Materials initiative. This global educational program also included sponsorship of the highly acclaimed exhibition Liquid Stone: New Architecture in Concrete, organized and presented by the National Building Museum in Washington, D.C., and a symposium on the same topic held at the School of Architecture, Princeton University.